JAN WORST

JAN WORST

PAINTINGS

1988 - 2008

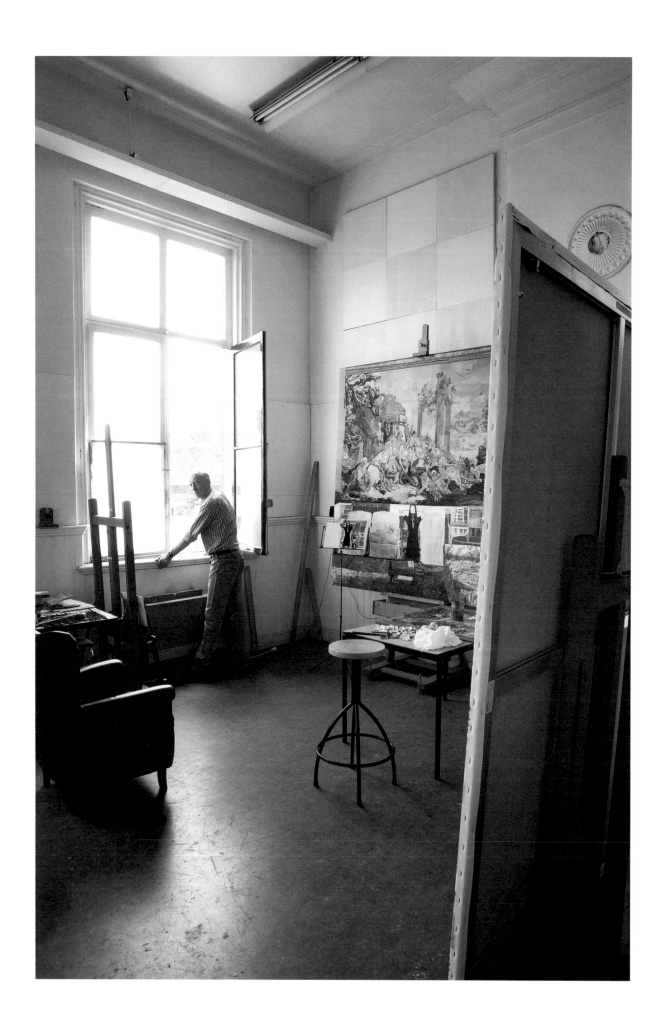

A Matter of Light

Gian Enzo Sperone

The mantra that was repeated in my high school days, "art is a lyrical perception of reality", was created by Benedetto Croce in such a simple way that it seemed as unbearable as a mathematical formula or a good syllogism for all situations, yet misleading; vaguely threatening. It's like this, or it's like this. And we thought: and if we took away "of reality"? or "lyrical perception"?

We'd be left with "art is". And we laughed heartily, as we did for almost all the things that allowed us to get through the endless school hours (which we'd later miss) with as little damage as possible.

When I first saw a work of Jan Worst – so formal, cold, calm – I couldn't help thinking it was strictly predetermined, with a rather philosophical precision and little of anything "lyrical". I was wrong. The paintings of this lanky Dutchman, with his measured ways and his beautiful bespoke English shoes of a considerable size, are an enchanted, treacherous world where, in a large complexity of elements, what lords it over all the rest is the light. And then there are the thousand pentimenti that take the natural slowness of this type of work to alarming levels.

I've never been to Heerenveen, the Dutch town not far from the sea where Worst was born, but from a map I discovered it's 169 km from Leyden, where Rembrandt was born.

As it's highly probable there are no mountains or forests with their inherent light and shade effects, the light dominates everything, evenly enveloping the entire visible world. Let's be clear about this: not that suffocating Mediterranean light, but the frugal yet clear-cut one of Vermeer interiors.

I can't resist the temptation to stray a bit more with idle considerations. In 400 years, the art of painting has changed a great deal, and especially in just a few years of the early 20th century, rather as the stones exposed to the weather have been corroded more during this century than over periods of hundreds or thousands of years. Painting, too, has been corroded by the ravenous intelligence of the painters – modern cannibals – and never before with such dis - inhibition and ferocity.

From this perspective, much contemporary painting is frankly impossible to look at, perhaps not at first glance, but probably the second time around.

Despite setting aside the standards of classicism, now dead and eaten by the worms (each one absorbing from the previous one, only to then swallow and expel without mercy), it's not clear how the splintering, dismembering, unravelling and mutilating can leave room for a form of representation which, however you look at it, is still the heart of painting. Even where the aim is just to hint.

Laying aside the problem of the light as a vehicle of expressiveness, and denying the relevance of the old rule of art being somehow decipherable, there is no desire to engage in new metaphors (because who notices anyway?). It would seem more practical to camouflage singsongs that have been picked up, recycling the rhythms deleted by the cinema, fashion, television or other various trash banalities. At the most, the aim is to arrive at the staging of a feeble toy theatre. The hope that a pubic hair, disinfected by the lens of a fashion photographer, can alone constitute a slightly reheated linguistic starting point is not enough to produce painting material.

Painting is a bewitching, unconventional glance, not mediated by anything else apart from the artist's interior mirrors; sometimes by the entrails.

It's also true that painting is just a system of signs that now have no order, more or less allusive, more or less penetrating. But the essential thing, yesterday as today, is to transpose one's own experience as a sensitive subject into the language; into one's own language, not that picked up from the dominating culture.

The art of Jan Worst is the representation of a silent, static life theatre, where a few humans are surrounded and dominated by objects. A world where nothing decisive happens and any tension promising energy and activity just wilts amid the formal perfection. A softened world with the good manners of classic elegance. Nothing personal, everything nearly calm: like an ideal scenario, so that the light becomes the real protagonist and anxiety can knock on the window of painting.

This filtering light of the inside is the only clue to an outside world. As if nothing existed apart from the domestic walls and everything, from birth to death, took place in that scenario of perfect furnishings.

This form of indifference and intransigence towards the viruses of nature makes the work of Jan Worst unique in its extreme, exaggerated fixedness.

New York, 5 November 2007

Mere Dreams, Mere Dreams!

Adrian Dannatt

What if the glory of escutcheoned doors,
And buildings that a haughtier age designed,
The pacing to and fro on polished floors
Amid great chambers and long galleries, lined
With famous portraits of our ancestors;
What if those things the greatest of mankind
Consider most to magnify, or to bless,
But take our greatness with our bitterness?

from Ancestral Houses by WB Yeats

Le lieu est lui-même en toi. Ce n'est pas toi qui est dans le lieu, le lieu est en toi.

The place is itself in you. It is not you that is in the place, but the place is within you.

Jacques Derrida - Sauf le Nom

As a precocious teenager Jan Worst was already involved in the street-fights of '68 as a "Provo", one of those avant-garde Dutch agitators, and ever since he has remained true to revolutionary anarchist beliefs, a radical punk, illegal squatter, even arrested for attacks upon the Queen of Holland's palace. Actually none of this is true, or maybe it is, for I know absolutely nothing of Worst's life other than dates of birth and art-school education. But the sumptuous oddity, the sheer singularity of his oeuvre is such that one reaches for any sort of biographical assistance, whatever clues his own history or character might grant to an interpretation of this hermetic domain. And surely our interpretation of Worst's work would shift if it was known that he had indeed been imprisoned for, say, spray painting upon the walls of Huis ten Bosch, the graffiti slogan " ALL PROPERTY IS THEFT!" Likewise, we somehow presume that Worst is not an actual aristocrat himself, has not literally grown up amongst and spent most of his life within just such rooms, and that these paintings are thus not to be understood as straightforward celebration of privilege. But it is not impossible, there is a strong art historical precedent of aristocratic (think Balthus) or even royal painters and there are certainly a sprinkling of contemporary artists, particularly of Italian and English origin, who come from social backgrounds almost as grand as those portrayed by Worst.

What would Worst's oeuvre "mean," how would we interpret it, if we knew that he was portraying his own home life, his family mansion, his relatives? Surely we would assume it was a non-critical, loving and sensuous homage to his own class, the exact opposite of the meaning we would ascribe were he the anarchist that we first imagined. Lured by Worst's world we immediately want to know about the artist himself, or more specifically about his social relationship to his aesthetic, his intentions, his own ideas, what he is here to tell us. Above all, what we fundamentally need to know is the artist's own relation to the very specific realm that he deliberately portrays again and again to the extraordinary exclusion of all other subject matter. What are his personal attachments or aspirations regarding this exceptional milieu? For however much we hope to try and judge art irrespective of any biographical information, just by the work itself, it is an entirely human failing to be swayed in our judgement by what we know about the artists themselves. We always need to construct stories, to resolve their plots, and the narrative that Worst has presented us with is so utterly mysterious, so seductively resonant, that we all naturally cast about for further clues.

For a true connoisseur the first thing that strikes one about Worst's work might be the dexterity and subtlety of his deployment of paint, the creation of such complex effects from such relatively simple brushstrokes, how his seemingly formal realism is built from near abstract pattern planes. But for most of us, naturally, what we immediately notice is Worst's subject matter. This is, to put it mildly, a most unusual theme for a contemporary artist, a strikingly unique topic, whose extremity blatantly challenges us. That challenge is inherently political because it goads us into examining and admitting our own relationship to wealth, privilege, luxury, and female beauty. Do we wholeheartedly approve? Do we want to have it, do we aspire toward these things, are these the secret sum of our hidden ambitions? Is this, let us for once be entirely honest with ourselves, the world that we want to inhabit and towards which all our everyday energies are directed? Do we approve of this world or do we disapprove, want it or reject it? Should such overt superiority, unashamed grandeur, be allowed to exist in our supposedly egalitarian times? Because he has posed this question to us, because he has forced us to consider such intimate ambitions, the extent of our complicity with this fantasy, we obviously would like to first establish Worst's own relationship to this world. Does he aspire and desire or analyze and despise? We will never know and that is precisely the deep potency, the magic of his oeuvre. As long as we do not know, cannot ever exactly establish Worst's own attitude to the milieu he so obsessively portrays then we are left in a state of ambiguity, moral and political, as to our own feelings. We may create fantastical hypotheses around him, invent these extreme biographical versions of a fictional Worst, but never divine his intention.

This biographical or even anecdotal imperative is partly inspired by a question of national identity, for the most unexpected, improbable dimension of Worst's work is that it should be made by a Dutch person. For nothing in Dutch society, politics or art history could prepare one for the emergence of Worst's oeuvre, and one can only imagine that its reception within that culture must be one of outrage, bewilderment or outright hostility. Indeed if some Dadaist provocateur was going to try and think up the one subject-matter, one style, that could actually rile and ruffle those famously tolerant, open-minded and liberal Dutch they might well arrive at Worst's world. For it is impossible to exaggerate the anti-elitism, the social liberalism and democratic conformity of the contemporary Dutch character, a country with the catchphrase "To be ordinary is extra-ordinary enough" and where any outward sign of

superiority, wealth or even just good tailoring is disdained. And that is just amongst the ordinary populace, whereas the Dutch art world is naturally all the more extreme in its distrust of money, privilege, pomp or circumstance, an entrenched hippy-socialism still lingering from the 60s despite all attempted reform. Holland may always have had great wealth but it has also always attempted to disguise, to 'democratize' such fortunes, as suggested by the perfect title of Simon Schama's book 'The Embarrassment of Riches.' Holland does of course have an aristocracy, indeed a monarchy, with suitably grand houses but they have never promoted or paraded their way of life, they have always existed with the utmost clandestine discretion. This may be changing, as certainly the Dutch love to bemoan the ascendancy of 'Nouveau Riche' show-offs, the emergence of a flashy generation of conspicuous consumers, they have always done so throughout history, and the old-fashioned distrust of luxury, or elegance even, remains strong.

The Dutch haute-bourgeoisie have long collected art, commissioned portraits of themselves and the interiors of their mansions, indeed the 'Golden Age' of Dutch painting revolves around such subject matter. Obviously those rooms of burghers, merchants and bankers were clearly of a certain class and deliberately contained objects of great value, whether globes, tapestries or indeed other framed paintings hung upon the walls. Curiously enough, the paintings these prosperous citizens collected with particular passion were not portrayals of their own class but rather genre scenes of bucolic or alcoholic peasant rural life, a paradox partly explained by Dutch egalitarianism. Yet those interiors are very different to those depicted by Worst. For when the worthy burgher had a painting made of his rooms it was not to suggest an unusual existence of exceptionally great luxury, in fact the emphasis was usually on the "ordinariness" of such domestic scenes, emphasizing similarities, human communality, rather than any difference. Thus, though the wall coverings in Pieter de Hooch's "Leisure Time in an Elegant Setting" (1663) seem terribly grand in all their golden-glimmer, everyone at the time would have recognized they are in fact just "Spanish" leather, a canny Dutch version at a fraction of the price of the original. By contrast, Worst's interiors are clearly aristocratic or royal rather than merely haute-bourgeoisie, they are built to impress, to awe, in a manner inherently antithetical to Dutch mores. Though perhaps one should not over-emphasize this issue of nationality, the fact remains that Worst's subject matter, maybe equally his manner of painting, is genuinely outrageous and provocative, if not deliberately antagonistic, within the context of the contemporary Dutch art world. Thus what could be seen as conformity or acquiescence within a different milieu, a different country or cultural environment, must here be understood as a genuinely radical gesture of rebellion, outrage to the point of ostracism. In such places there are even still some surviving artistic circles that consider figurative painting in itself automatically reactionary, the prejudice of a prior idealistic era in which all forms of realism were politically suspect. Within such an ideological reading, Worst's realism is integrally bonded, entwined, with his subject matter as it would be hard to imagine abstracted versions of such historical houses, with the exception perhaps of Howard Hodgkin's socialite blobs or Turner's watercolors of Petworth. Curiously, in relation to photography, there are several renowned contemporary artists, whether Karen Knorr, Patrick Feigenbaum, Tina Barney or Thomas Struth, who have created specific series of photographic studies of European aristocratic families as an overtly conceptual project. This seems acceptable precisely because of the presumed factuality of photography, unlike the implicit 'fictionality' of Worst's painted world. There would be an undoubted satisfaction in being able to think of Worst's work as simply "reactionary," to celebrate it as a reaction against all prior dogmatic political positions, a deliberate break with aesthetic and social adherence. But its position is altogether more equivocal, its potency in its ultimate neutrality, its refusal to take sides or to make any statement of purpose.

In the context of that long-lost dogmatic art discourse of entrenched political conviction, Worst's art proposes an absolute and unforgivable transgression, an explosive act of rebellion, and surely one secretly wishes that some time-machine could whisk Worst back to, say, the Marxist orthodoxy of late 60s downtown Manhattan. Indeed a seminal essay from that very era, Sidney Tillim's 'A Variety of Realisms' as published in Artforum in June 1969 makes several points curiously pertinent to Worst. "But the modernist tic that post-Pop and pre-Pop figurative art have most in common, albeit with different results, is a tendency to serialization. Serialization refers to the variation of formal themes within given conceptual conditions with a given number of elements and a characteristic combination of these elements. It is not merely a variation on a theme but a renewal of the basic problem each time." This is certainly applicable to Worst, who is clearly challenging himself, re-posing a 'basic problem' with each canvas. Tillim talks of just such an artist who "…constructs setups that are obviously 'machines' which provide an endless flow of varied shape, pattern and color." Thus we could consider the continuity of Worst's subject-matter as precisely such a 'machine,' a grid of vectors, a cross-referenced inventory of motifs, that produces a steady if slow 'flow' of major works. Or as Tillim puts it, "Interestingly enough, serialization is incompatible with anecdotal painting, thus paving the way for the return of the masterpiece." Though Tillim may use the quaint term "revisionist values" to describe such artists, his summation of their interests still seems valid, that they share " a comparable lusting after tactility, after strongly modeled form, clear contours and deep illusionistic space" and "the same frontality or actual flatness that inhibits maximum illusion." This issue of illusion, of optic deception, is notably moot in Worst's case as we witness the curious push-pull of his pictorial plane, his penchant for the extreme fore-grounding of a figure or object, a chair, table or child, in relation to the perspectival recession of the overall composition. From very close-quarters, seen from inches away as an actual painting rather than reproduction, these dominant shapes in the immediate foreground are essentially abstract, blocked geometric massing, and often of somber, darker tones in opposition to the whiteness, the brightness, of the far distant light. Thus many paintings will have the bottom third mapped out with darker, bulkier passages which seem abstract due to their close-up scale, then a middle-passage of transitional tonal variants, often of flesh-tones suitable to figural elements, and the top third of lightest, thinnest summation. Such striation, from lower chiaroscuro to higher sublimity, from patterned foreground to impeccably detailed vanishing point, leads the eye ever upward and across the surface of the canvas. Tillim concludes that "Technique is necessary for the sake of the imagination," a necessary reminder that mere technique in itself is secondary to the artist's intellectual and even moral capacities, or really just their having something 'new' to say. Thus to place Worst solely within an historic or geographic context, the tradition of Flemish and Lowlands painting is to compromise the sheer bravery, the maverick oddity, of what he gives us.

That said, there are certainly some intriguing parallels between Dutch "Golden Age" art, for surely Worst's actual style of painting is closer to the super-matt flatness, the tonal quietude of Vermeer than to the glossy surfaces of photo-realism? Likewise Worst chooses certain motifs, wallpaper, carpet, tapestry, not just because of the luxury they represent but because of the pleasurable challenge posed by having to paint them. This is the same bravura relish of difficulty deployed by Vermeer in "Allegory of the Catholic Faith" (1670-72) with its dominant tapestry and that strangely positioned female, her foot perched improbably upon a globe, which also recalls Worst's own heroines. There is an element not just of trompe l'oeil but also postmodern self-referentiality when Worst paints such wallpaper patterns, because his own technique, especially in earlier works from the 1980s, suggests the very contours and colors of precisely such continental block-print wallpaper, most notably Zuber, from the mid 19th century. Although always 'painterly' rather than graphic, Worst deploys the chunky, bold, clean-edged flatness of those hand-stenciled designs, not least in the repetitive motif of leather-bound books, which was long a favorite in this field. (Such books are, of course, inherently abstract both in appearance as rectangular objects and as containers of coded information, though it is curious to note that despite this plethora of volumes very little actual reading takes place in Worst's pictures, a pleasure seemingly reserved for the rare adult male.) Indeed, as opposed to their slickness when photographically reproduced, it is surprising just how dependent Worst's paintings in the flesh are upon the tactile reward of oil paint upon canvas. This combination of firmly delineated contours and scumbled weft, strict geometry and painterly effects playing off each other, might recall the architectural caprices of Bernard Boutet de Monvel or those near edible interiors of Félix Vallotton.

Any emphasis upon the interior, and upon its furnishings and decoration, upon the tactile physical details of these rooms is also a consistent theme shared by Worst and his 'Golden Age' antecedents, a refusal to go outside, the resistance to a landscape which might dissolve all individuality. Worst shares a penchant for the long corridor, for the receding perspective of the floorboard, the open door and the room-beyond-the-room beloved of his 17th century compatriots, and he also shares with them a certain white-light, a specific dazzling blankness granted by the exterior day. Although in some of Worst's paintings one can detect the suggestion of leaves and trees, even a park, lake or faintest mountain through the windows, usually the outside world is rendered as just an undefined whiteness. These areas of stunning emptiness, of sheer sensual brushwork are one of Worst's most impressive painterly ploys, whole zones of monochrome worthy of Ryman's own tonal range. This whiteness is also the whiteness in the empty windows of the 'Golden Age' interior, with its suggestion of artificial side-lighting constructed like a diorama, a perspectival box-of-tricks, a well-lit film or stage set in itself. And just as those earlier Dutch interiors were originally specific houses, painted often as commissioned portraits of particular properties, but have by now become generalized embodiment of an idea-of-home, so also Worst's interiors are very specific yet also unlocatably infinite. They are surely real places but also akin to those houses which recur within one's dreams, where it seems so certain one has definitely been there before, in a previous dream or maybe some distant reality. The myriad, multiplying chambers of Worst's imagination are both actual and fantastical, but do they all exist within one single structure, a palace of infinite mathematical extension, or do they belong to different buildings? This is the dream-logic

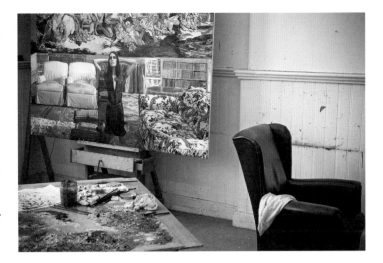

of 'L'année dernière à Marienbad' in which the haunting familiarity of the chateau represents the 'eternal return' of the human memory, but it is also the practical reality of that Sicilian palace in 'The Leopard' by Tomasi di Lampedusa, which can be explored for a week without exhausting its plethora of unknown rooms. To quote the Prince of that novel, rightly proud of such continually proliferating quarters, "A house of which one knew every room wasn't worth living in." We do not know where we are within Worst's rooms; do they belong to us or to some well-known family? Are they symbolic of all such interiors or are they highly individual and unique? At the time they were painted many 'Golden Age' interiors would have been recognizable to their local audience, "Oh, that's so-and-so's front parlor!" Similarly, we seem to recognize aspects of Worst's rooms. Is that not Woburn Abbey, the false bookshelf of The Travelers Club on Pall Mall, could that not be Chatsworth or Blenheim, do those library steps not belong to la biblioteca antica of Torino's Archivi di Corte or perhaps to Beistegui at Groussay?

We are tempted, teased, with glimpses of recognition, an ache of familiarity which is ultimately negated by the higher fiction of these places. Are we supposed to recognize these rooms as specific palaces and villas? Surely not, no more than we are supposed to recognize their beautiful inhabitants as specific fashion models, actresses or celebrated mannequins. But they too are so oddly familiar, we have seen their poses, their positions, their perfect cheekbones and ideal limbs elsewhere, earlier, in some 'collective unconscious' construed from forgotten glossy magazines, haute couture photo shoots, high fashion catalogs, flirtatious female publications. We seem to know these women, to have surely seen them somewhere before in precisely the same way as these rooms and corridors are curiously familiar, their new conjunction, their current combination thus doubly odd. In some paintings it is almost as if Worst is challenging us to identify his sources, or at least playing with the sheer improbability of his models' positions. Posed so dramatically on top of tables, consoles, billiard tables, perched there for our admiration and in suspension of our disbelief, what are they doing and how did they get there? Worst makes it quite clear that he has chosen these strange, impossible locations in which to perch his women as both a compositional challenge and an almost Surreal provocation. Is that some Yogic or Tantric position being assumed upon the gleaming flat top of a bureau plat, are we in expectation of a levitation, the apparition of a madonna posed for assumption, annunciation? Thus though Worst's actual painterly

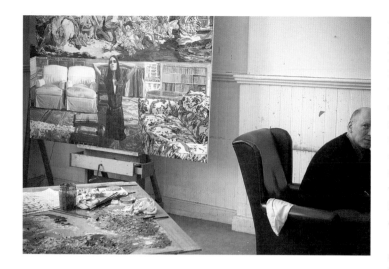

technique is the very opposite of Photorealism and his work long pre-dates the cut-and-paste aesthetic of the digital image-bank, he deliberately challenges us with his oh so presumably photographic sources, with the collaged superimposition of these Amazons.

Another possible parallel with Dutch 17th century interior-painting is the curious absence of adult male figures. Though they do appear on occasion, formally besuited gentlemen of a certain age, presumed paterfamilias gray at the temples or entirely bald, on the whole they are notable by their non-appearance. Instead Worst's cast usually consists of a beautiful female, still safely distant from middle-age, and a child, male or female, whose relationship to this elegant woman is entirely, centrally ambiguous. For if their closeness in age suggests sibling status, their voyeuristic distance or pose, the literal and metaphoric gap between them suggests the threat of a new, very young stepmother, the temptations of a far-too-attractive super-nanny or even some sort of hired escort whose duties remain tenuous. It is the relationship between this clearly attractive female and the interior in which she finds herself that remains the core mystery at the heart of Worst's universe. This mystery is brought to the fore, made overt, by the interaction or often notable lack of such, between the woman and the children who also inhabit this domain. The erotics of the gaze are confused and compounded by the fact that this striking stranger, and she is a stranger surely, so often shares the stage with a child who could, only just, be her own yet seems mystified or maybe attracted by her presence. If in 'Golden Age' painting the child-adult relationship is usually more obvious there is also often a surprising lack of mature males, the domestic domain being that of women and children, and issues of uncertain paternity or even outright bastardy, not to mention courtesanship are often encoded in these compositions. The much younger second wife, the 'professional' beauty and the mistress are certainly not unknown within those historic paintings, along with the recurrent implication of educational duties. As Jeroen Dekker attests in his essay on 'Educational Messages in 17th Century Dutch Genre Painting' the portrayal of the private sphere of family life, the 'maternal-interior' was paramount. "Children do not simply grow up; they have to be educated to become decent adults…the Dutch portrayal of children was less a celebration of childhood as a unique stage of life than an attempt to show how children could be molded and shaped through a variety of educative purposes." There certainly seems to be a suitably 'wide variety of educative activities' suggested by Worst's scenari, as if the

woman is patiently awaiting the child's eventual adolescence, appropriate maturity, or almost trying to tempt them into assuming some precocious knowledge. To quote Dekker, "Education here refers to those forms of individual behaviour that aim at introducing children, by way of cultural transmission, to the cognitive, emotional, social, moral codes of an existing culture." We may presume that the children in Worst's paintings are the inheritors or heirs, the rightful inhabitants of these houses, and that those singular women are, by contrast, more recent intruders, agents of change whose erotic or sartorial drama stands in contrast to the 'codes of an existing culture.' But it could even be that the children are actually versions of these women at an earlier age, the embodiment of a more innocent youth, and so any distance between them is the actual separation of all those past years.

The open ended, never-resolved drama Worst re-stages again and again seduces us precisely because of its uncertainty, because we do not know where this place is nor whom its inhabitants are, nor their relation to each other, to their setting, or to our own guilty complicity. It is visually beautiful, and we seem to remember once upon a time that that was an assumed prerequisite of an accomplished work of art, the children are beautiful, that female is certainly beautiful, but we remain uncertain how to link them, how to dare bond all this together with desire. We are attracted to the painting as an attractive object, its very size, its texture, its physical presence, and we are of course attracted to its attractive subject matter. Yet quite aside from any puritanical reservations regarding depictions of wealth we cannot shake some small residue of guilt. Because is that young boy or that pre-pubescent girl really aware of what they are looking at so shamelessly and does not their fixed gaze replicate our own voyeurism? On the rare occasions when a grown adult male does appear he is never actually looking directly at the beautiful woman, whereas by contrast the children seem always to be staring at her, with an open interest. This libidinous confusion suggests the metaphysical paradoxes of Jacques Lacan in which "Every desire is the 'desire of a desire'. The subject never finds a multitude of desires, only entertains towards them a reflected relationship. By way of actually desiring, one implicitly answers the question-"which of your desires do you desire, - have you chosen one?" Worst's extremely "reflected" relationships treat us to a refracted if not shattered fan of myriad mirrored desires, whether our most basic desire for physical beauty, our desire for the perfection of certain architectural modes or our desire for visual art itself. What ultimately disturbs us in all this is the possibility that Worst himself holds the key, knows exactly what he is doing to his viewers and yet refuses to grant us a clue, sadistically plays with our needs, our 'drive', our pleasure. Surely somebody within these paintings must know what they are doing there, who is in love with whom or just who wants what or whom? There is a sort of ultimate cunning at play here, a game of power wielded by the painter-deity who has created his own world of polymorphous perversion. But whilst the viewer may know that they want to be a part of it, somehow enter into this elaborate game, ultimately it is only the God-like Worst who controls his own creatures and never ruins the effect by explaining his intent. To quote again the good Doctor Lacan, "The Other 'knows' what it wants from us; it is only we who cannot discern the Other's inscrutable will."

To see one painting by Worst on its own grants an entirely different impression, if not deceptive misinterpretation, of his work because judged as a single entity it could be confused with an impeccably rendered, idealized portrait of a certain class of people in appropriate

class of dwelling. Of course there is enough honor and satisfaction in the ability to actually successfully execute such paintings to satisfy even the most exigent artist and nobody is going to question the greatness of Sargent's society portraits or those portrayals of upper-class European interiors beloved by Walter Gay. But that is not what Worst is about at all, that is not what is meant at all.

Just as the one thing a book cannot do is capture the physical sensation of being in front of one of Worst's paintings as an object, what by contrast it can do is present his oeuvre in its entirety, in all its true oddity. For if one whole gallery full of Worst's work begins to grant some sense of his intentions, his master-plan, then to see, to flick through, the full range, the entire collected oeuvre, from the beginning until today is to at last get some approximate sense of its startling singularity.

For only when one looks at these paintings as an all-inclusive group can one realize how they make up a rigorous conceptual project of absolute determination. Worst is thus revealed as the master of one of those systematic if not scientific late 20th century creative processes comparable to the repetitive-strategies of Daniel Buren, Lawrence Weiner, Niele Toroni or the aforementioned Robert Ryman. If Sol LeWitt was both a Conceptual and a 'Minimalist' there seems no reason Worst should not be equally acclaimed as the first of such Conceptual and 'Maximal' artists.

For twenty years Worst has been painting what seems to be the same house, the same interior, or very close variants upon its stylistic unity, and a recurring cast of characters, some of whom must surely have grown up by now, must have moved elsewhere, exited the scene. Or are they incapable of leaving? Is there no exit, no escape from this strange domain, does an invisible force (maybe the force of the picture plane itself) restrain all these characters as in Buñuel's film 'The Exterminating Angel'? For there is surely something literary or cinematic in this claustrophobic huis clos, a self-contained maze within what may well prove to be the proverbial gilded cage. The very first line, the stage-directions of Genet's play 'The Balcony' seems appropriate here, "On the ceiling, a chandelier, which will remain the same in each scene." As with Genet we have the uneasy suspicion that there is a disturbing, yes anarchic sexuality that runs through these salons, that everything our society is predicated upon, that these reassuringly grand rooms represent and uphold, can be suddenly re-wired by bare flesh alone. Worst's characters could easily be masquerading in any number of disguises, that elegant châtelaine might as well be the local whore tricked out in her very best, the games of role playing and deception multiply in such confines. To quote Arthur in Genet's play; "And I got dressed up to stay here, to go walking through the corridors and look at myself in your mirrors. And also for you to see me dressed up as a pimp…. I'm not meant for outdoors. I've been living within your walls too long. Even my skin couldn't tolerate the fresh air…maybe if I had a veil…"

Worst is dealing with dangerous material, a visual beauty invidiously tied to power and wealth, the sort of beauty which is continually co-opted into the circuits of commercial and monetary exchange, whether through auction houses or antique dealers, by ties of marriage or even modeling agencies. The potency of Worst's work depends precisely upon its ambivalent status, its promiscuity as an object for sale and subversive purpose as image. We will never be able to buy everything we want, we could never purchase the abundant range of physical beauty that Worst so generously grants us, this world is beyond us though we are offered, by implication, all of this, merely by it's being contained within one of his images. But even in owning just one of his paintings we have been deceived, for if all art is to some extent about loss then surely the first loss it embodies is the eventual realization that all we've been given is simply just oil paint on canvas, nothing more. And in that loss, the pleasure and discrete sweet pain of such deception, is itself some sort of home, some sort of palace for our imagination, knowing that only fiction, only art, ultimately survives time's onslaught unlike even the grandest buildings that come to dust.

PLATES

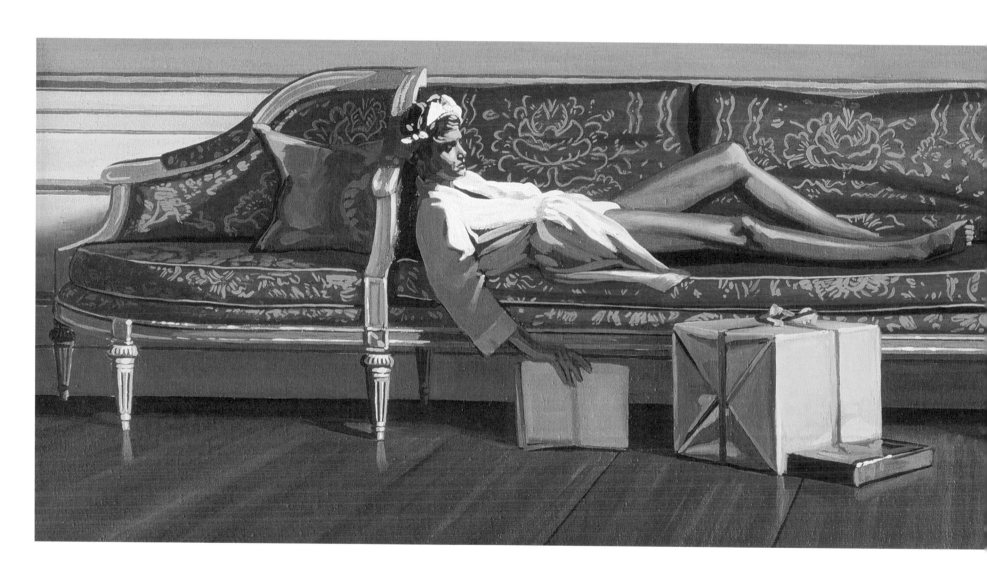

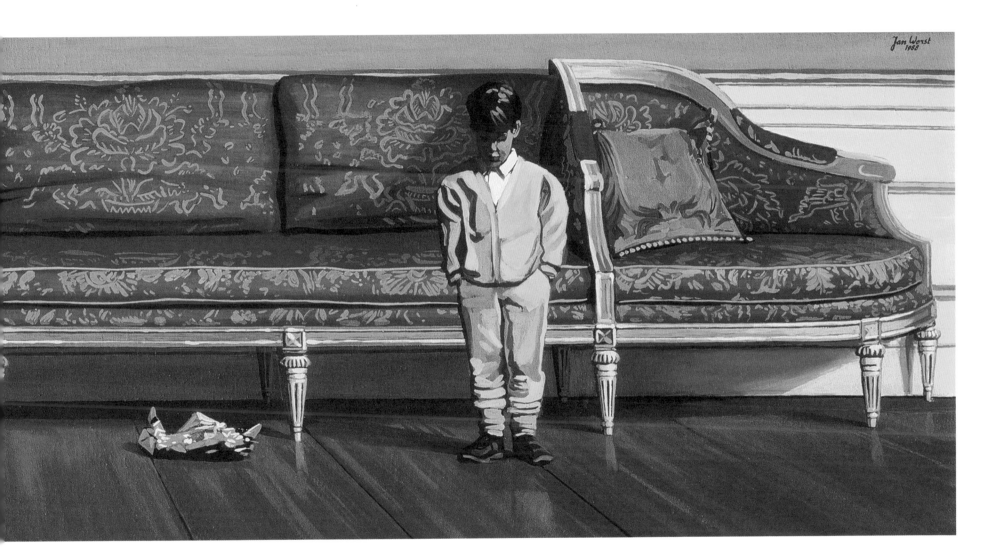

(page 14) *Confidente*
 1988

De droom en de verantwoordelijkheid
1988

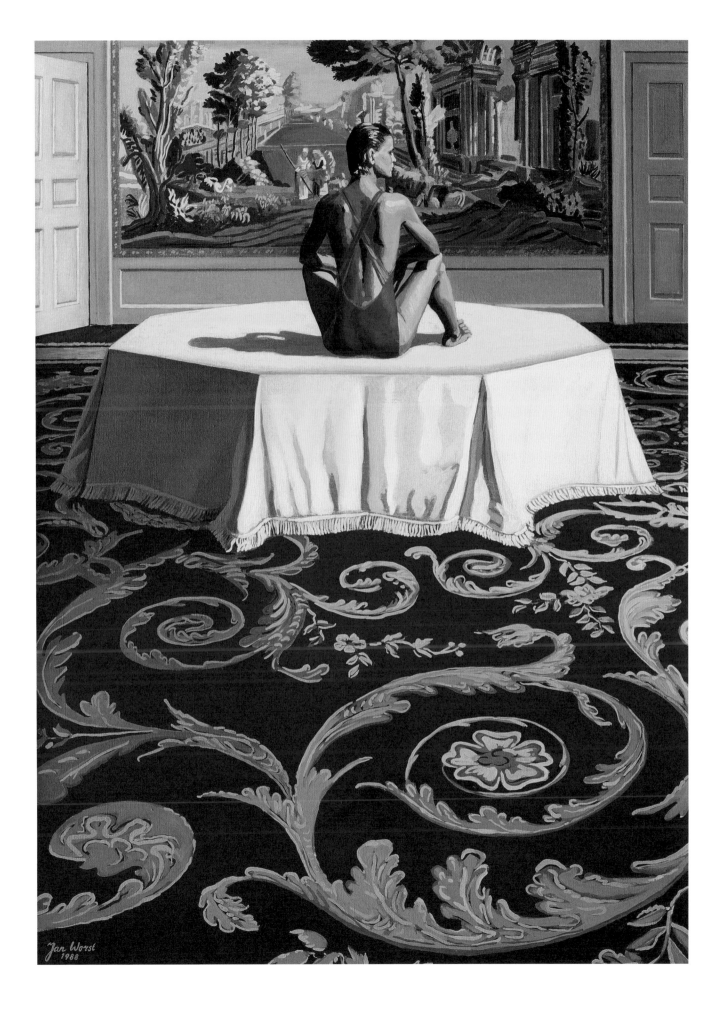

Elysium
1988

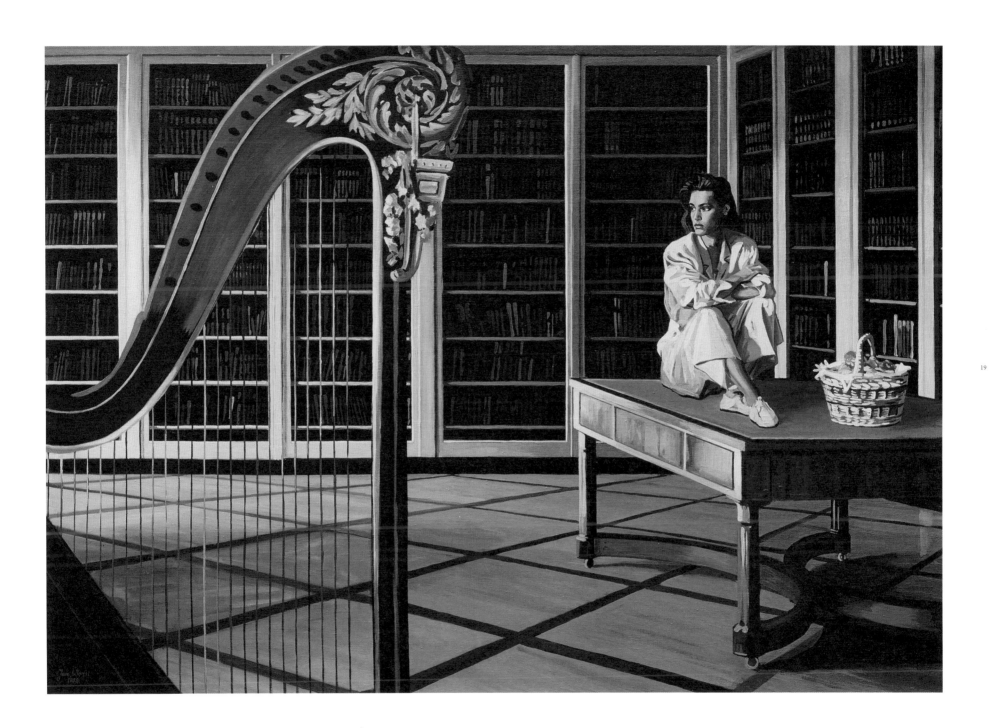

Belvédère
1989

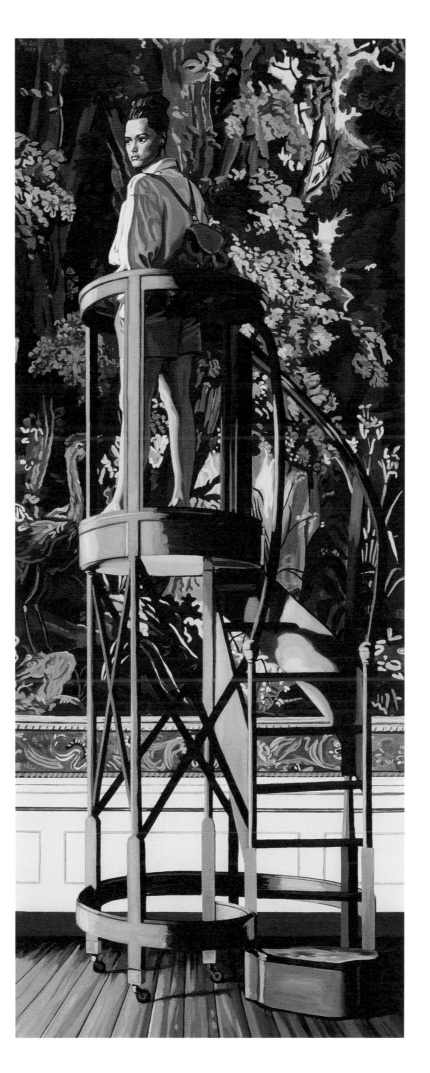

Zeus en Nemesis
1989

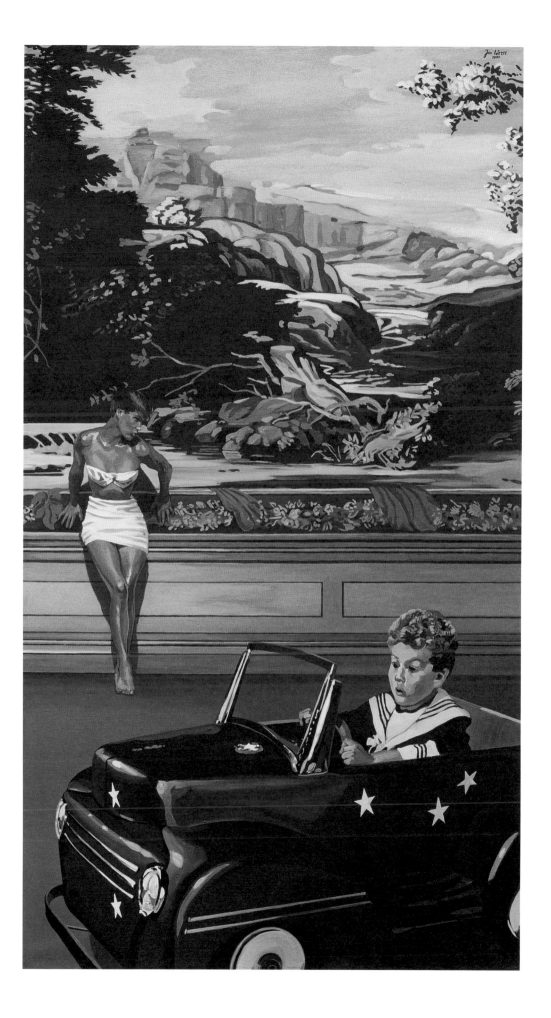

Deugd als slaapmiddel
1989

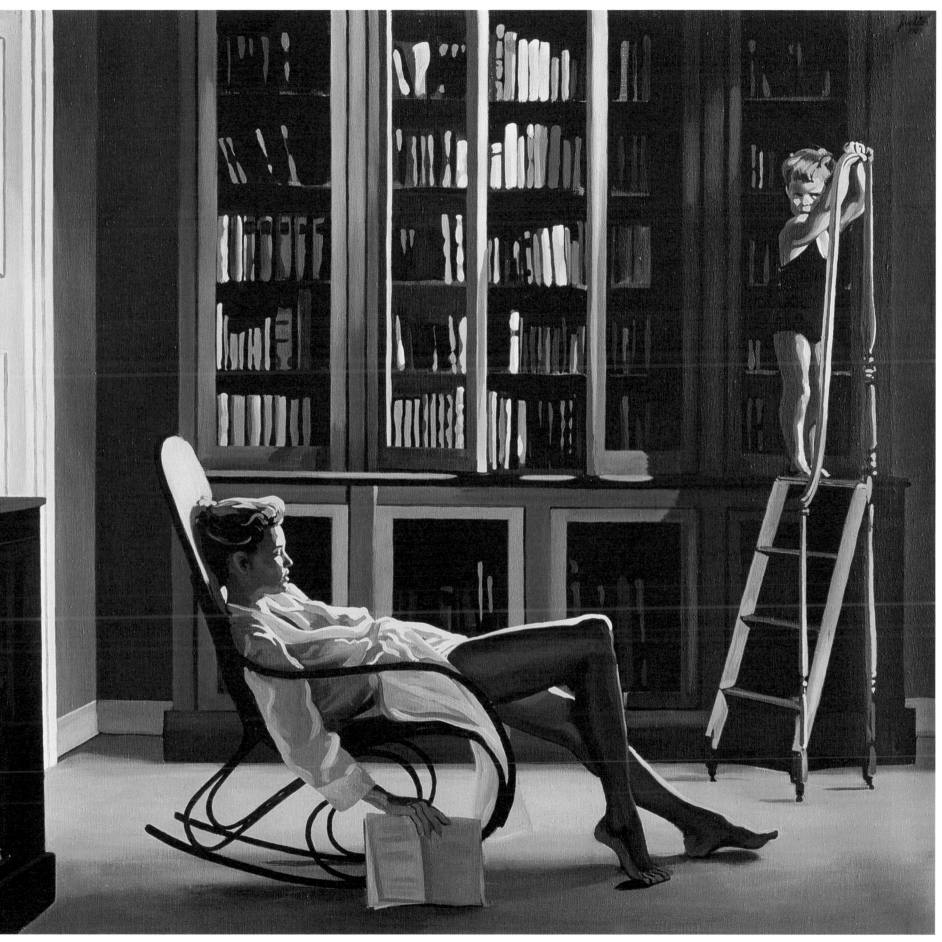

A propos Diogenes
1989

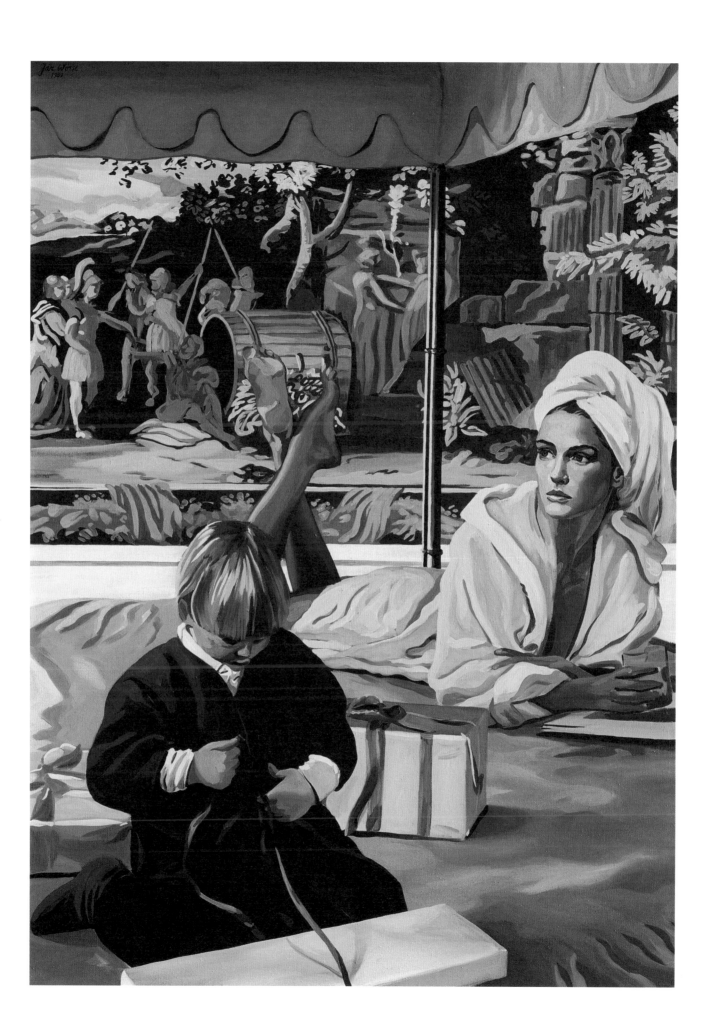

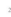

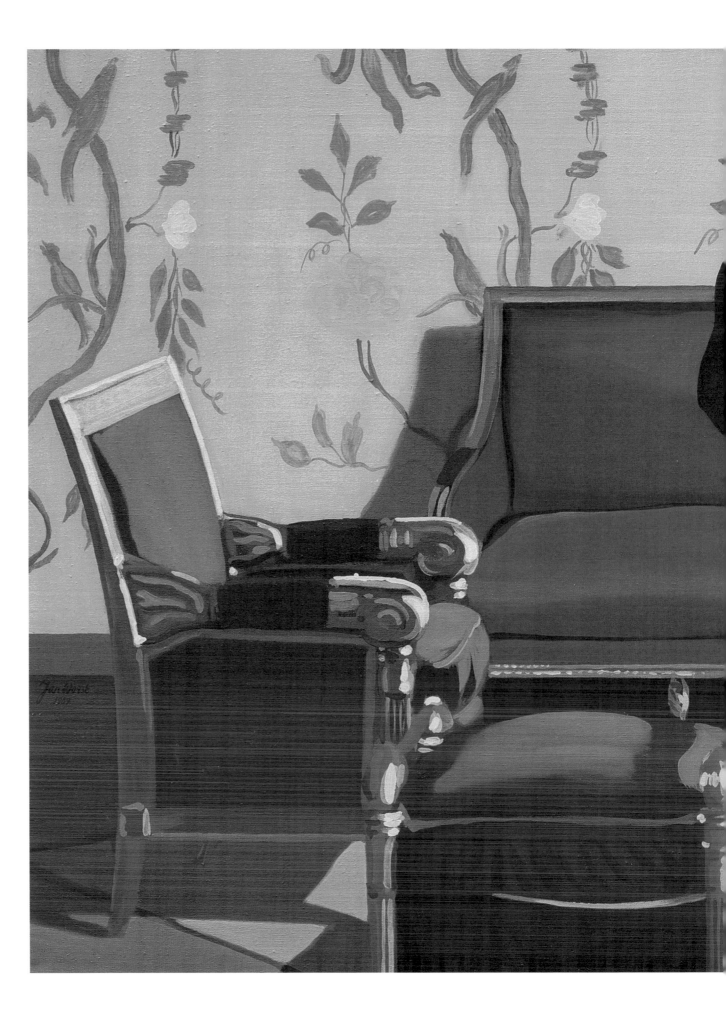

Ter geruststelling van de scepticus
1989

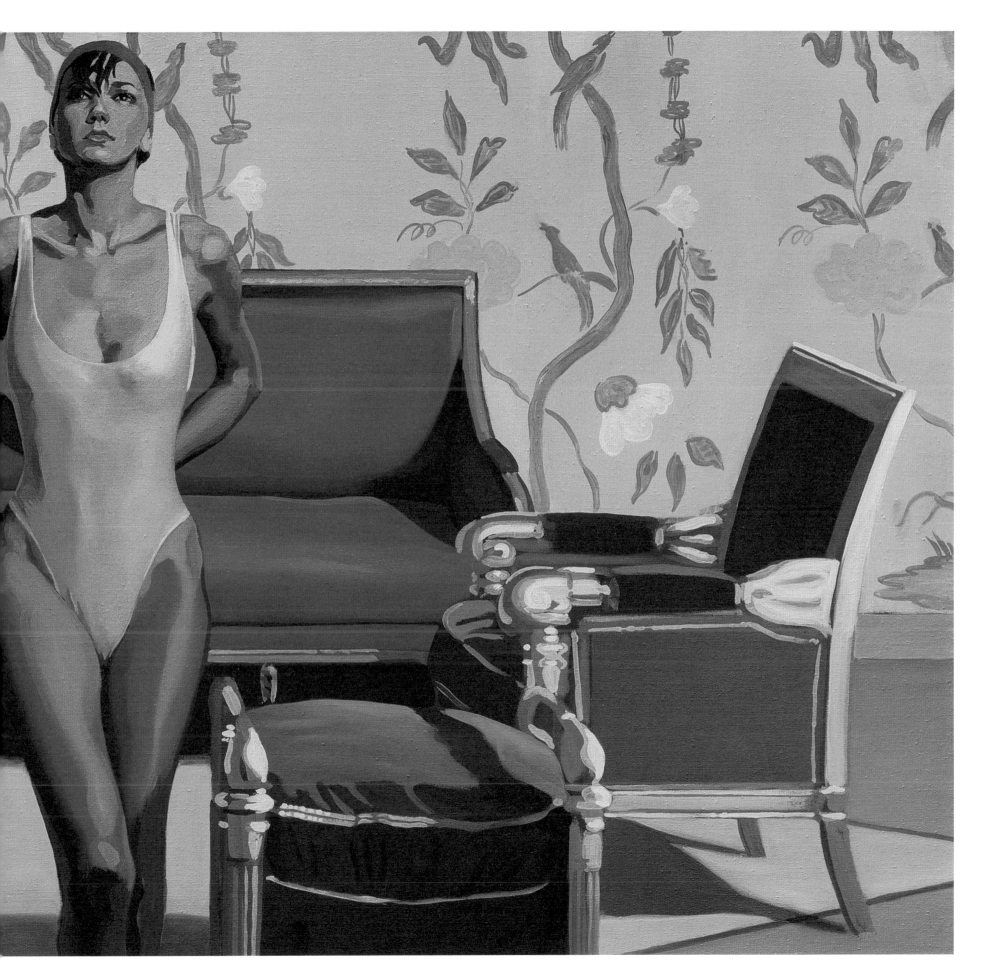

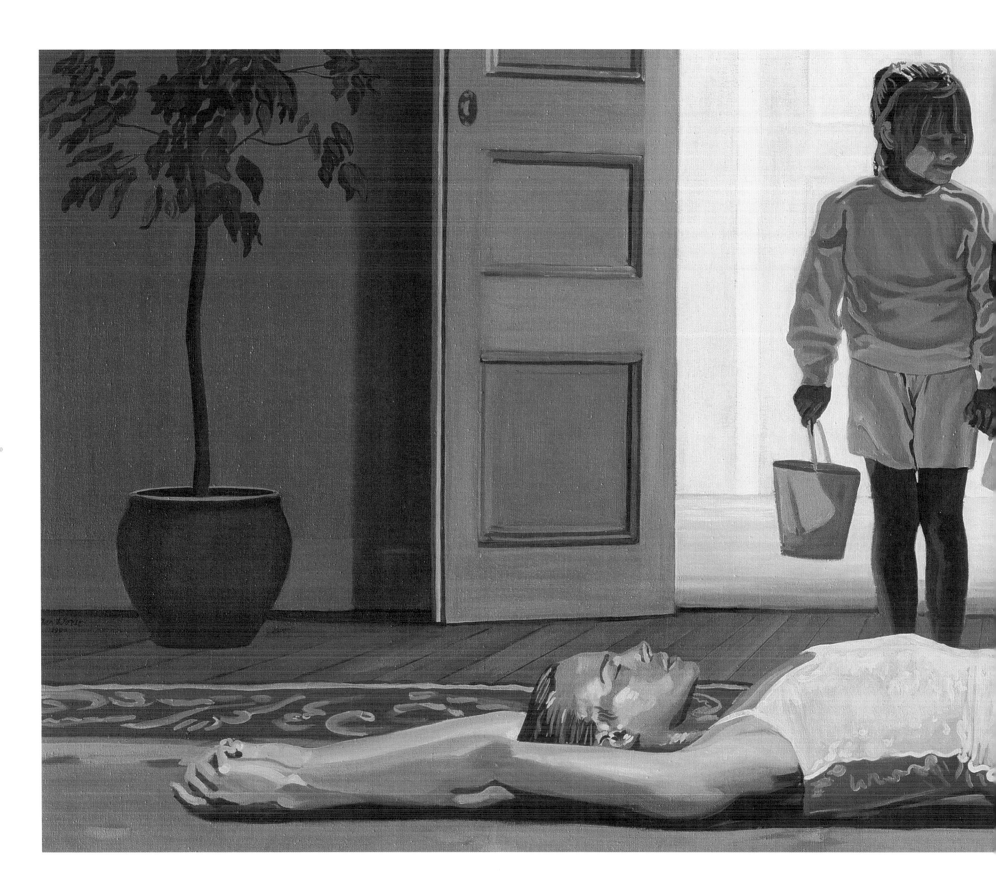

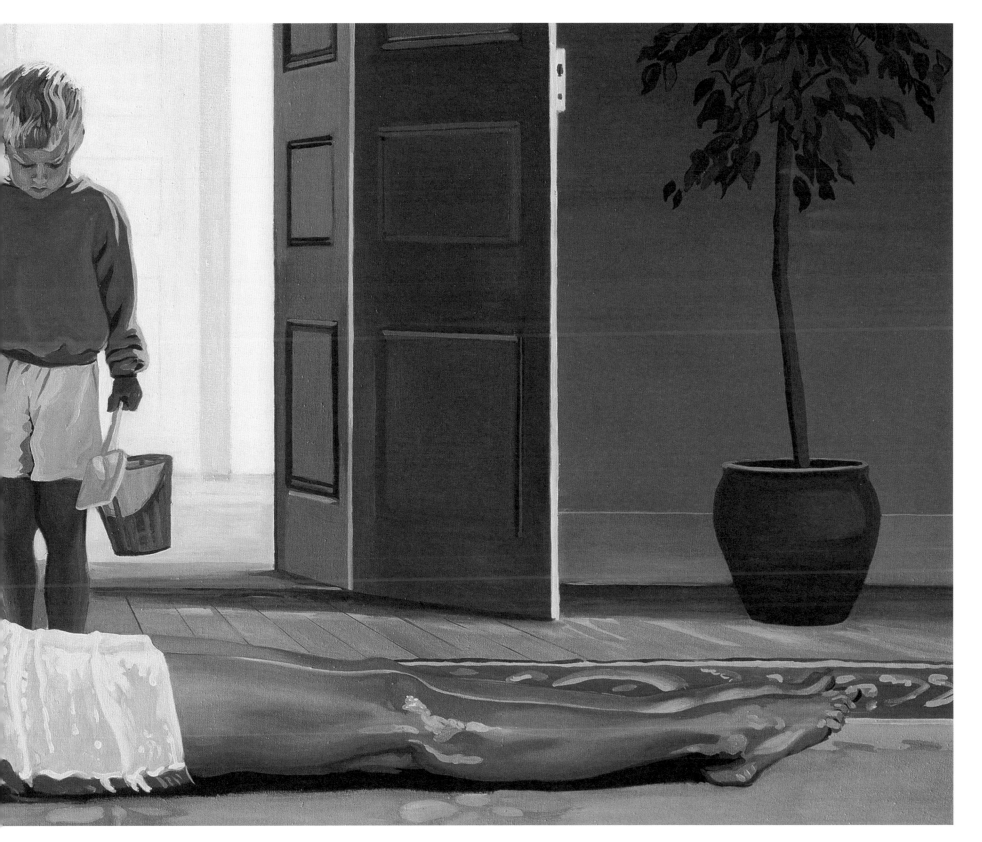

(page 30) *Presqu'ile* *De eenzame wandelaarster*
 1990 1990

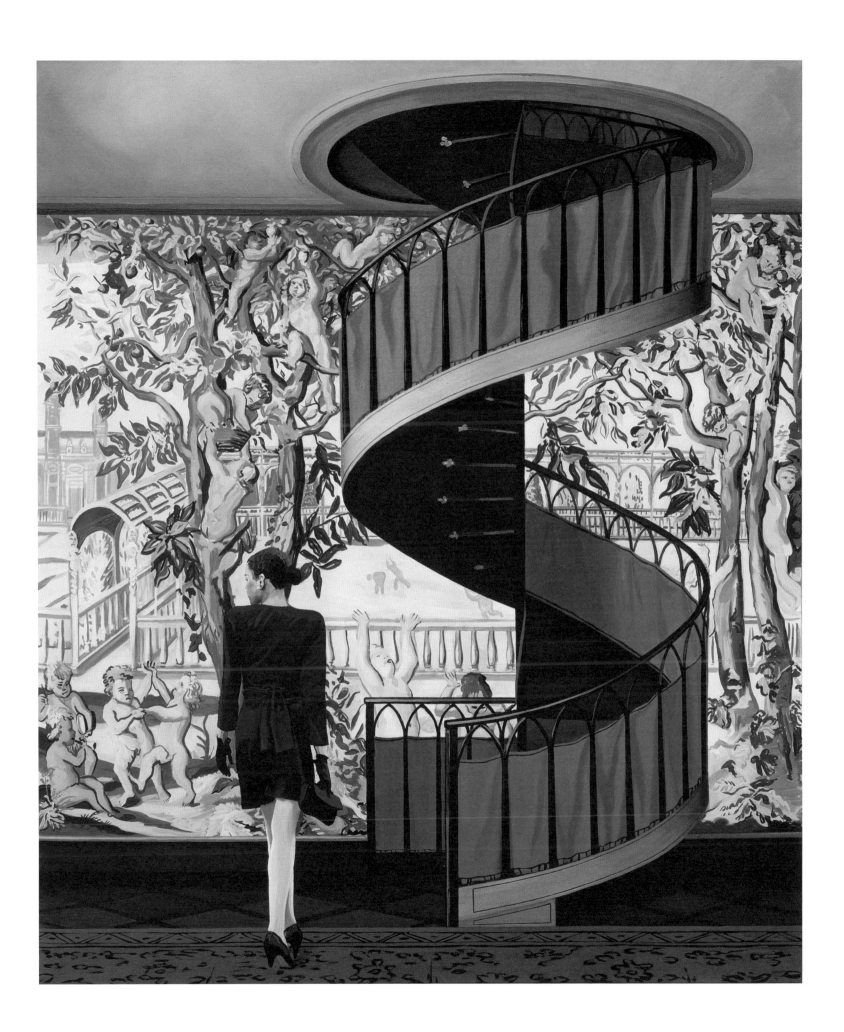
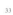

Kinderszene
1990

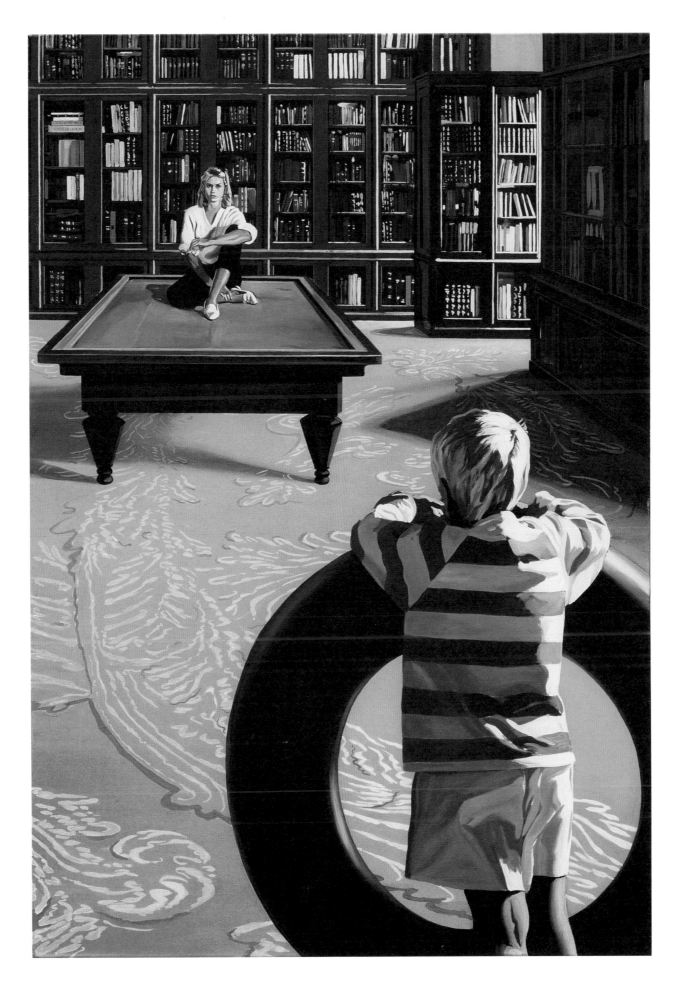

Et in Arcadia ego
1990

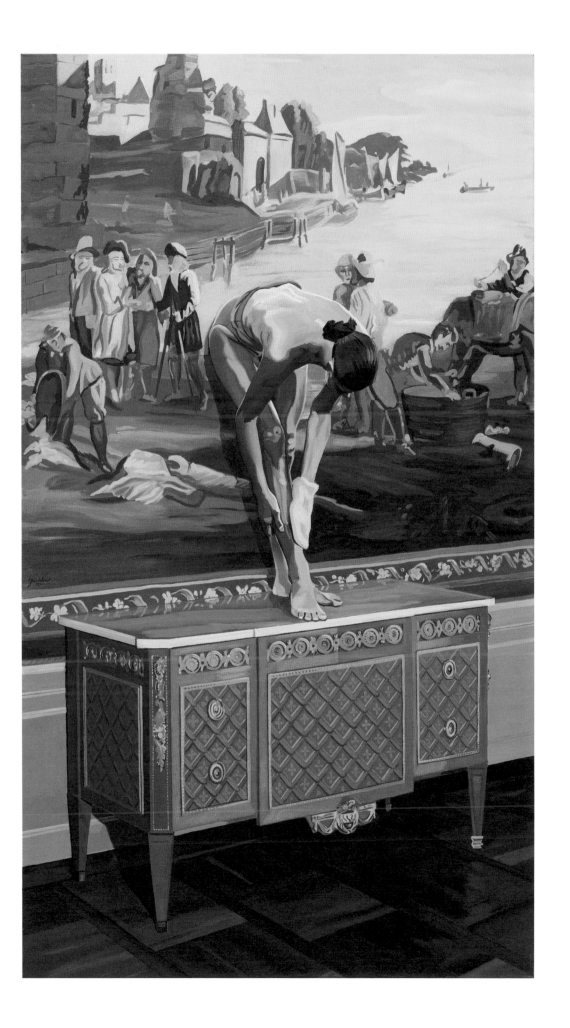

Hoc erat in votis
1990

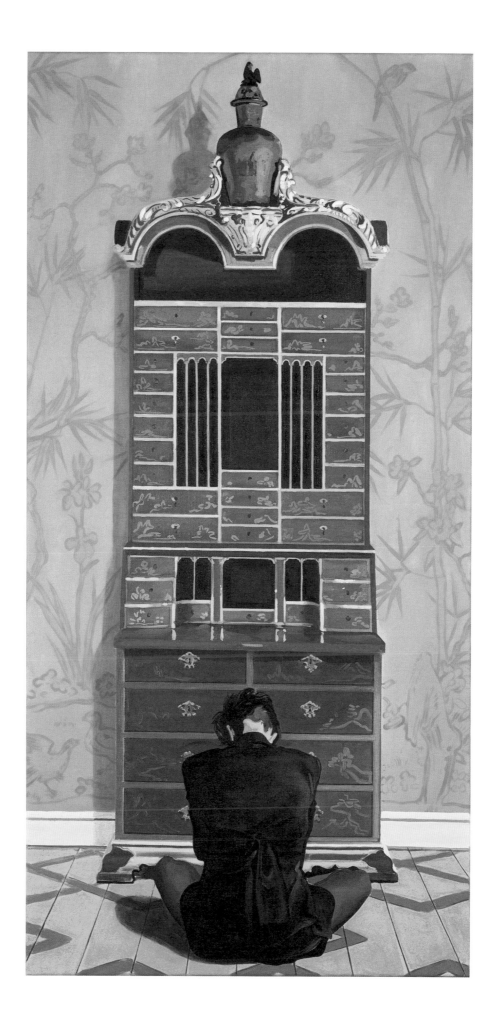

Dialogue intérieur
1991

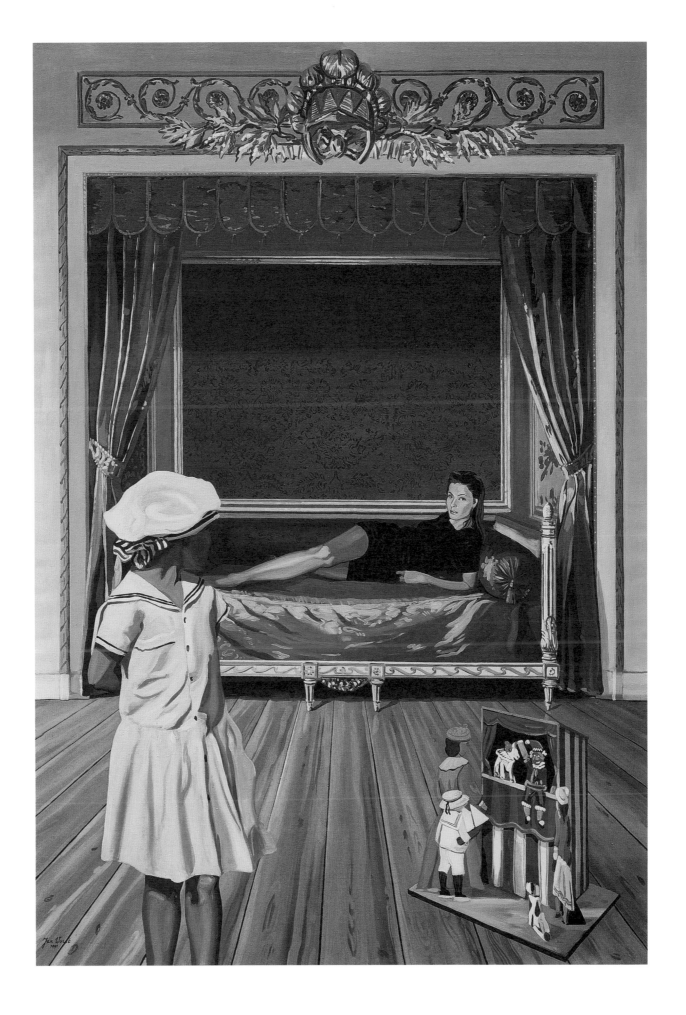

42

In Parenthesis
1991

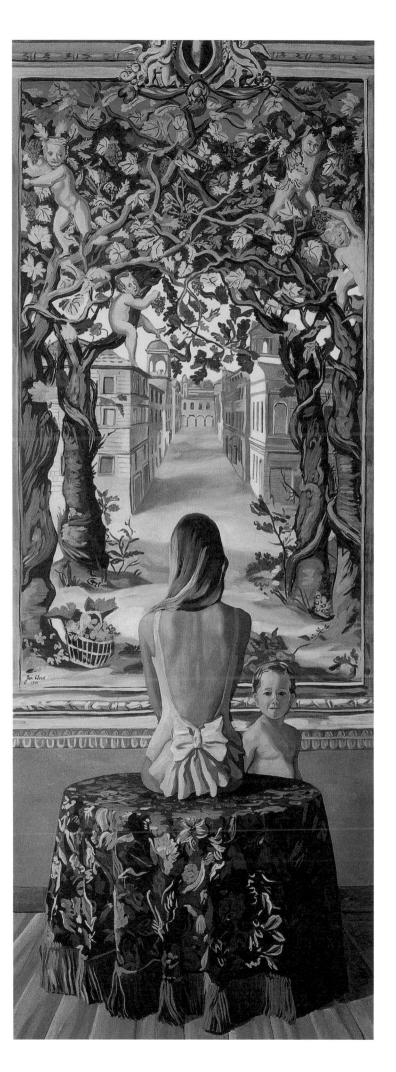

The Ecchoing Green
1991

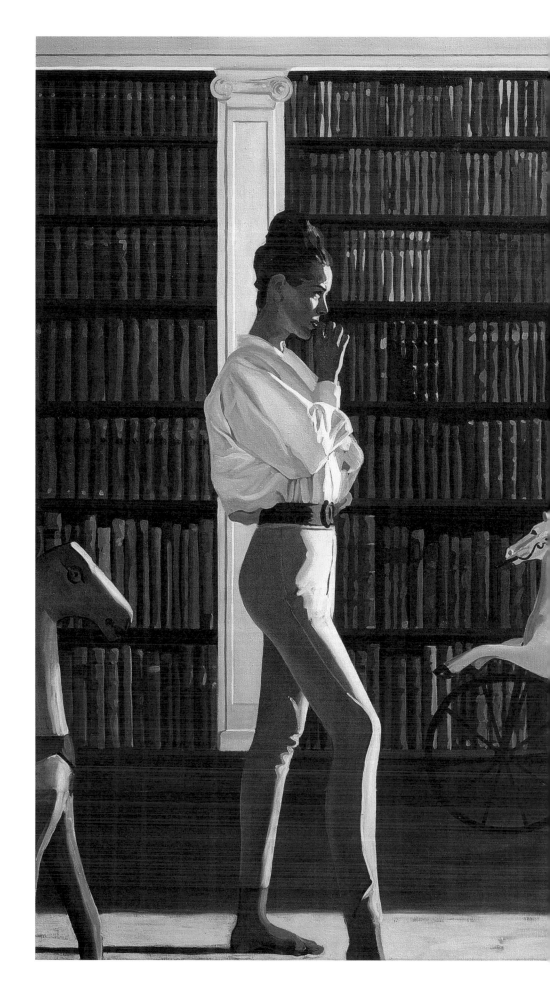

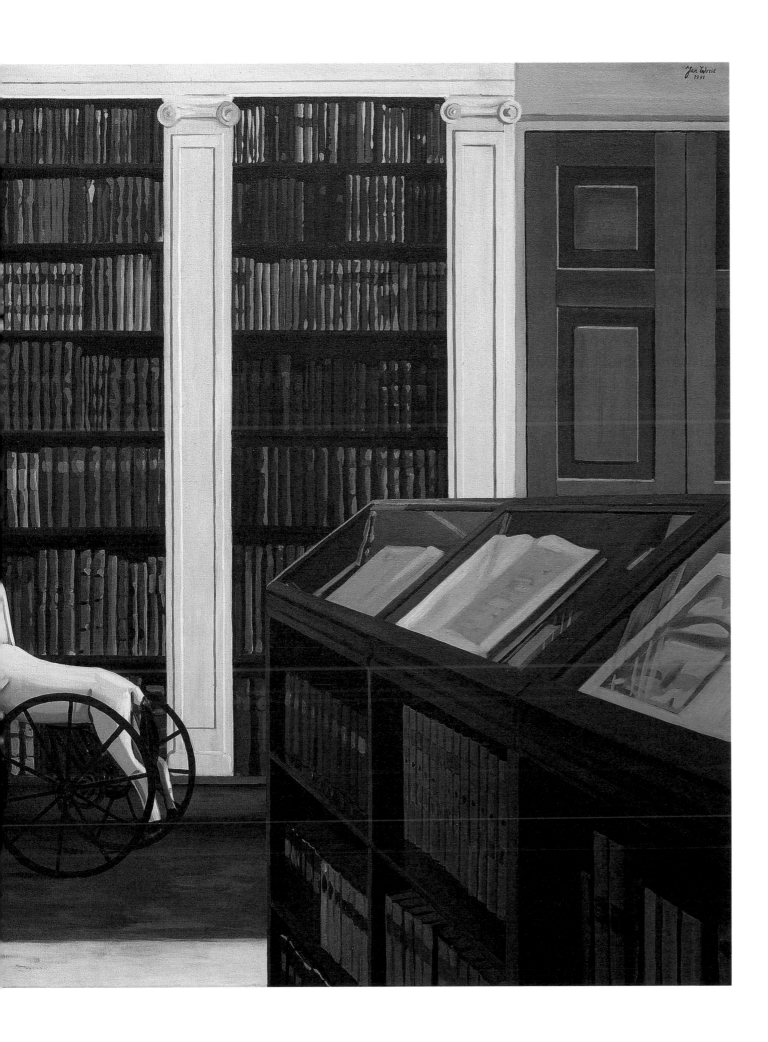

As idle as a painted ship upon a painted ocean
1991

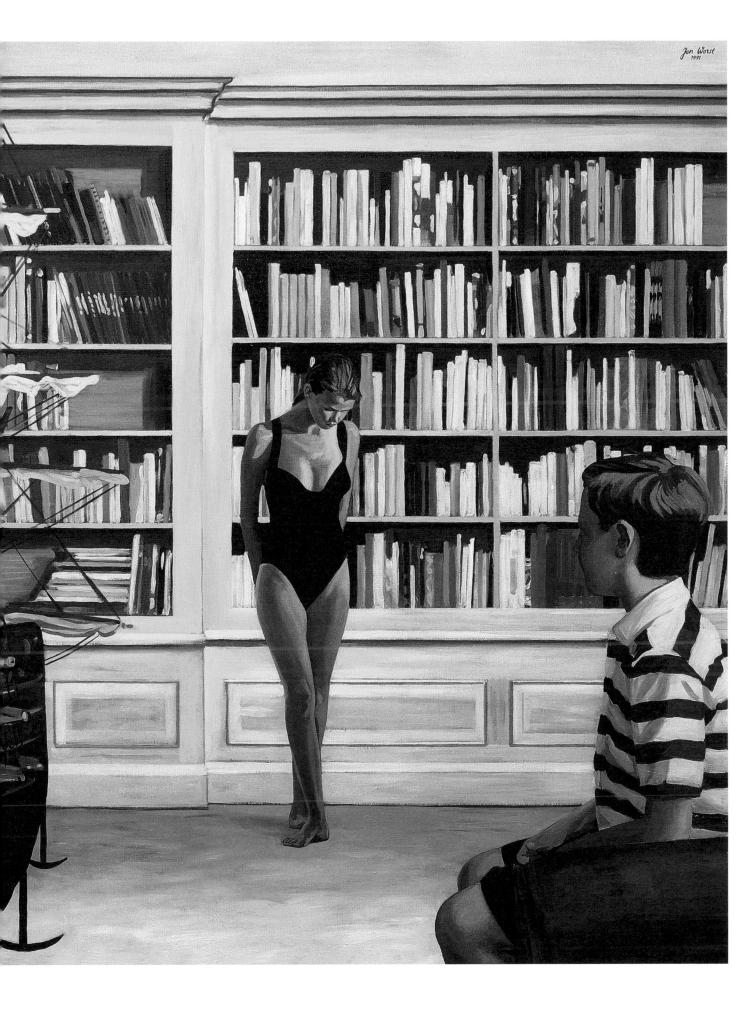

Retour des Pêcheurs
1991

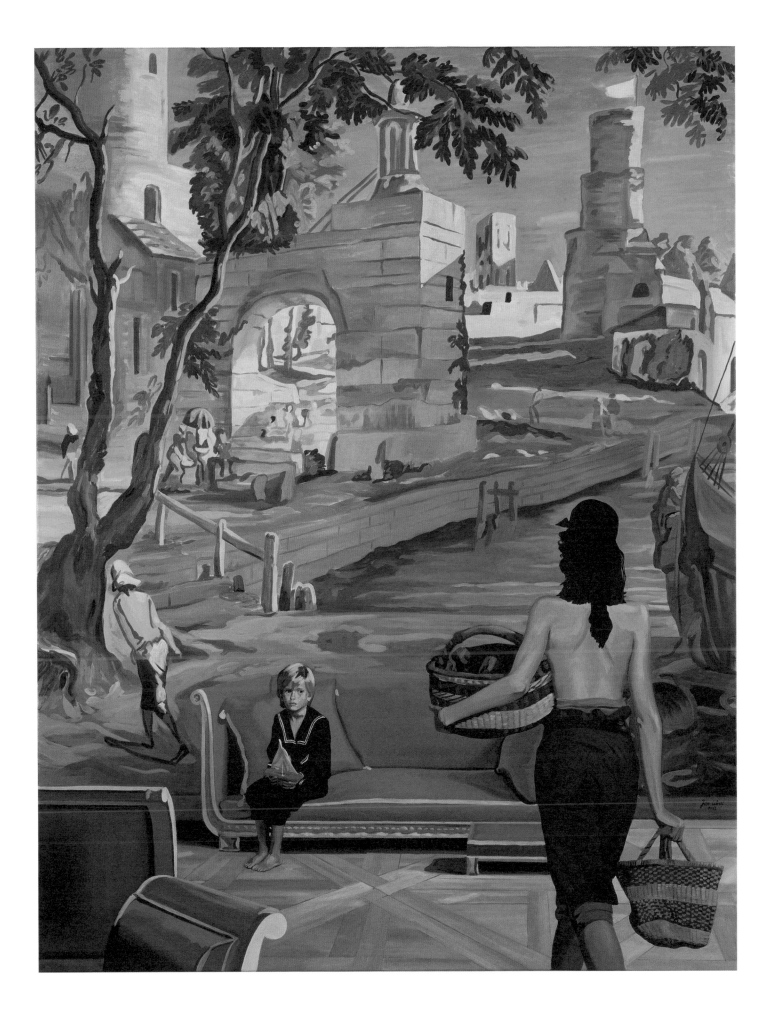

49

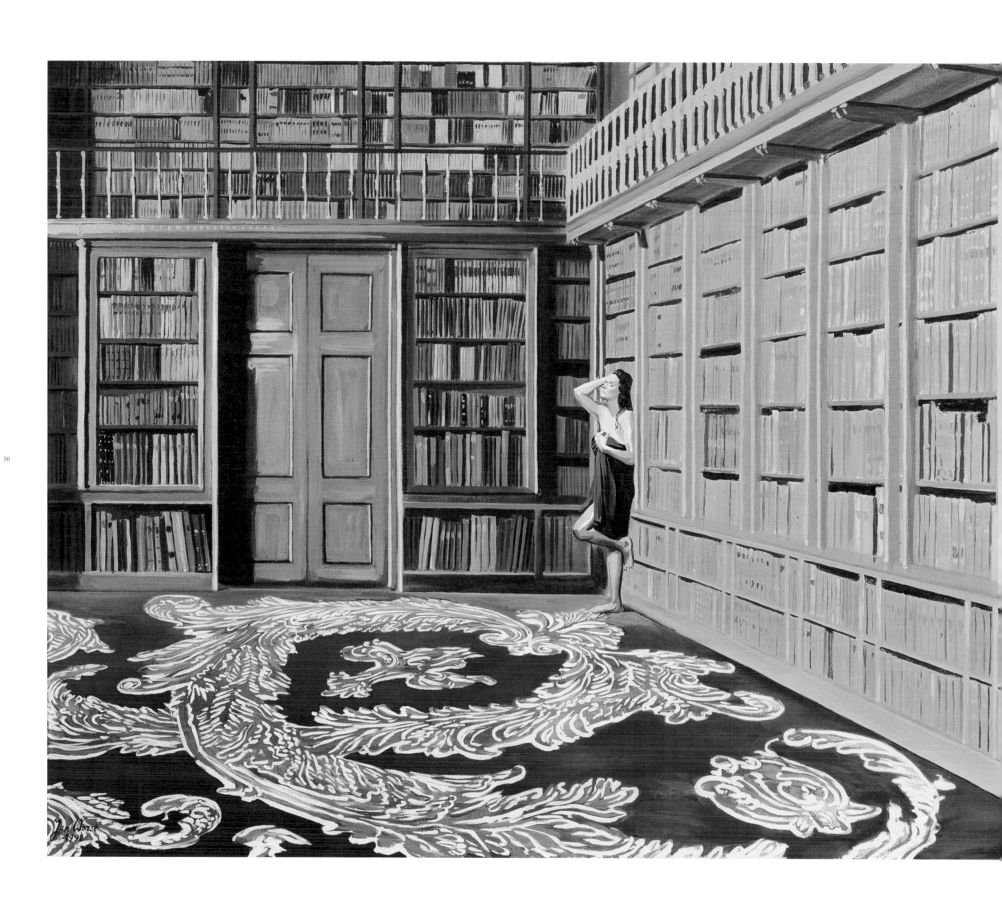

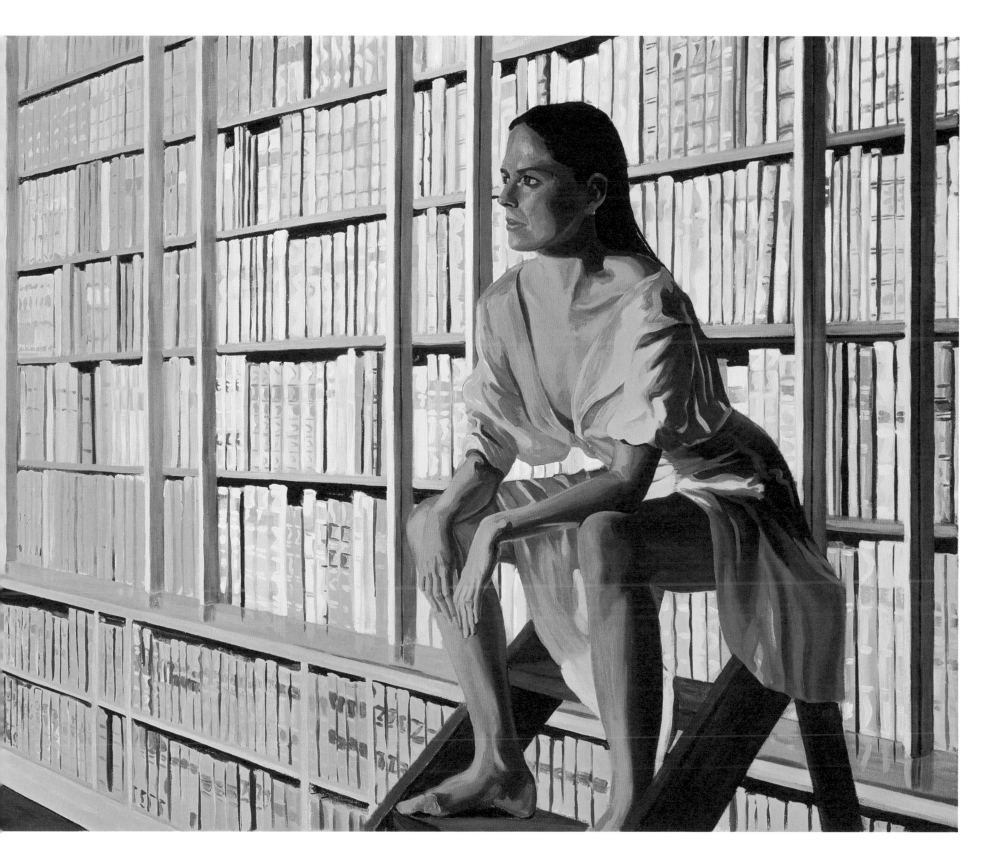

(page 50) *Sirenenküste*
 1992

De groene bibliotheek
1992

Sta Viator
1992

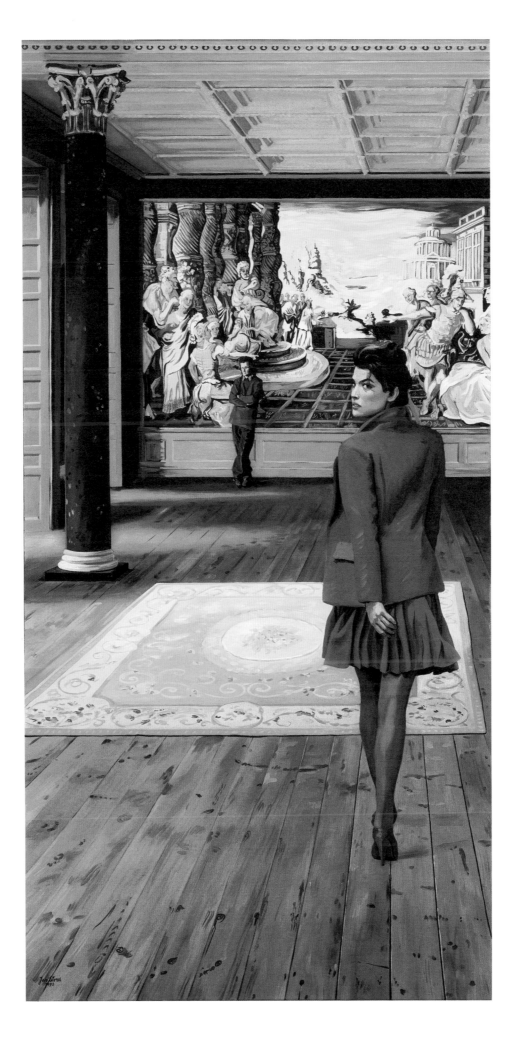

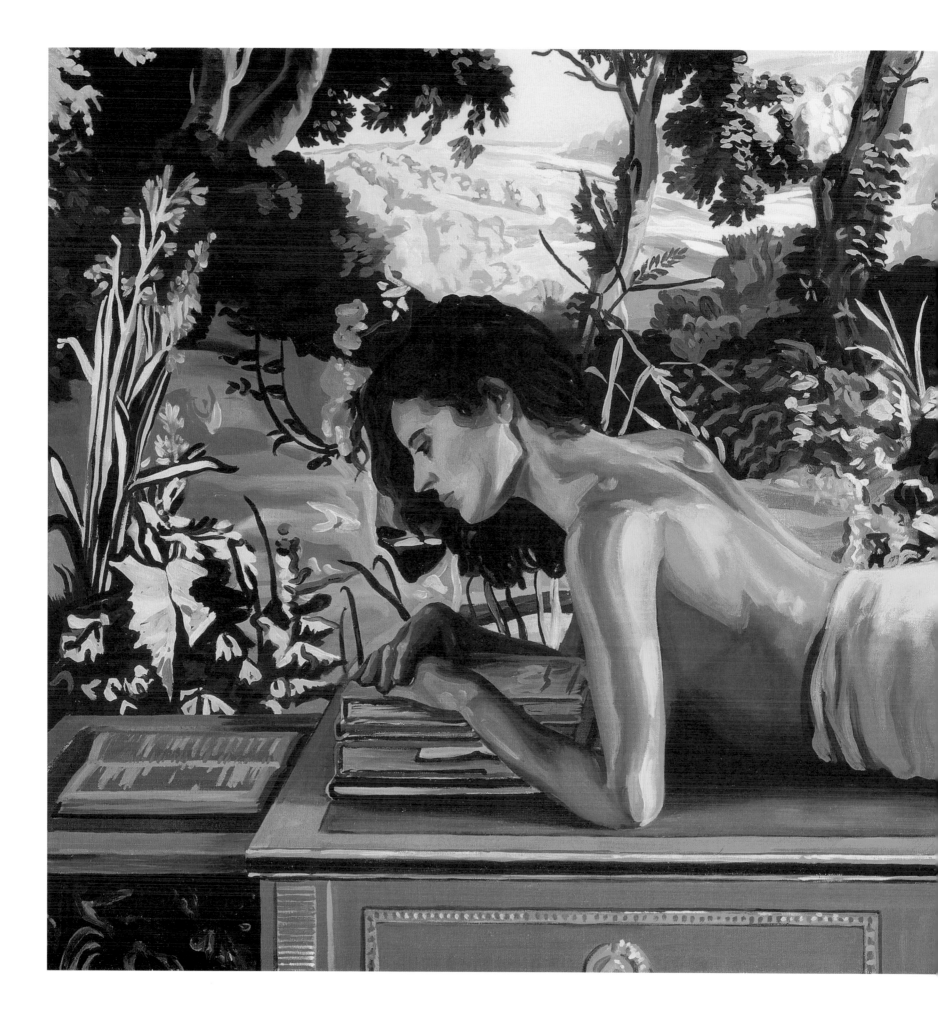

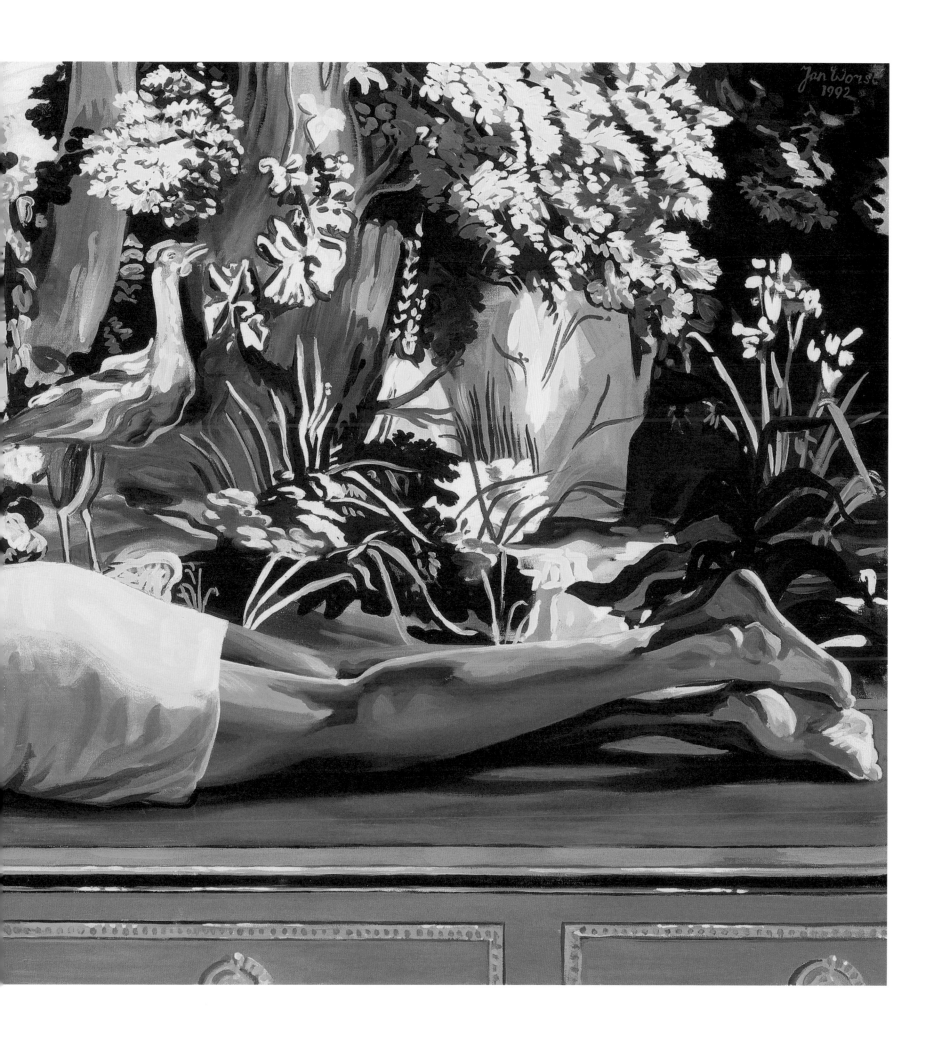

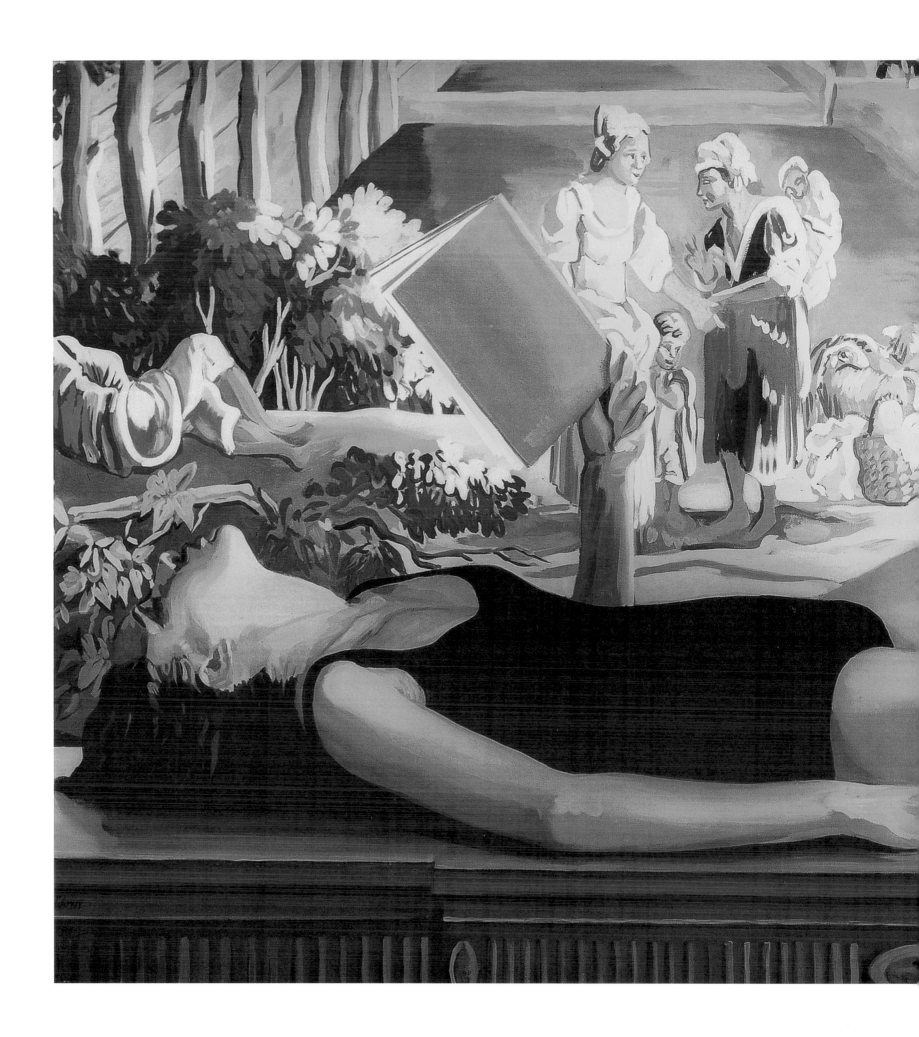

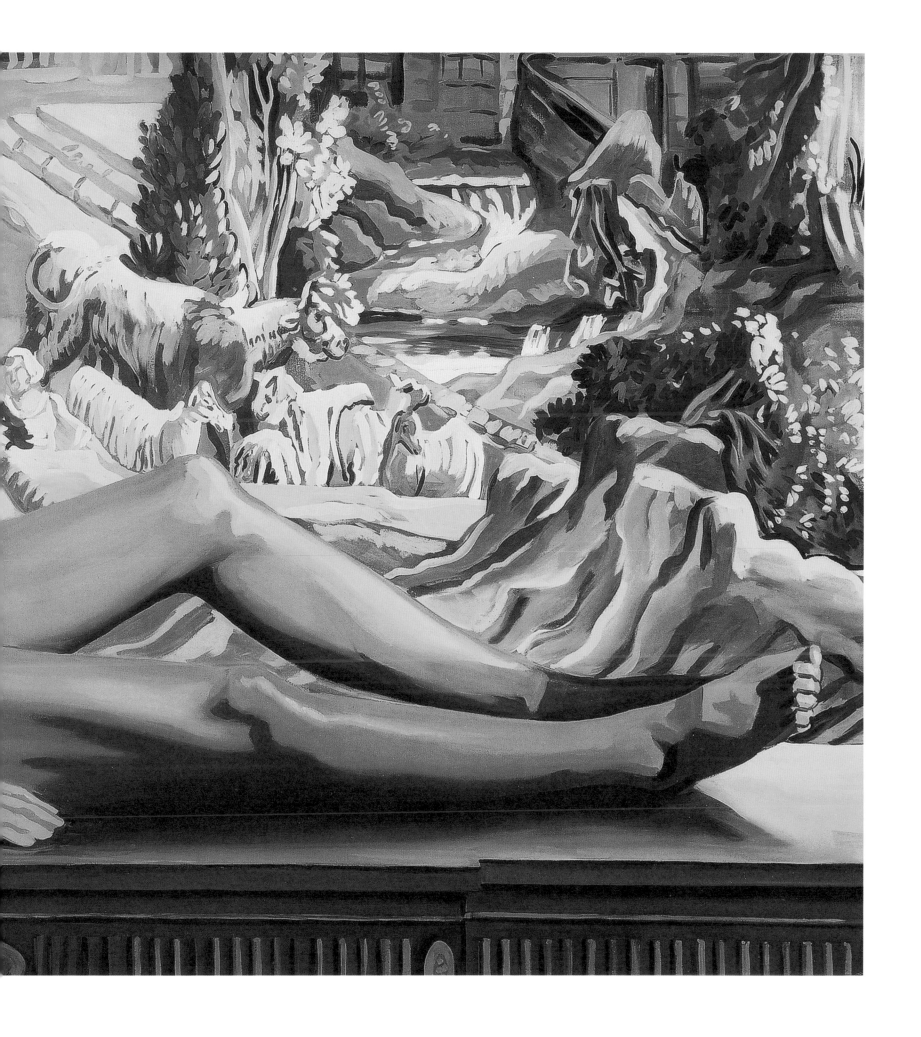

(page 56) *De lezeres*
1992

(page 58) De gevaarlijke roman
1992

Reisebild
1992

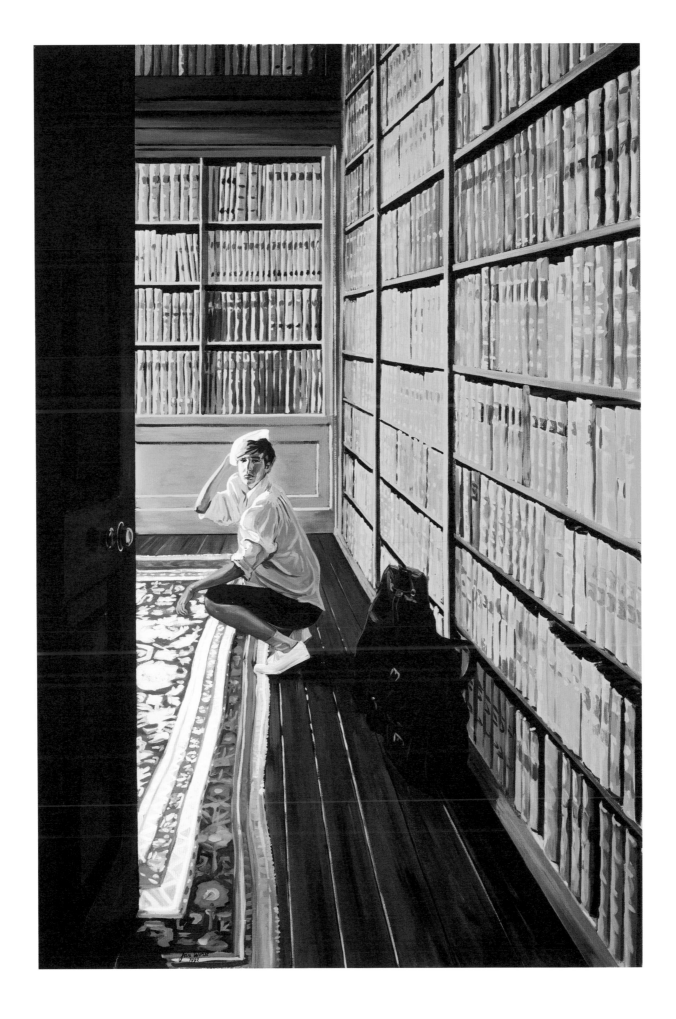

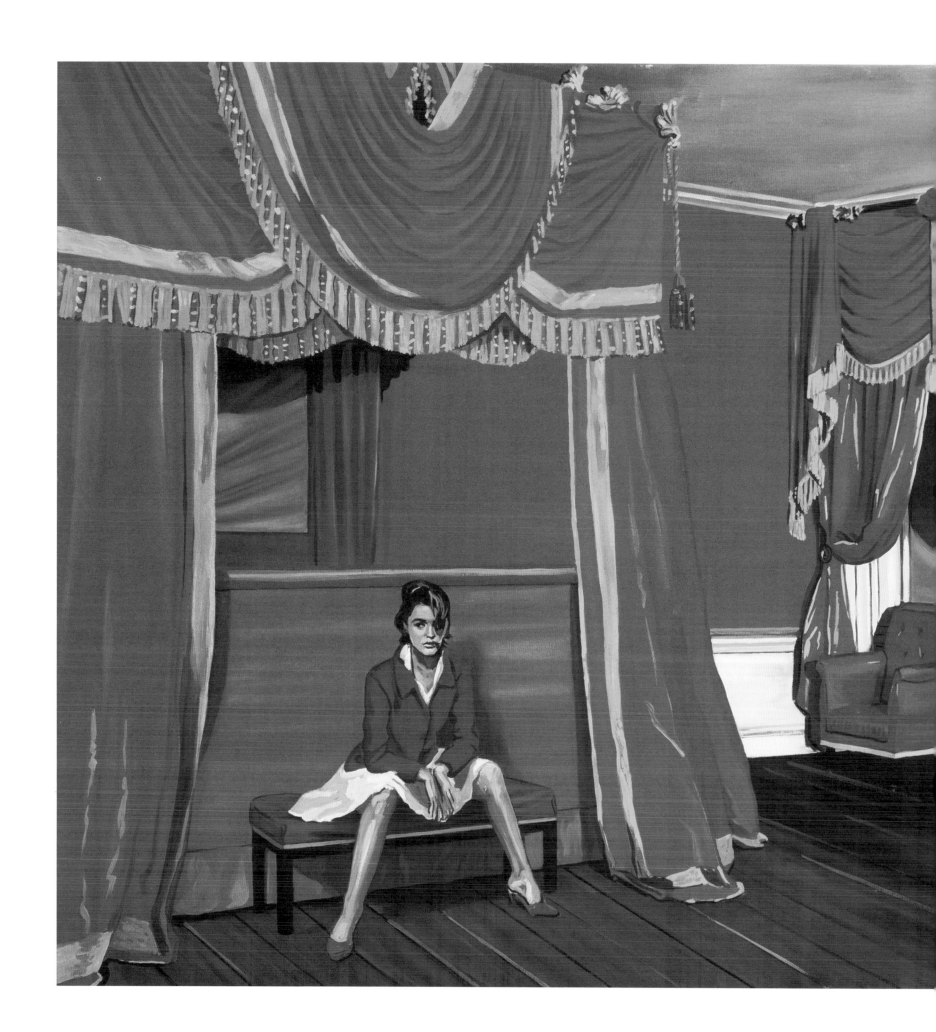

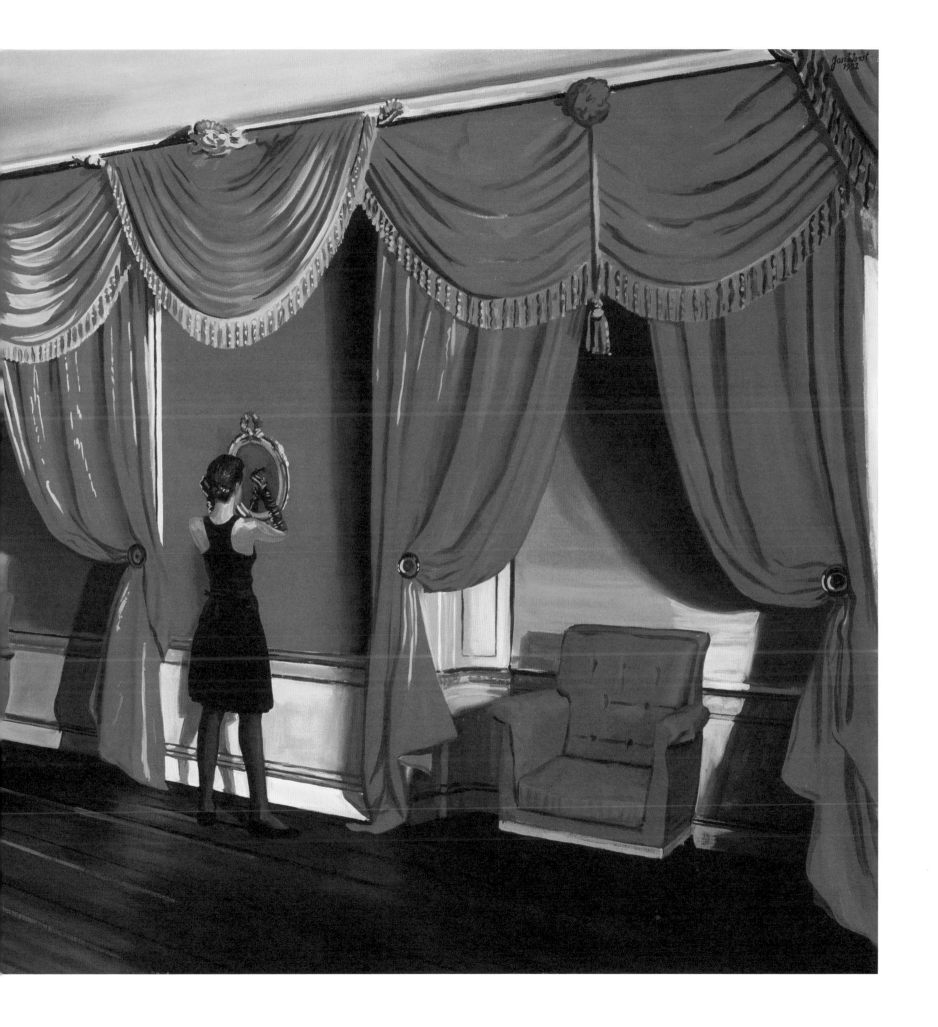

(page 62) *Die 2 Mädchen* *Allegorie*
 1992 1992

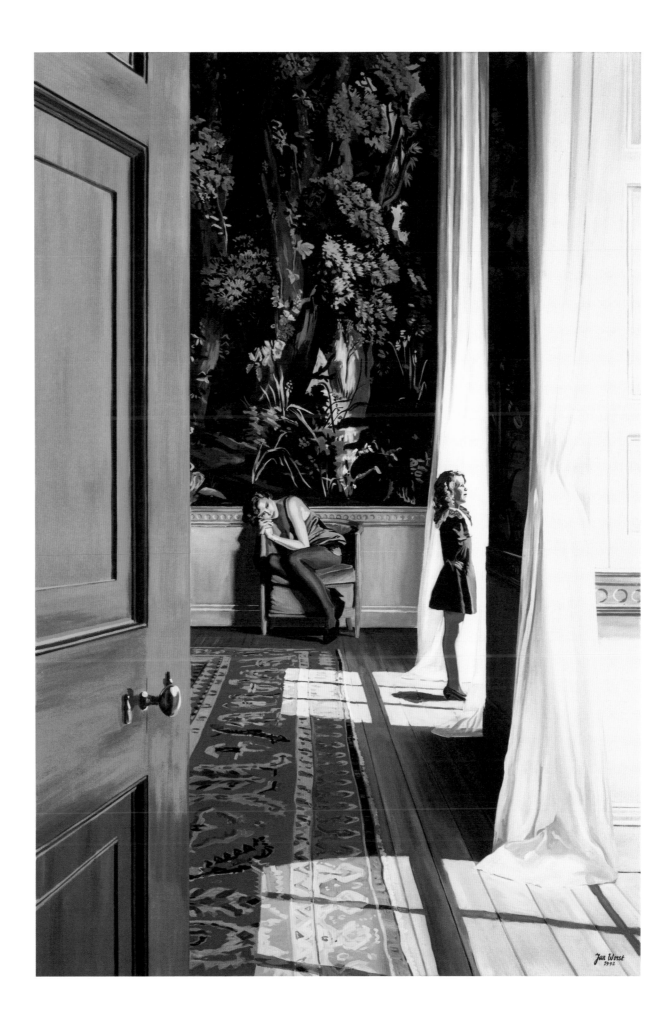

De ontmoeting
1993

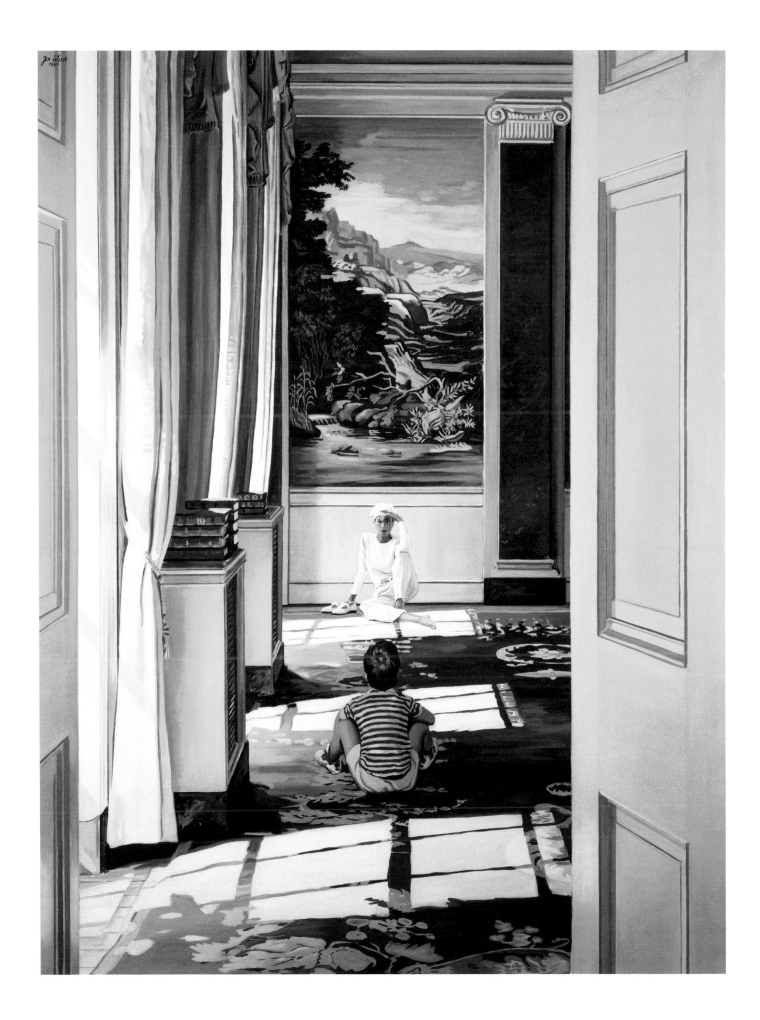

Senso
1993

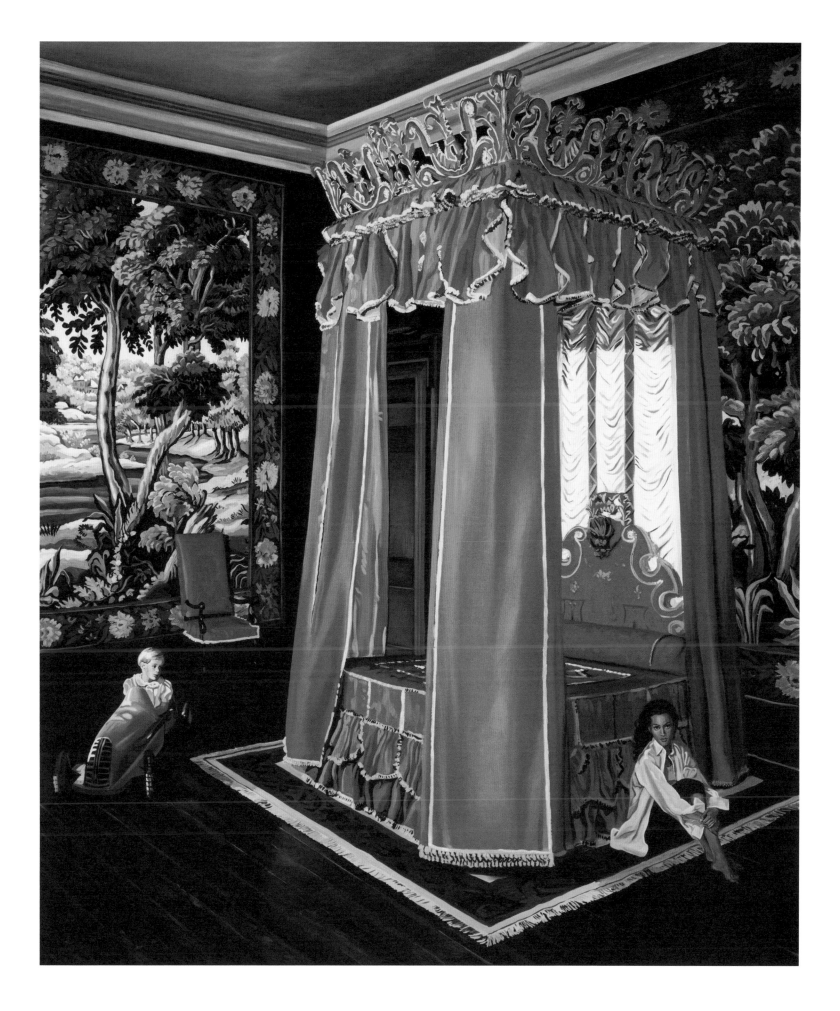

Seewind
1993

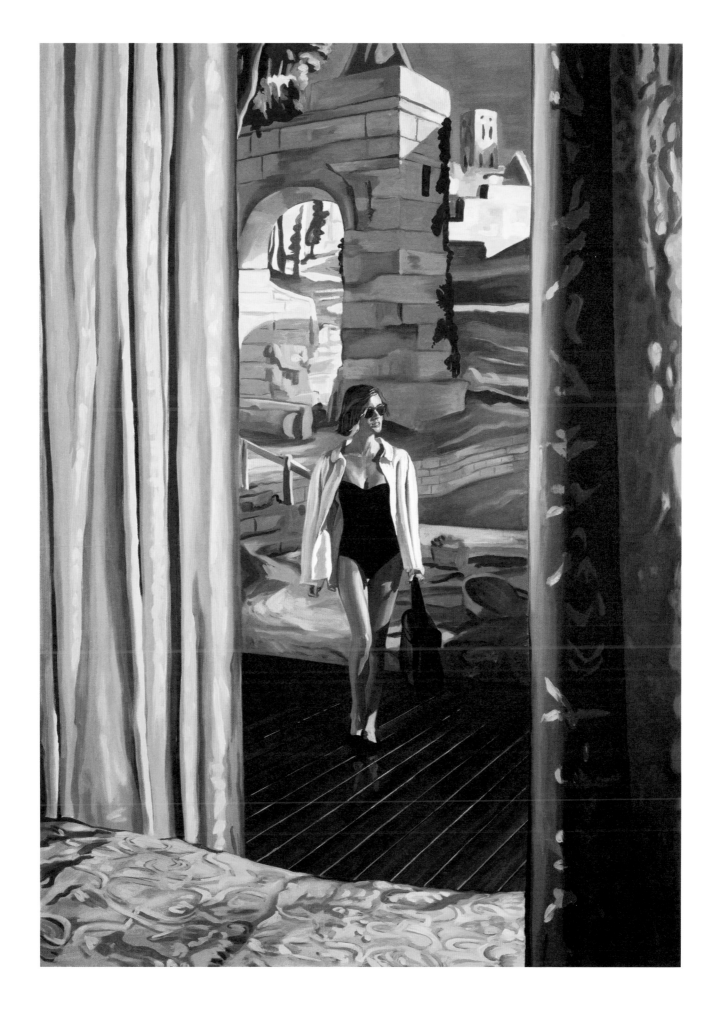

Lesebild
1993

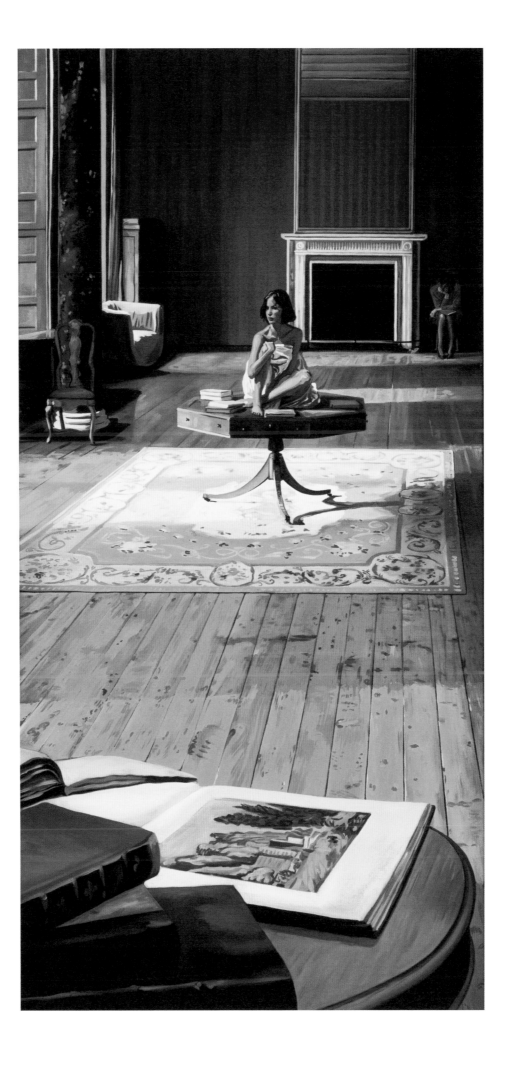

Bibliotheek met twee vrouwen
1993

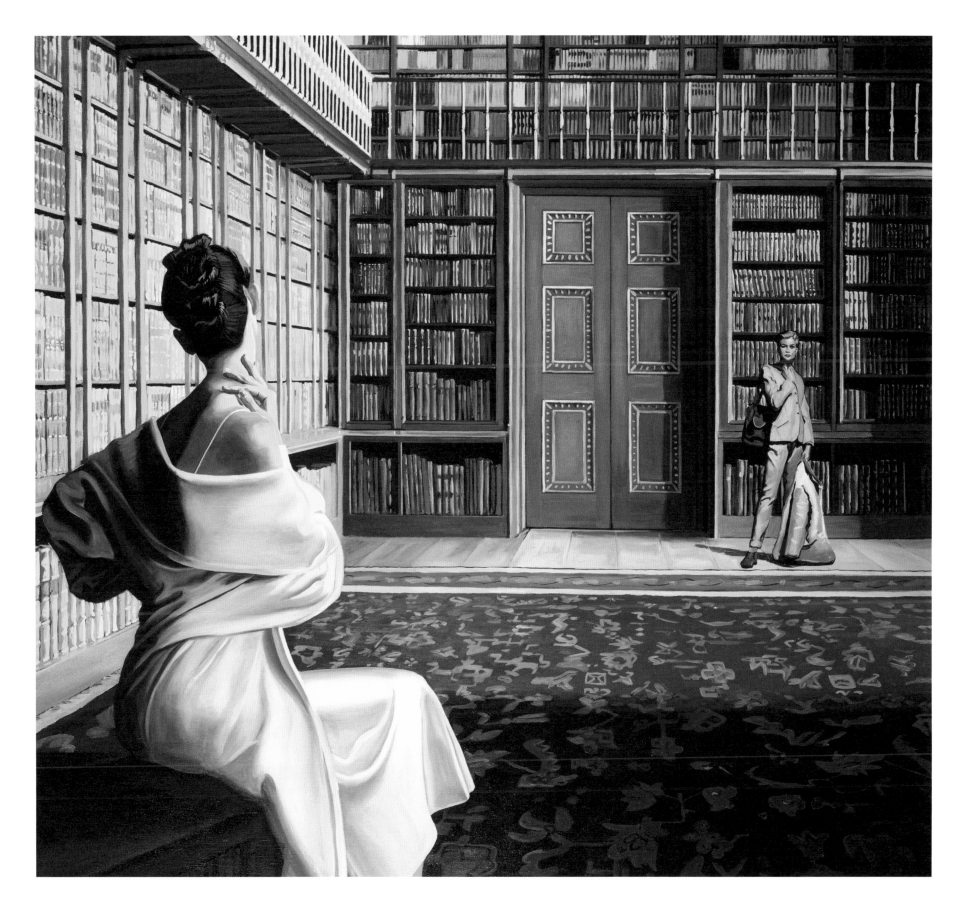

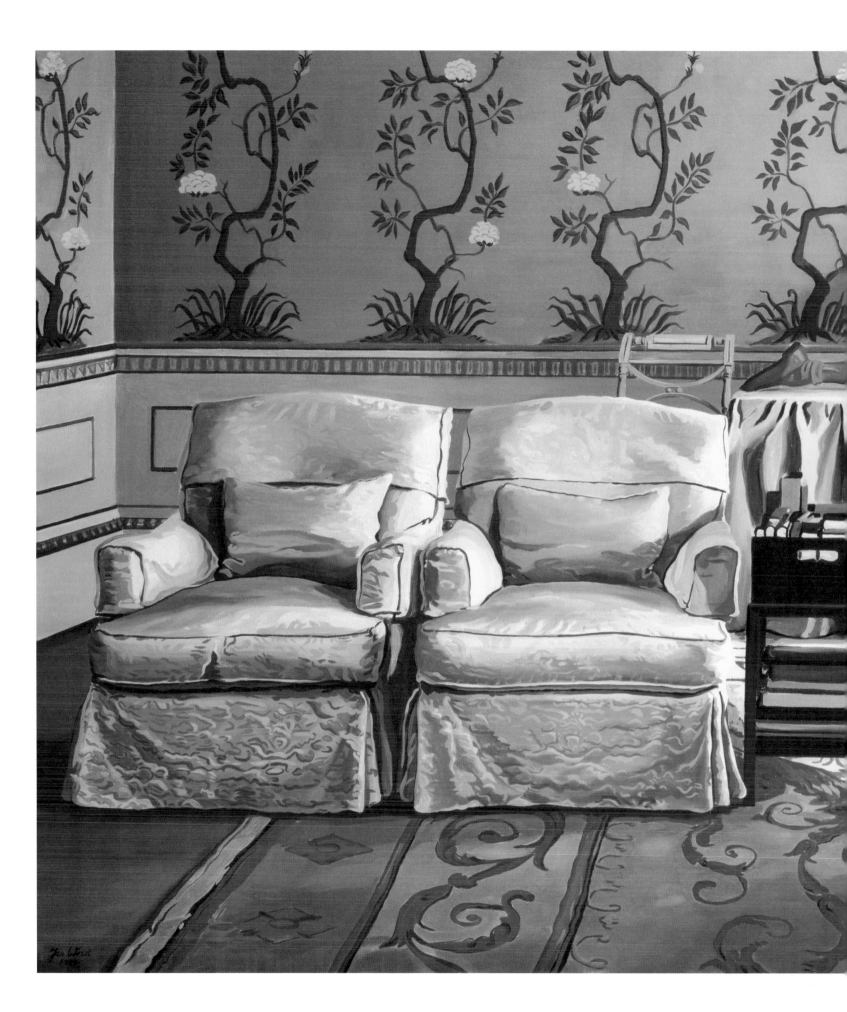

Die Abenteuerin
1993

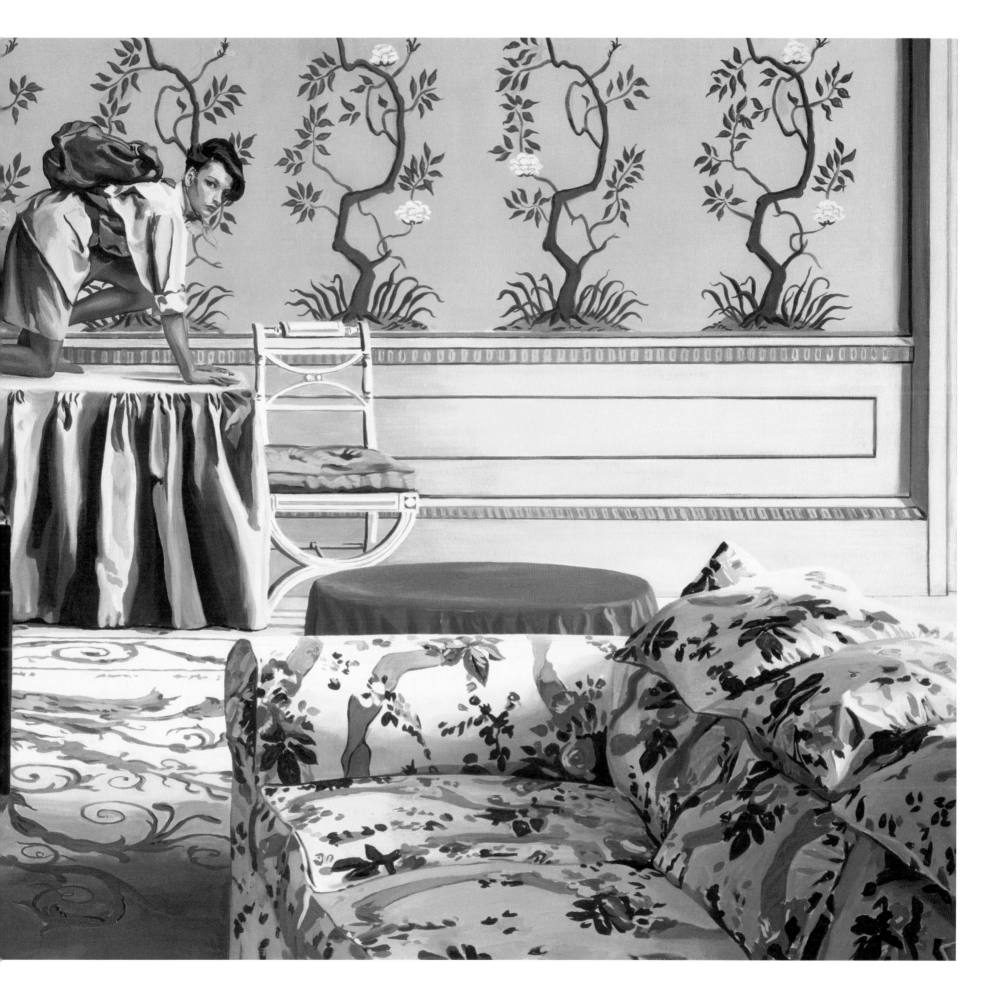

Spelenderwijs
1993

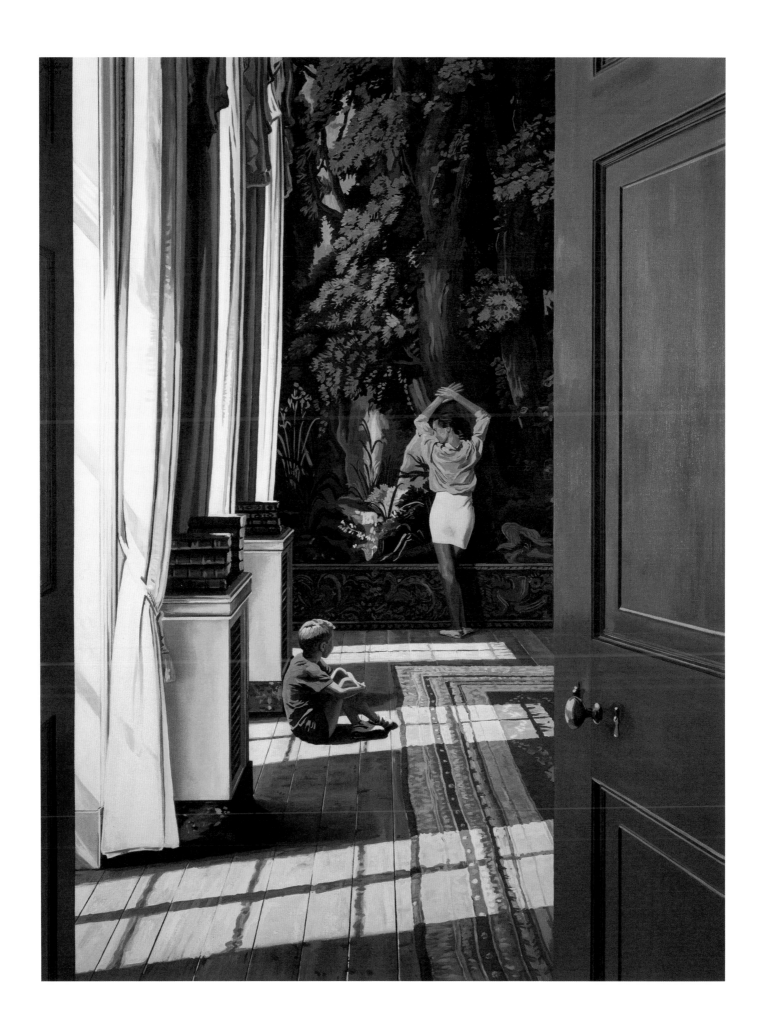

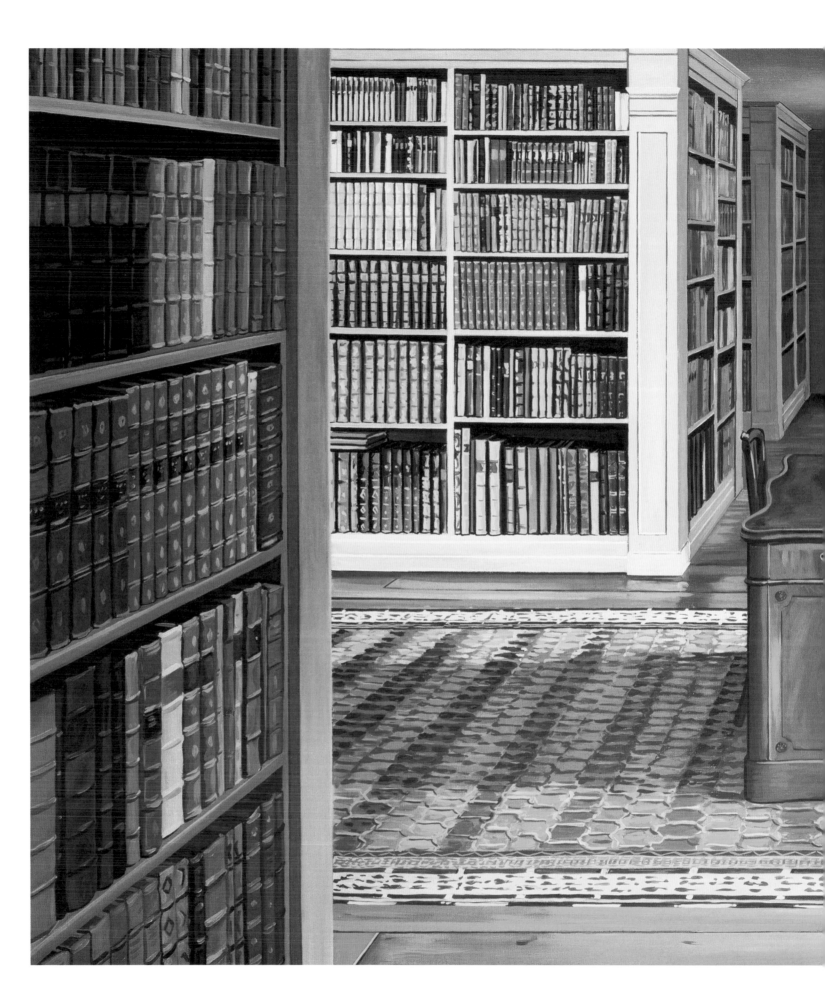

Labyrinth
1993

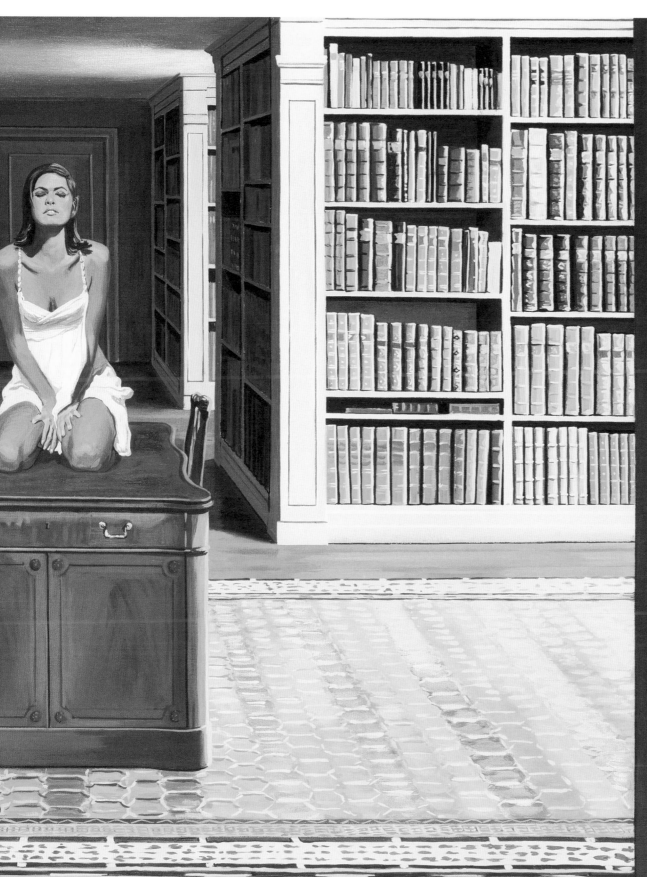

Vertrek
1994

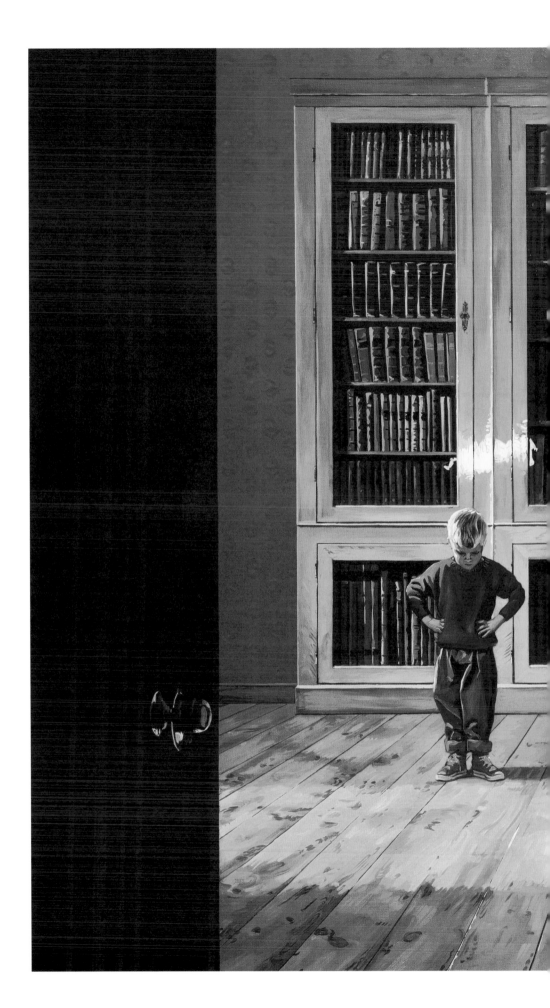

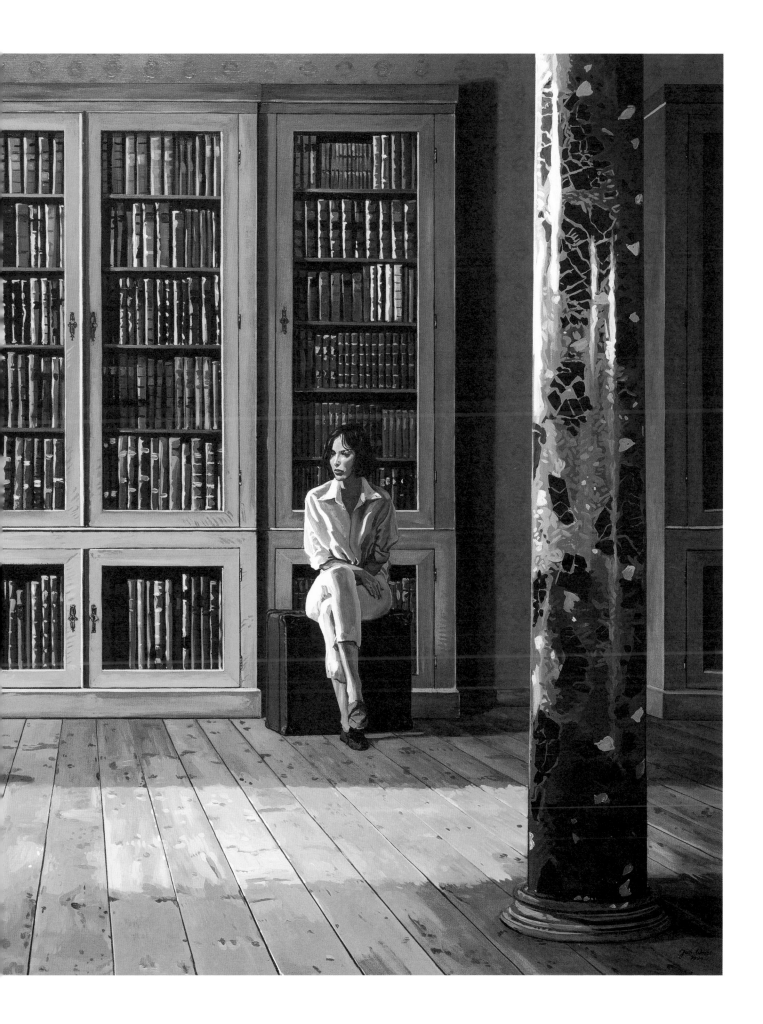

Aandachtig
1994

Pastorale
1994

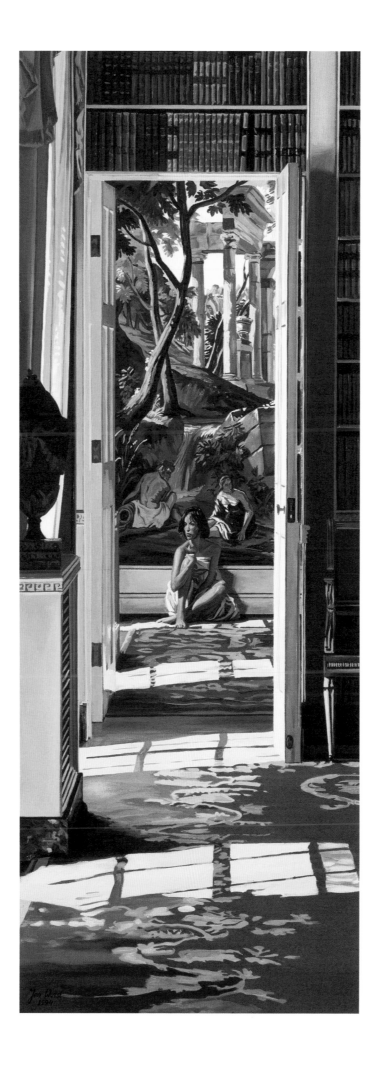

Il Tuffatore
1994

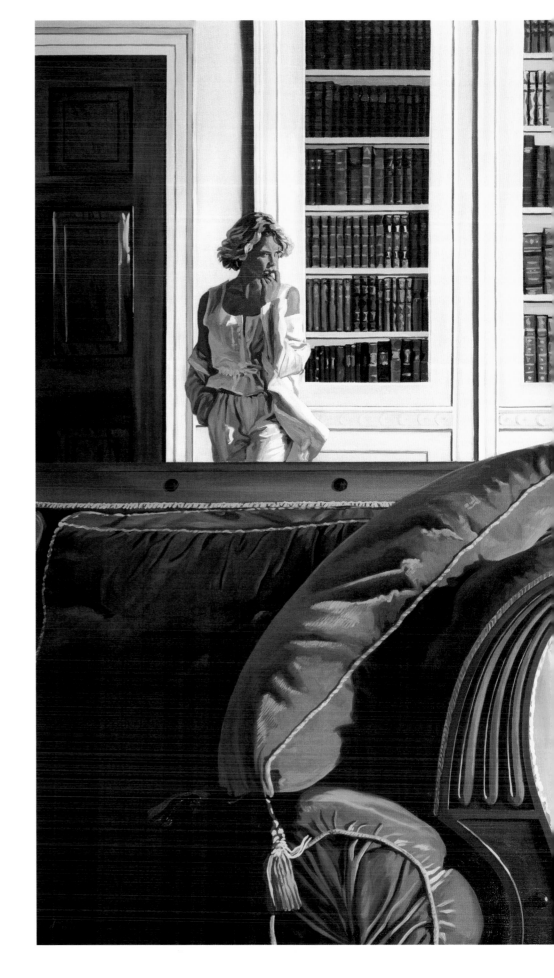

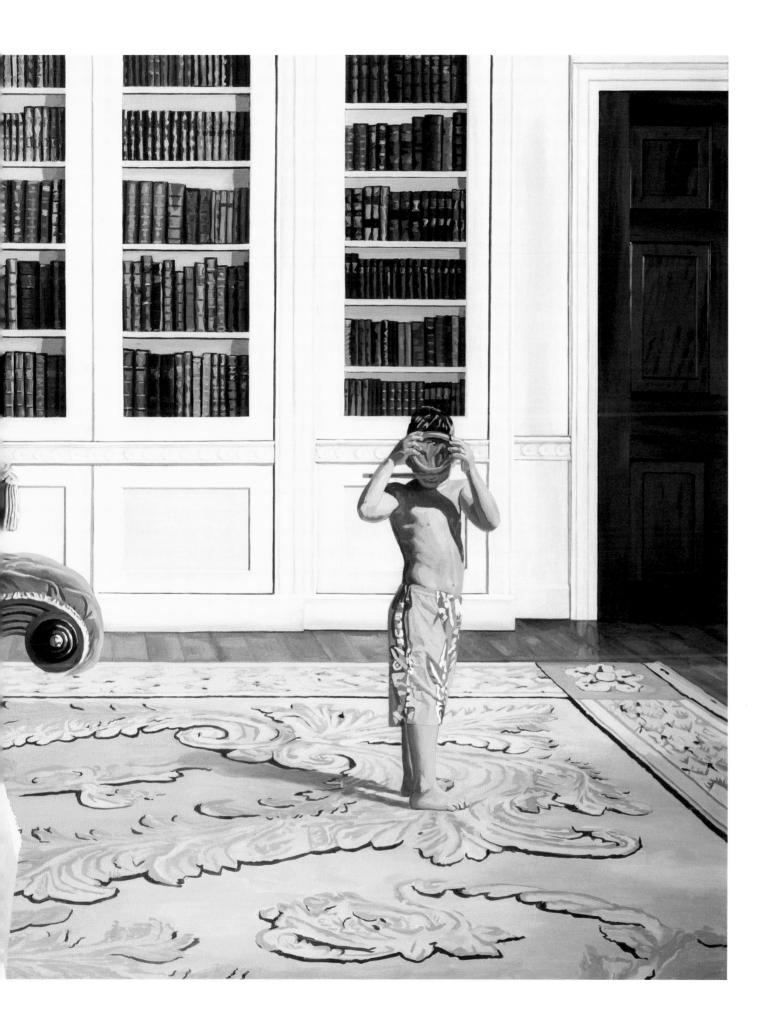

Het vrolijke meisje
1994

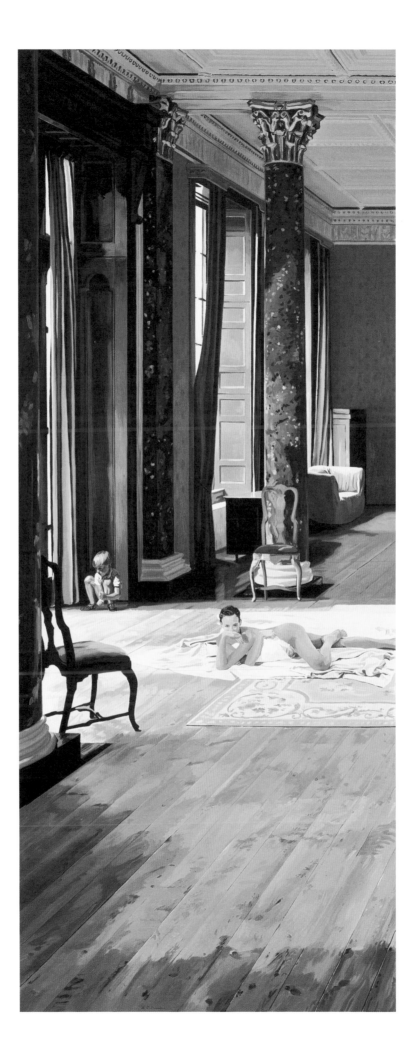

Rückenfigur
1994

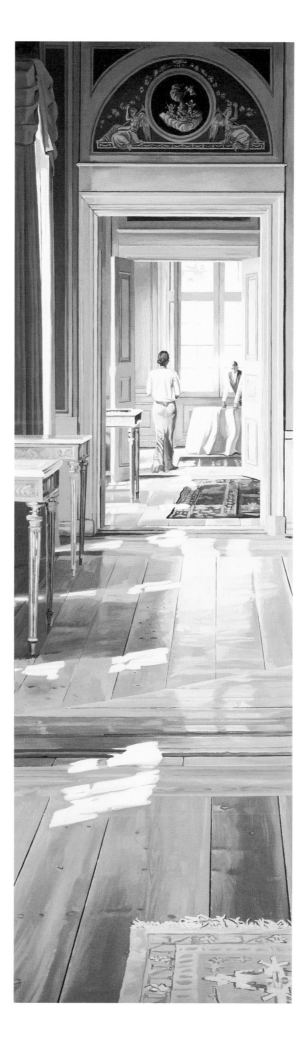

In 't voorbijgaan
1994

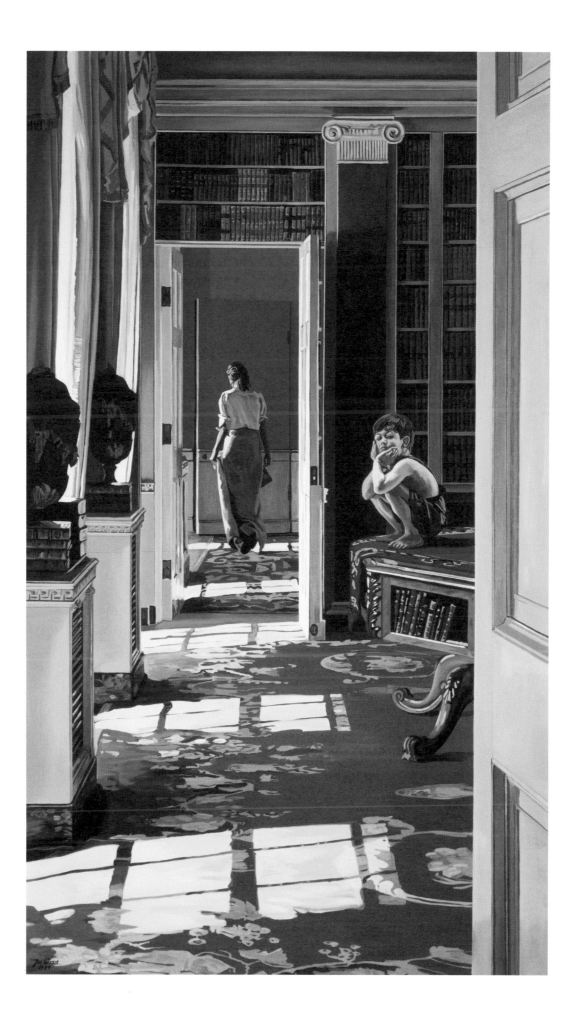

Het spel
1995

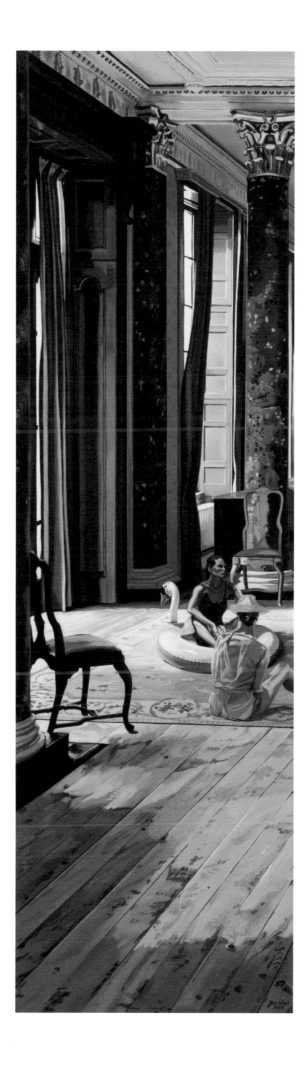

Indolent
1995

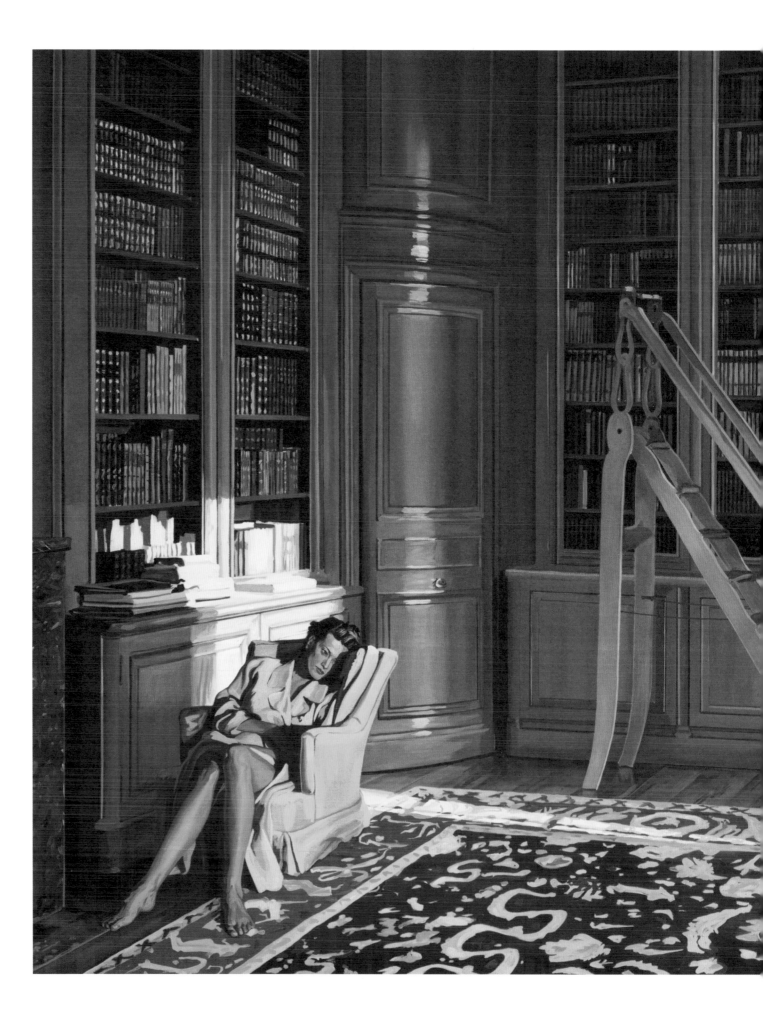

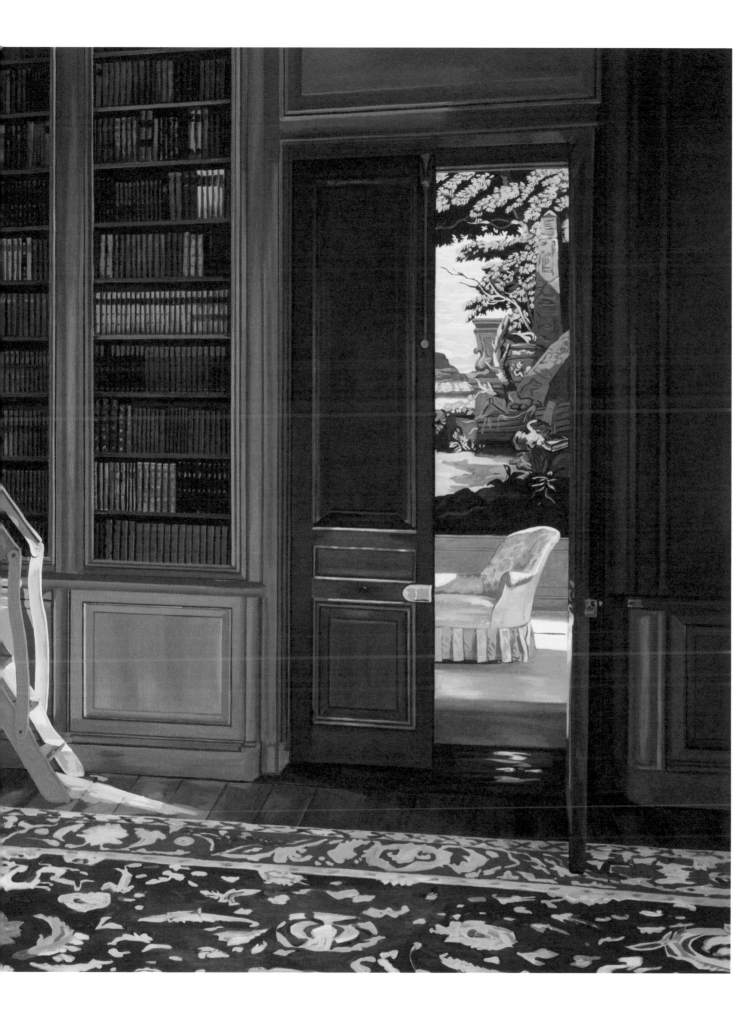

Antiek idool
1995

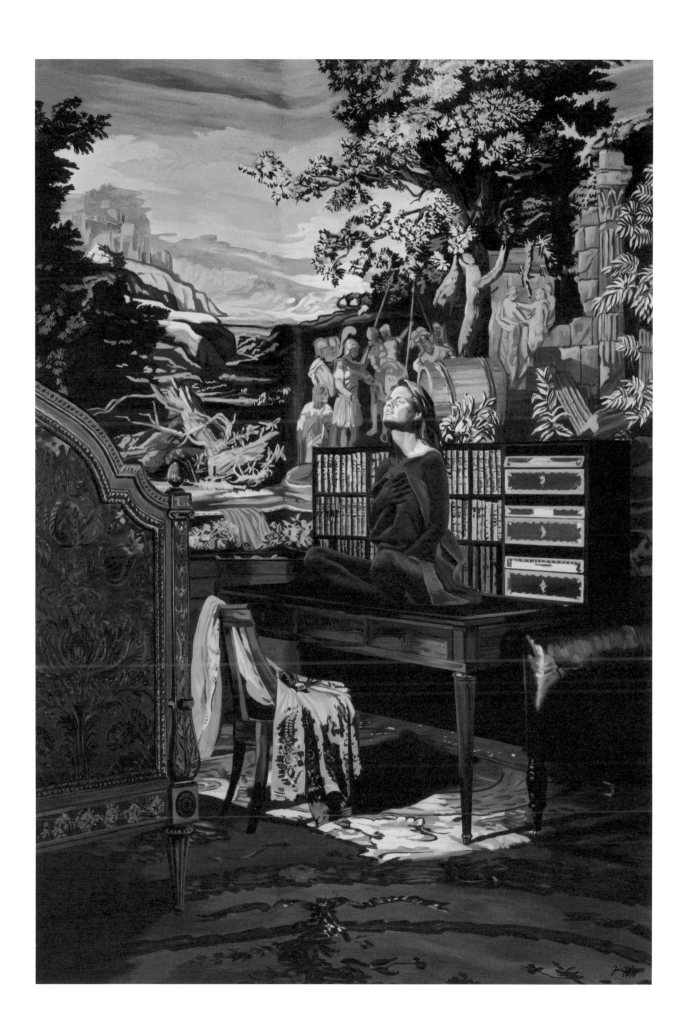

Verwant
1995

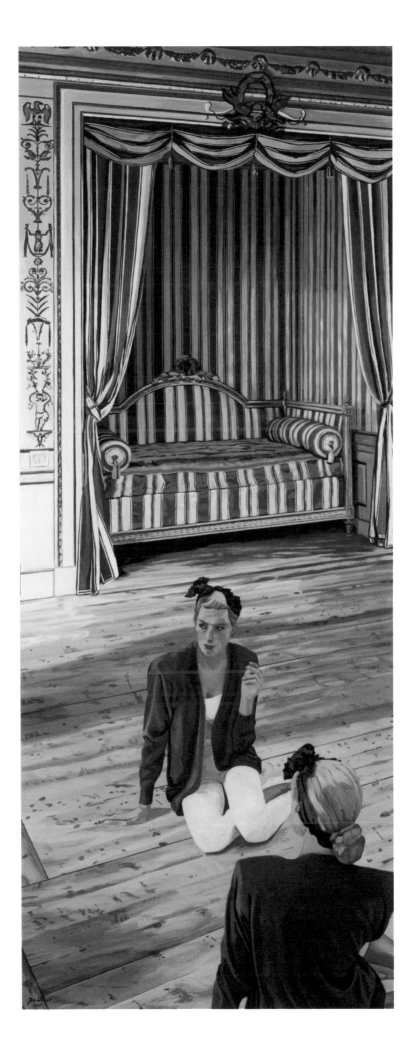

Allegorie II
1995

Herr und Hund
1995

Man en vrouw
1995

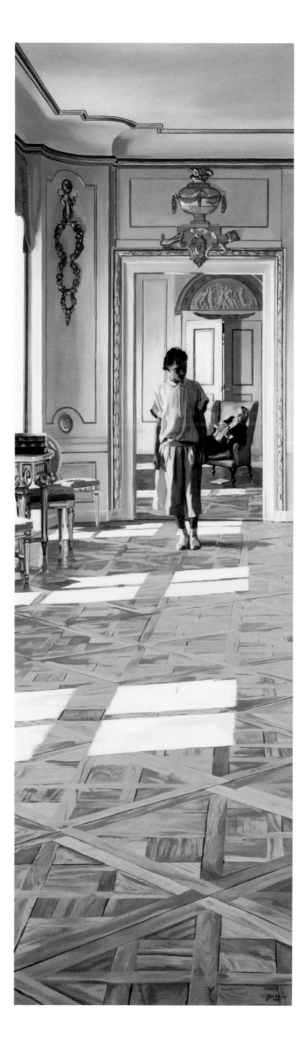

Het geschenk
1996

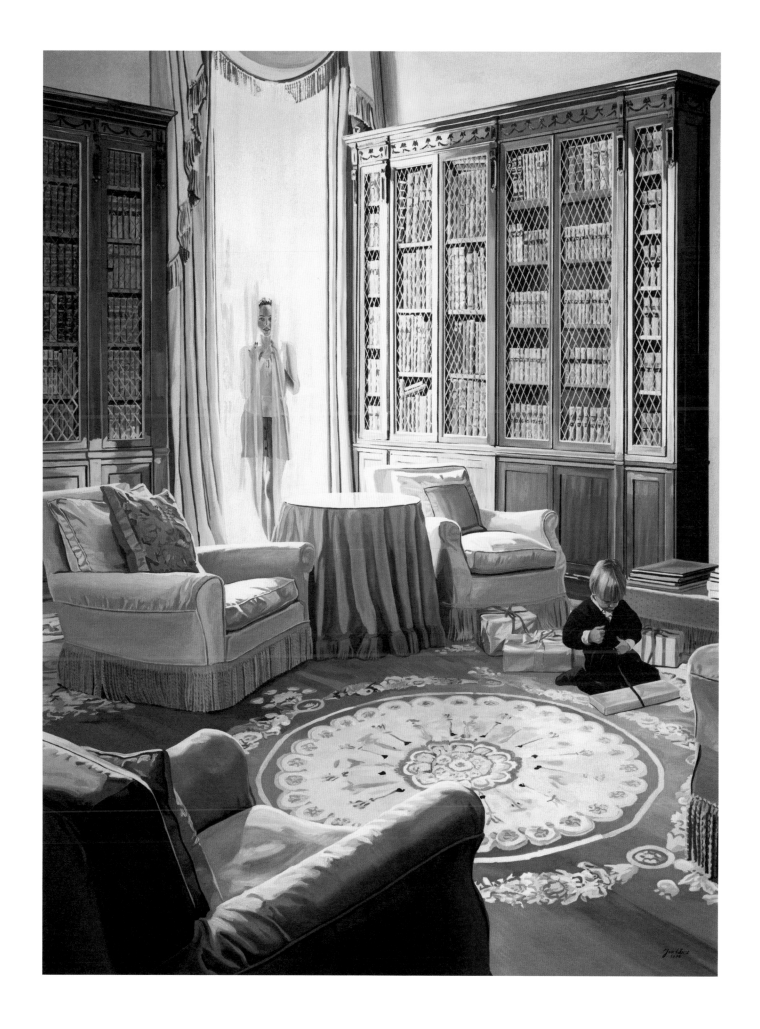

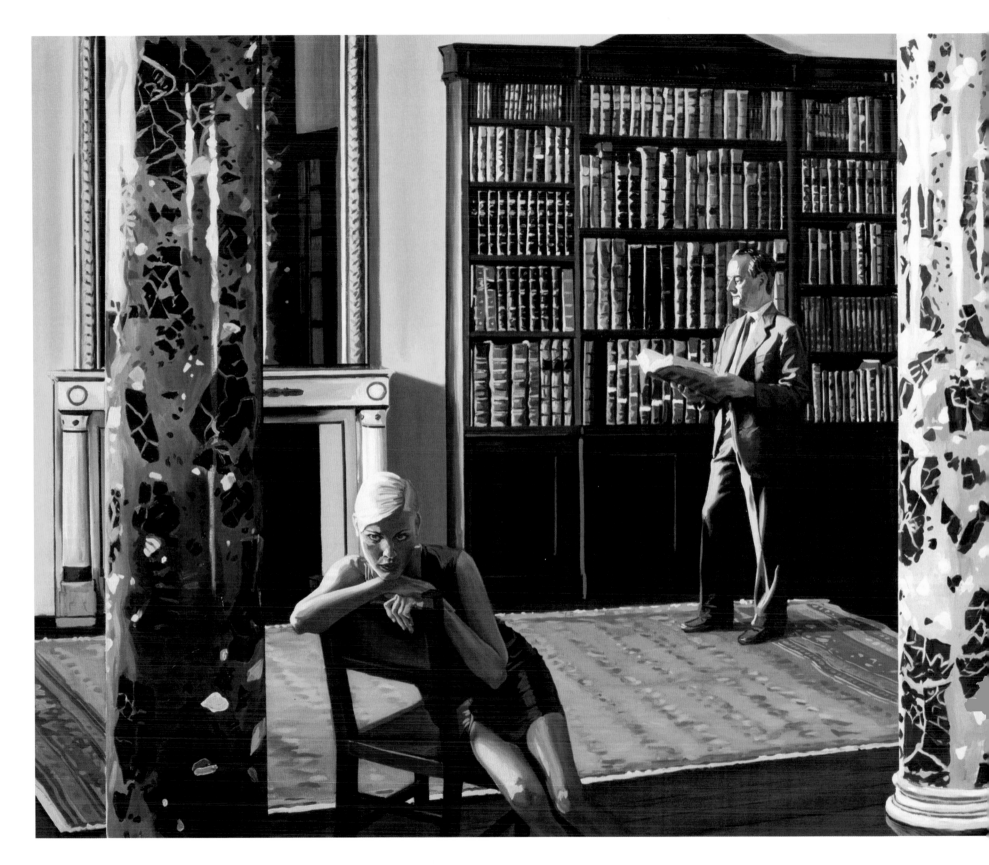

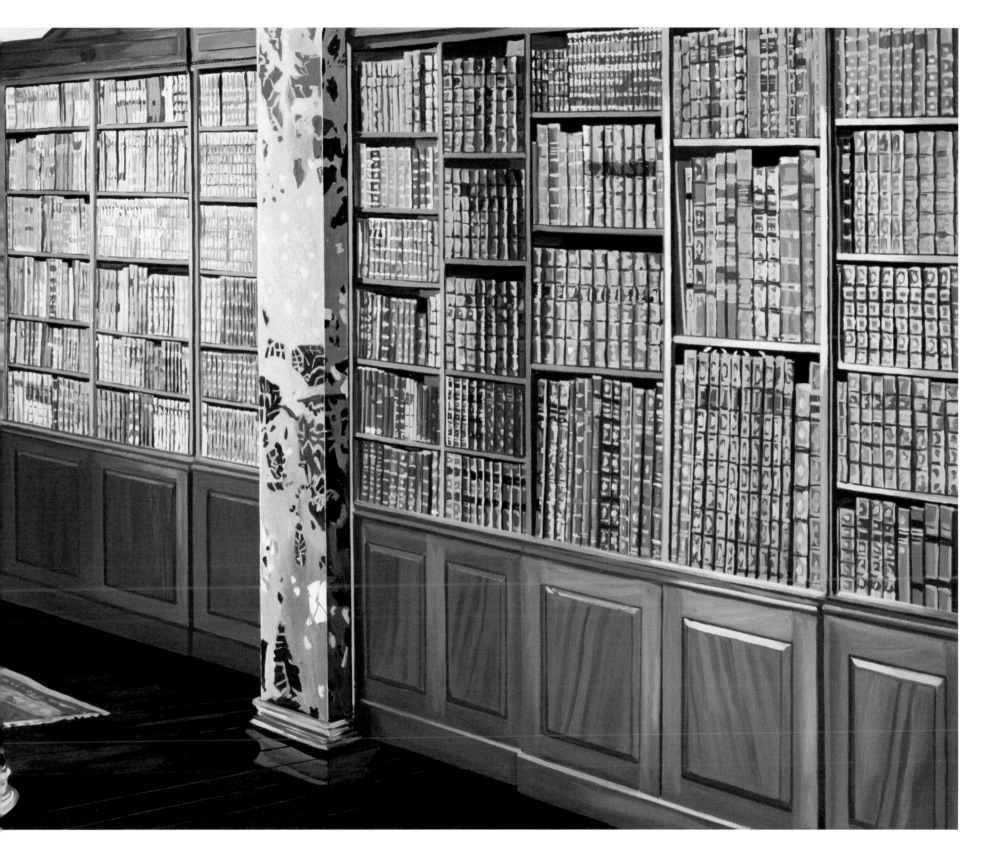

(page 112) *De voorlezing* *Dagdroom*
 1996 1996

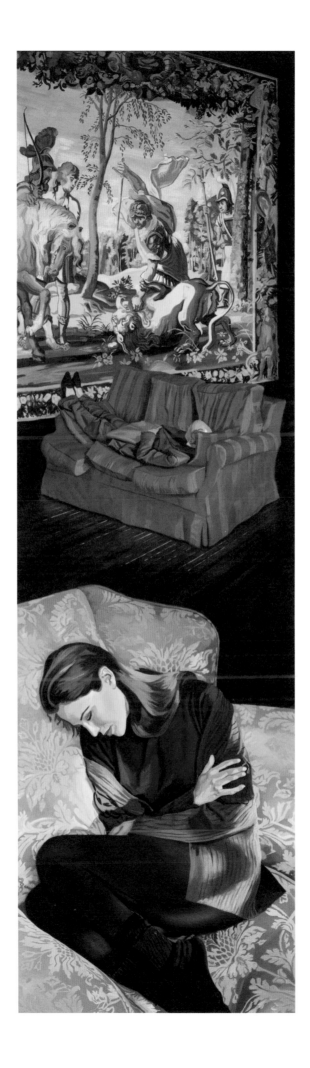

Lesefieber
1996

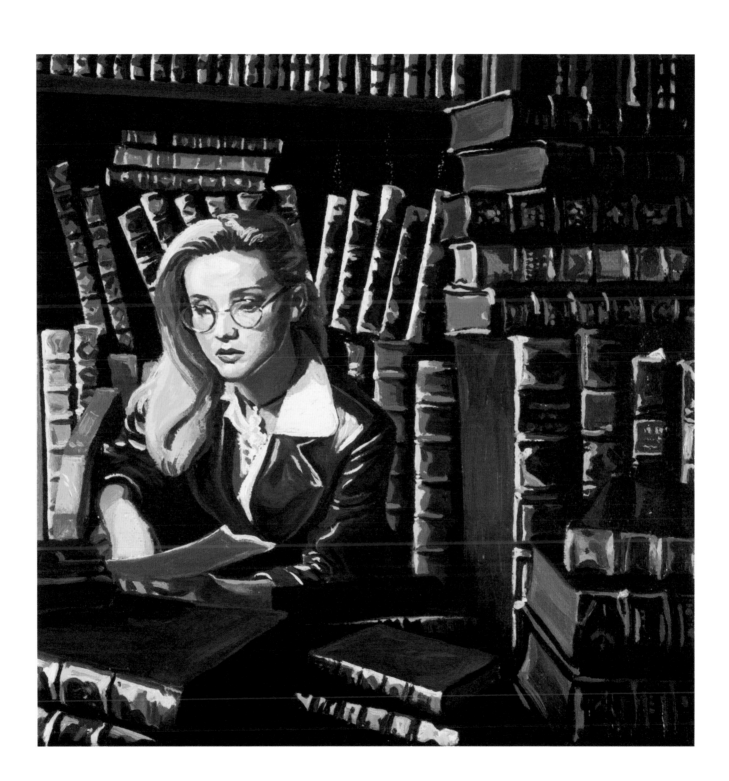

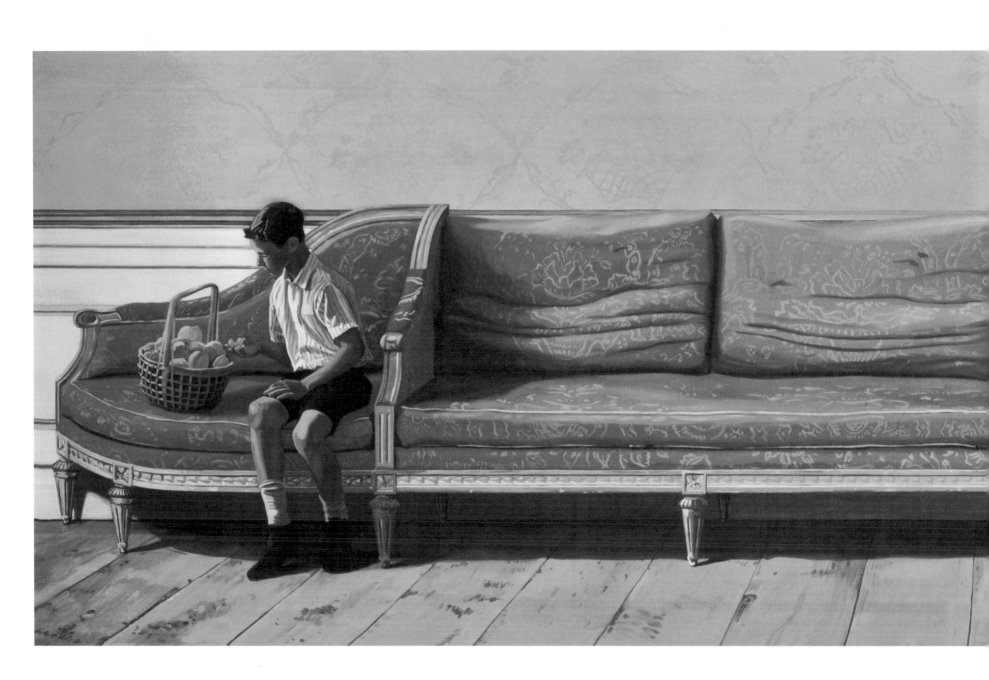

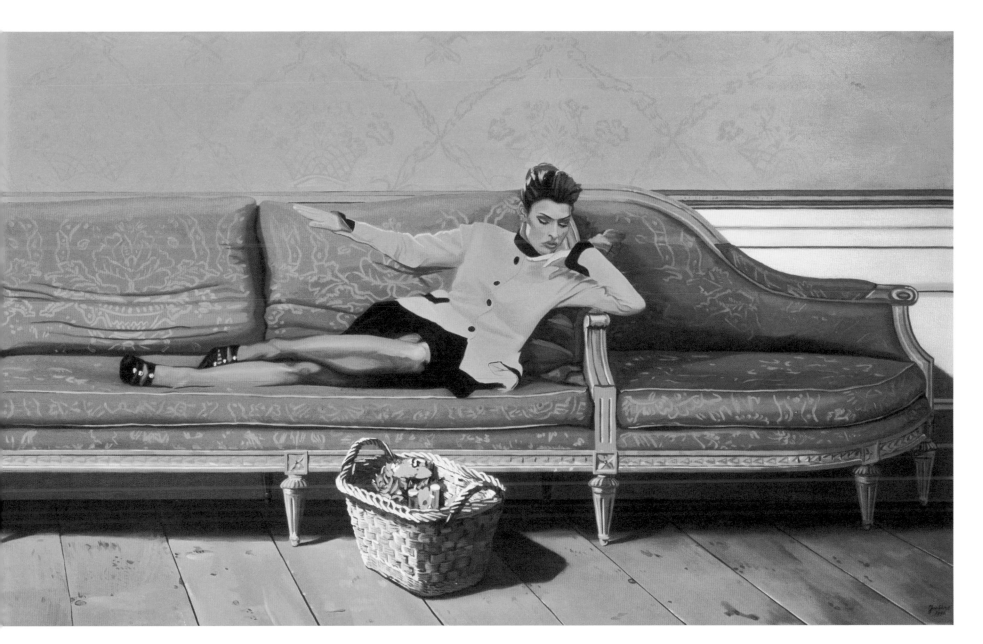

(page 118) *Confidente II* *De rode stoel*
 1996 1996

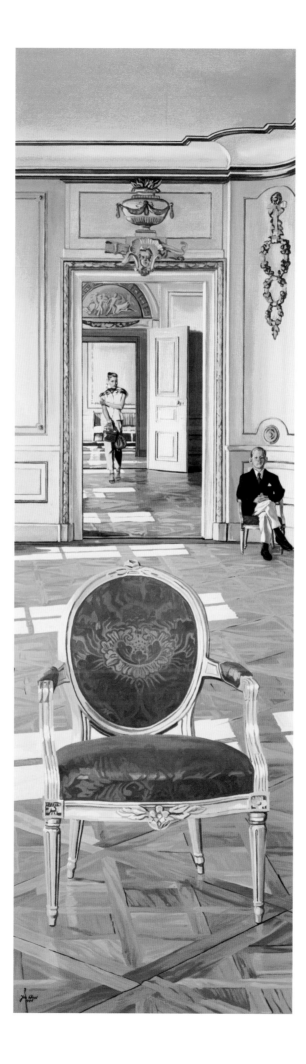

Urszene
1997

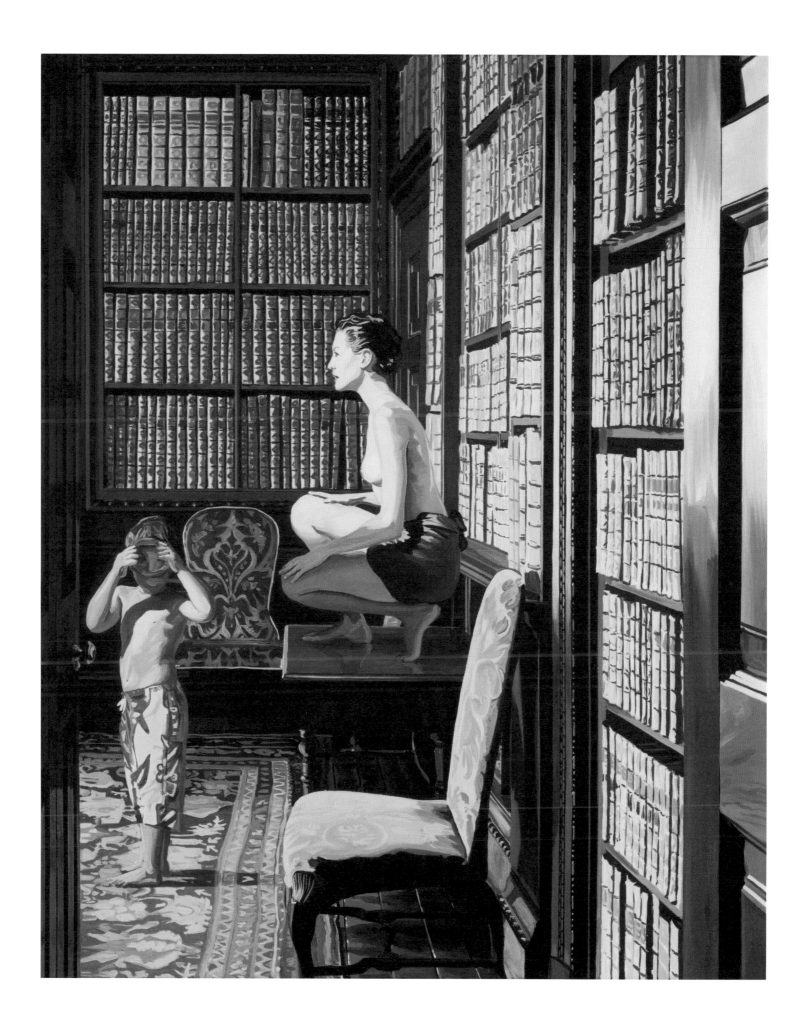

Primal Scene
1997

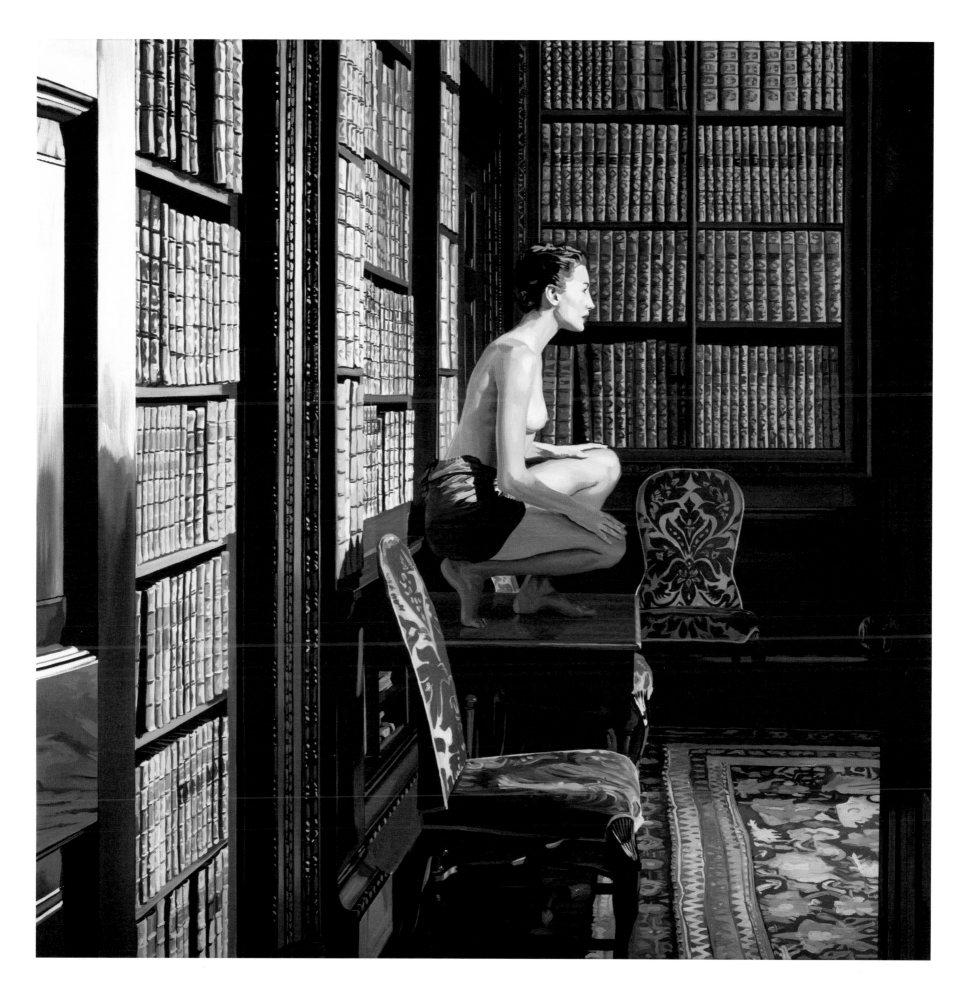

Cicerone
1997

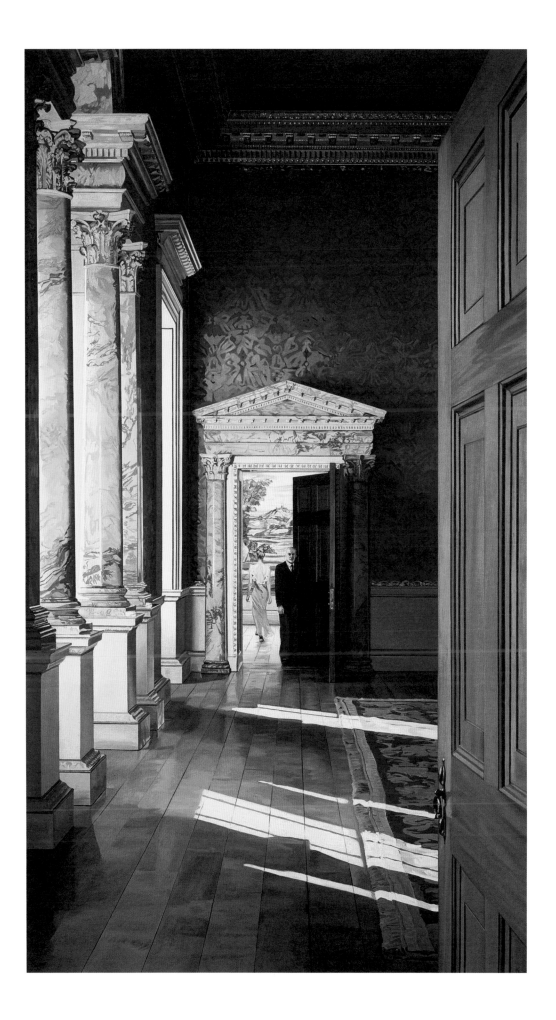

Camera Lucida
1997

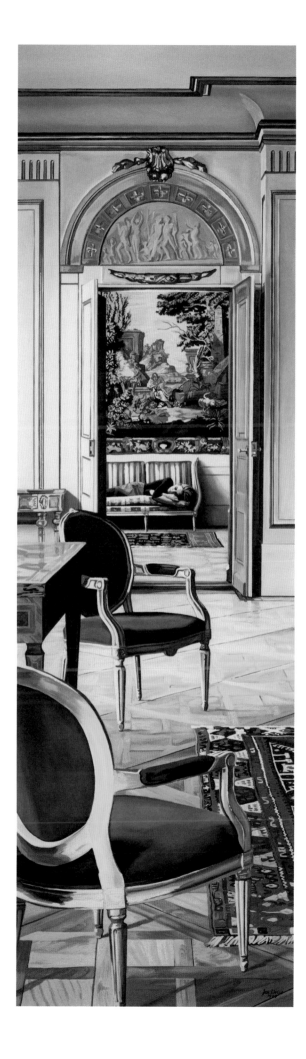

Die Fenster
1997

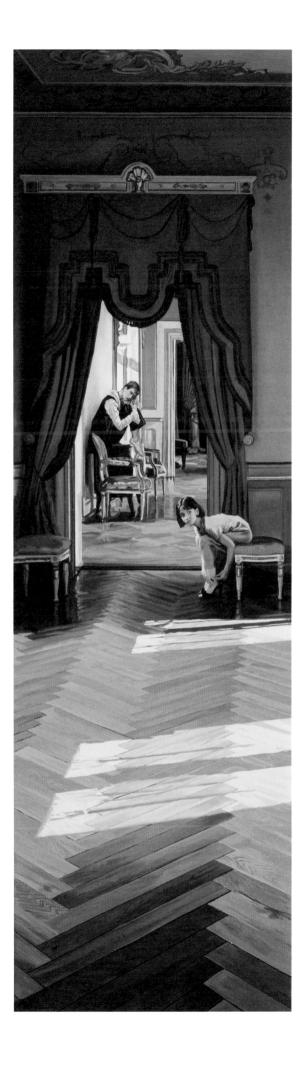

Kammerspiel
1997

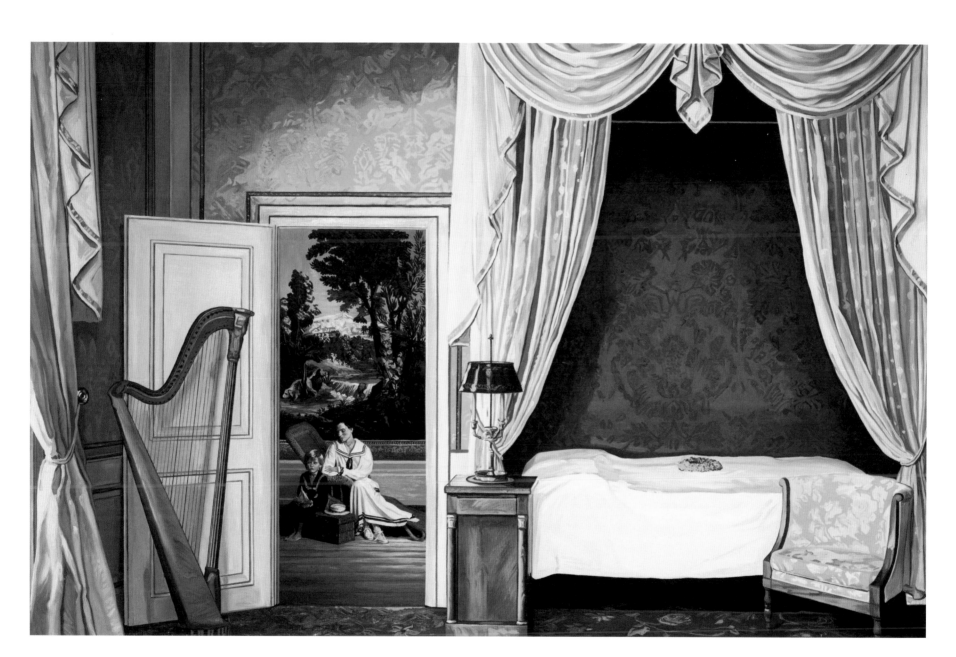

Erscheinung
1997

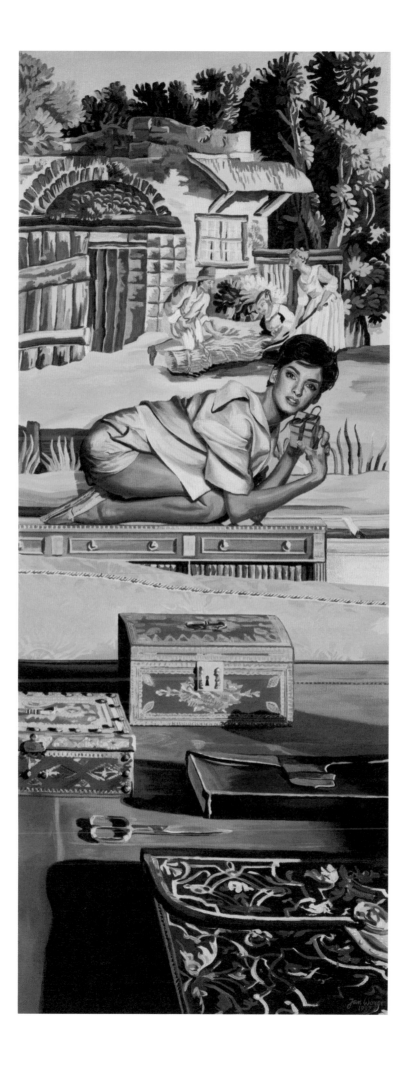

Verschijning
1997

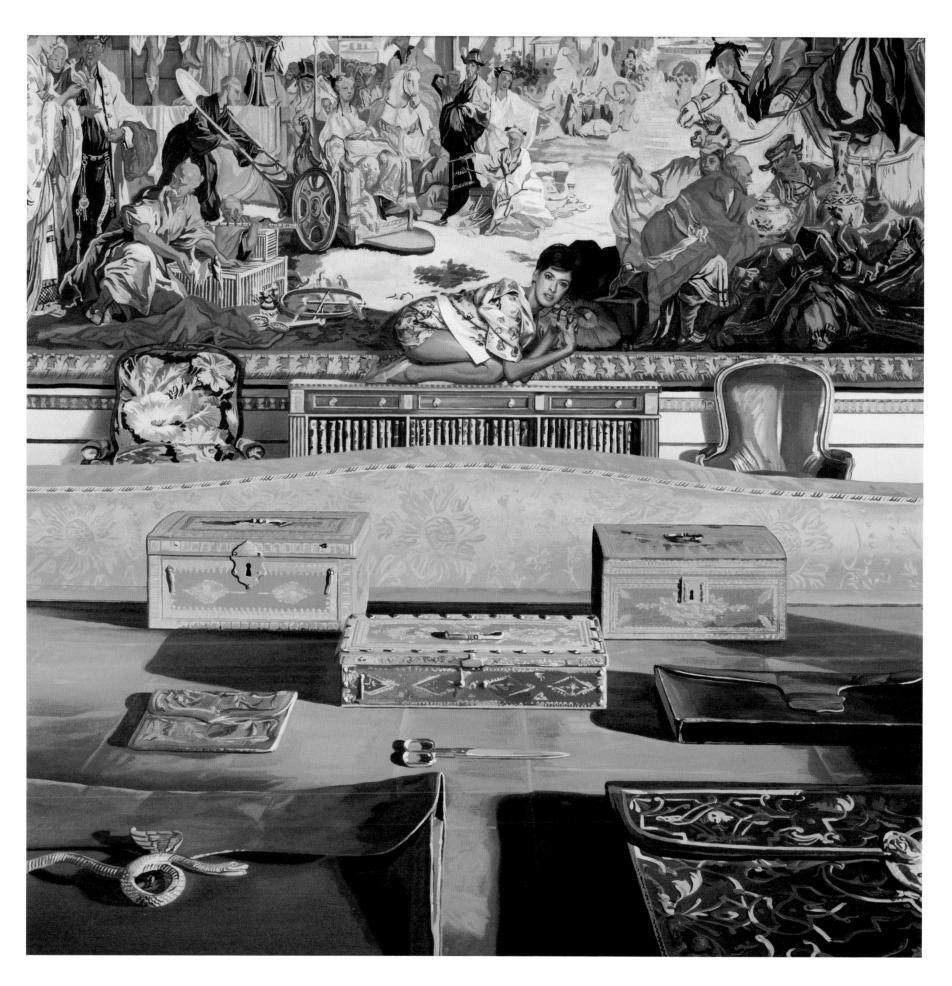

Good Looking
1997

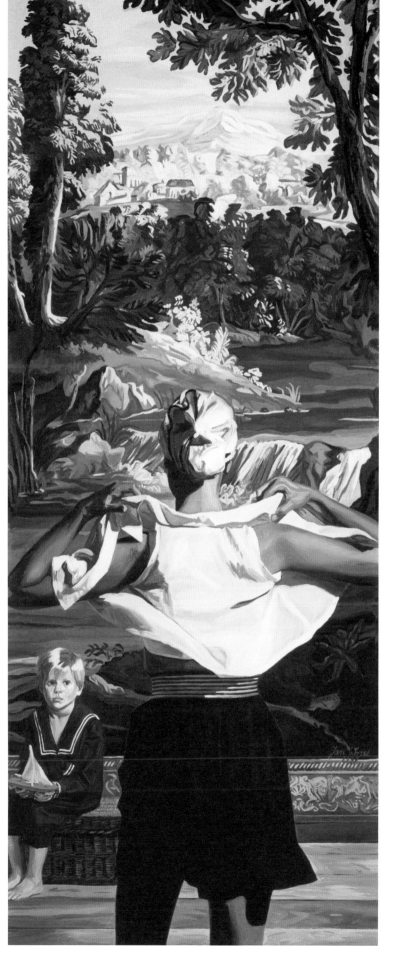

De Huisvriend
1998

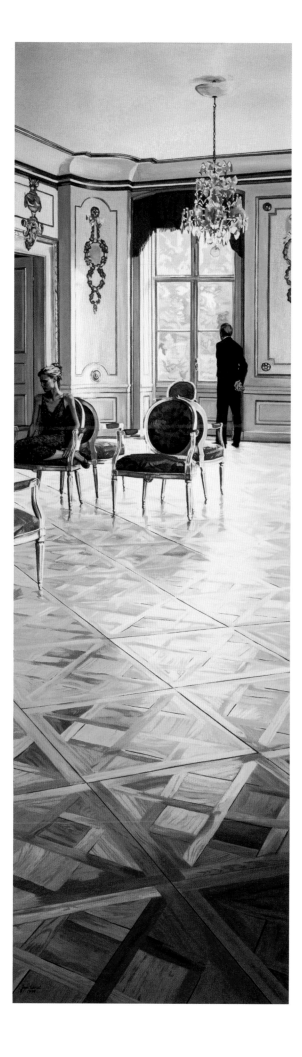

De moralist
1998

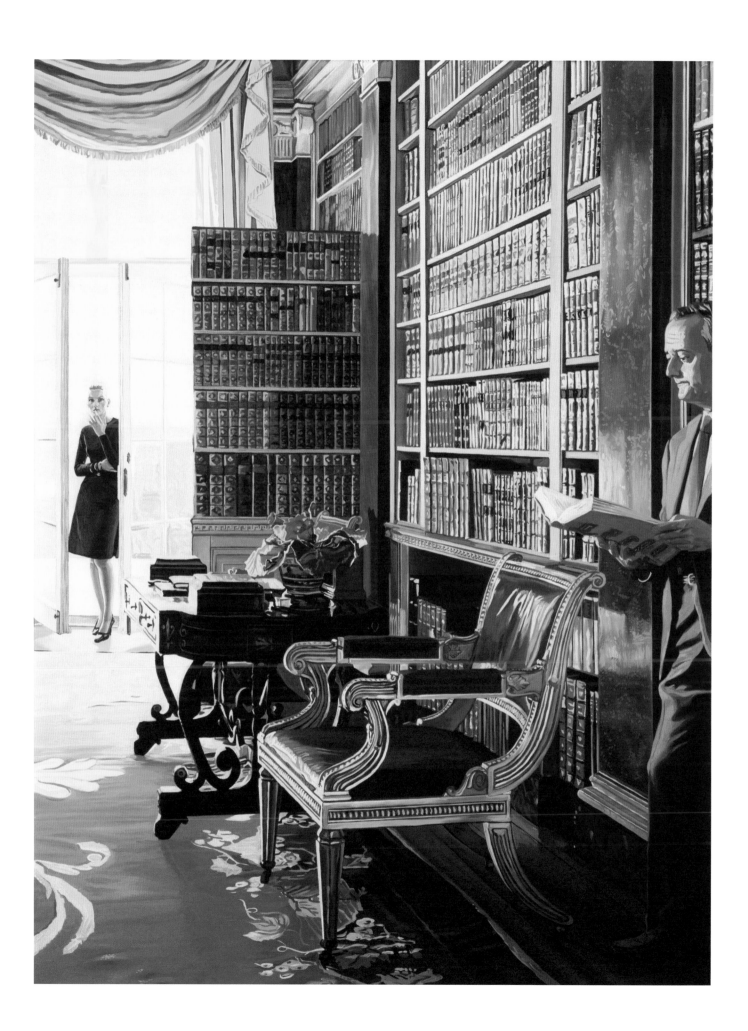

Herinnering
1998

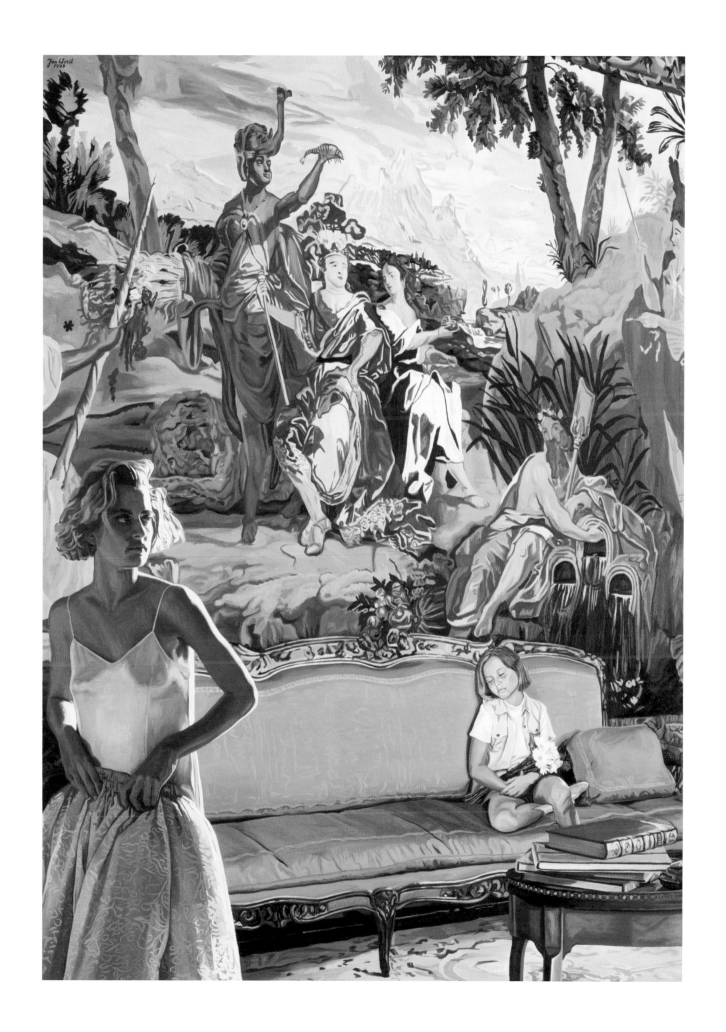

Good Looking II
1998

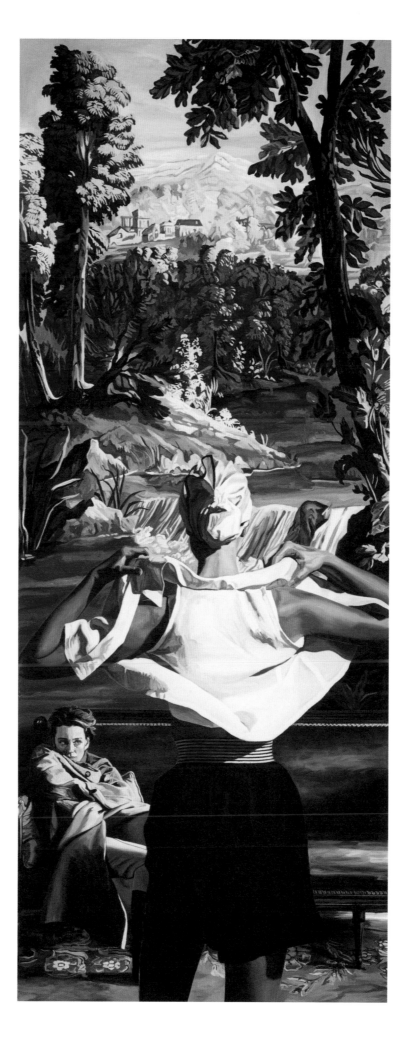

De briefschrijfster
1998

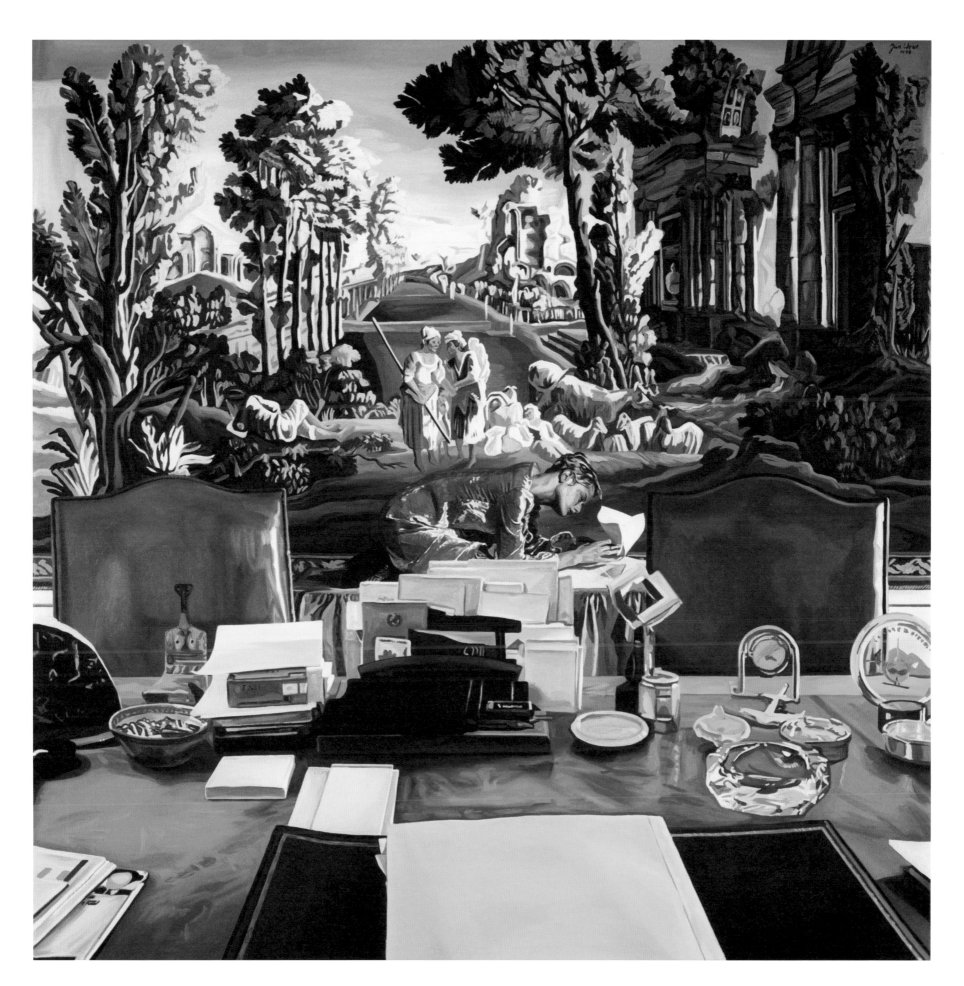

Disperaat ensemble
1998

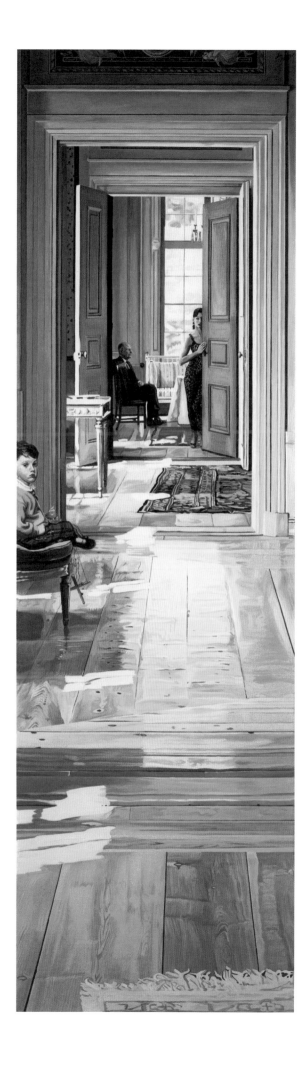

De rode kamer
1998

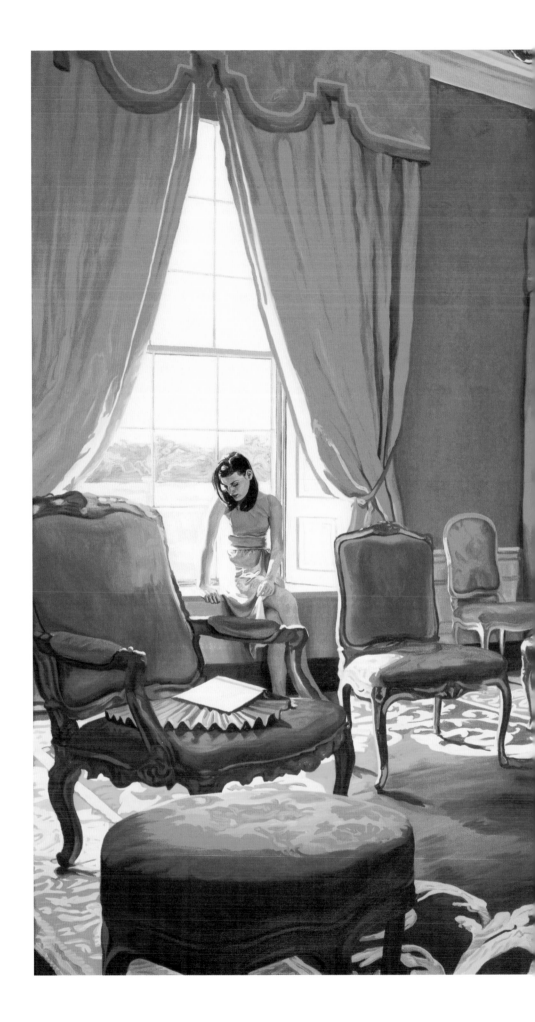

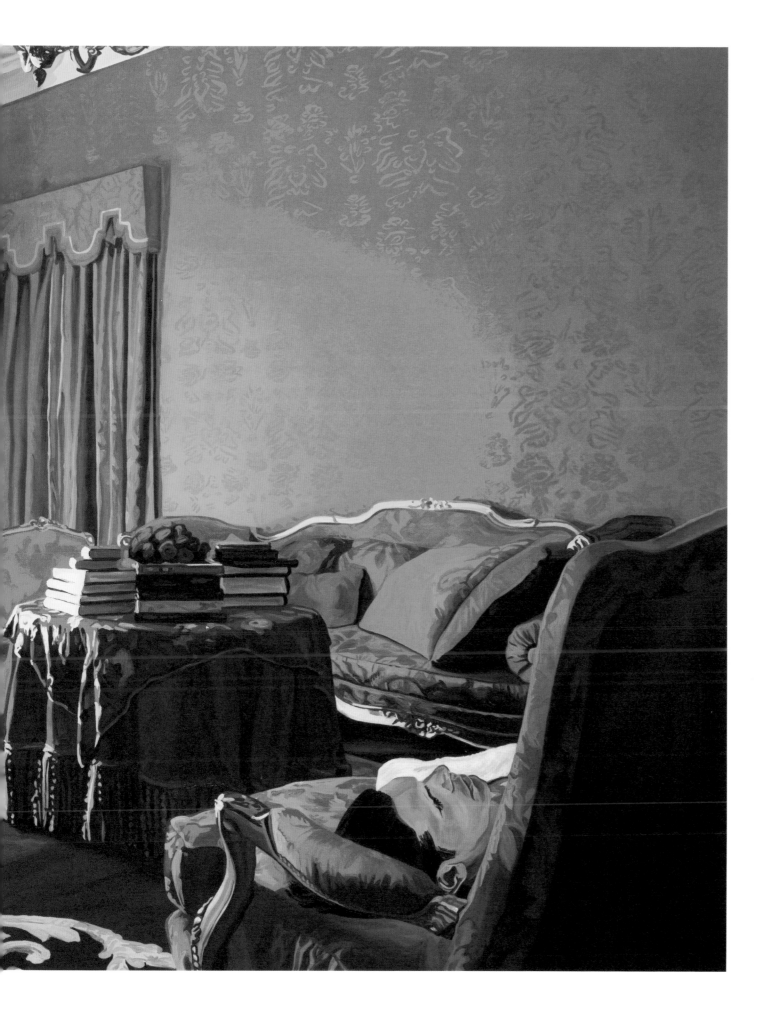

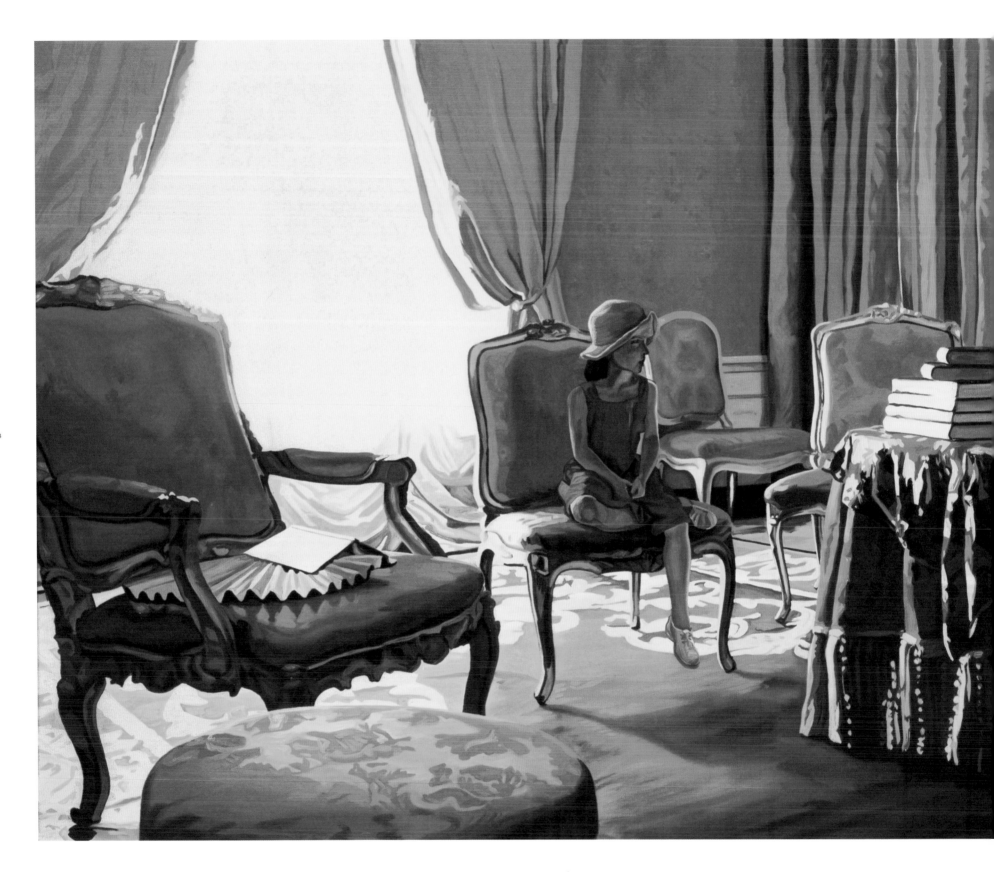

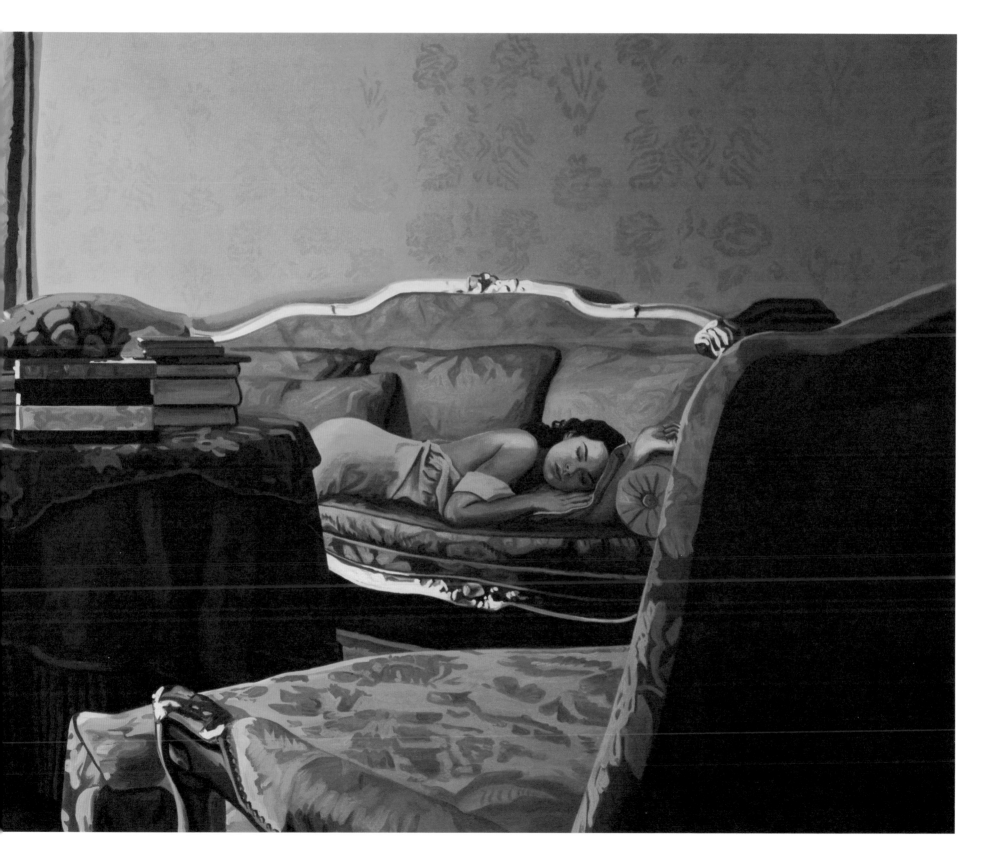

(page 154) *Sweet Neglect* *The Captive*
 1999 1999

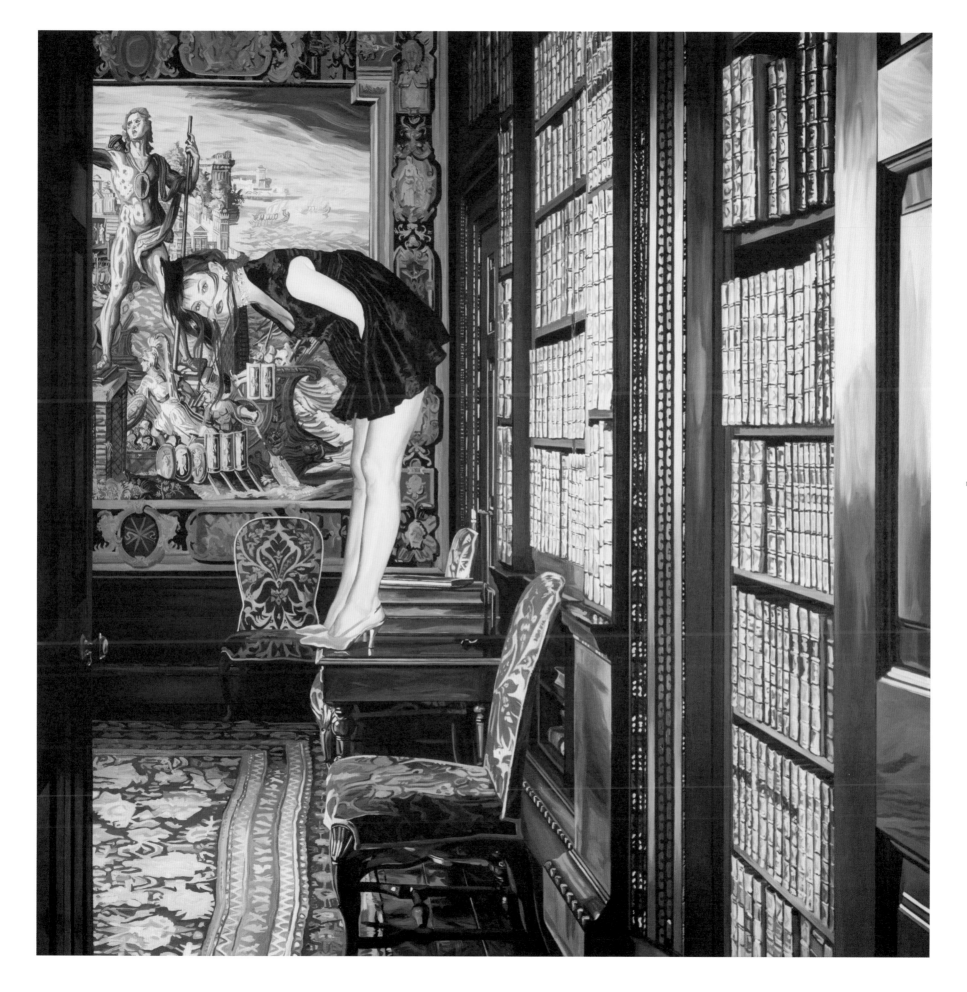

The Secret Miracle
1999

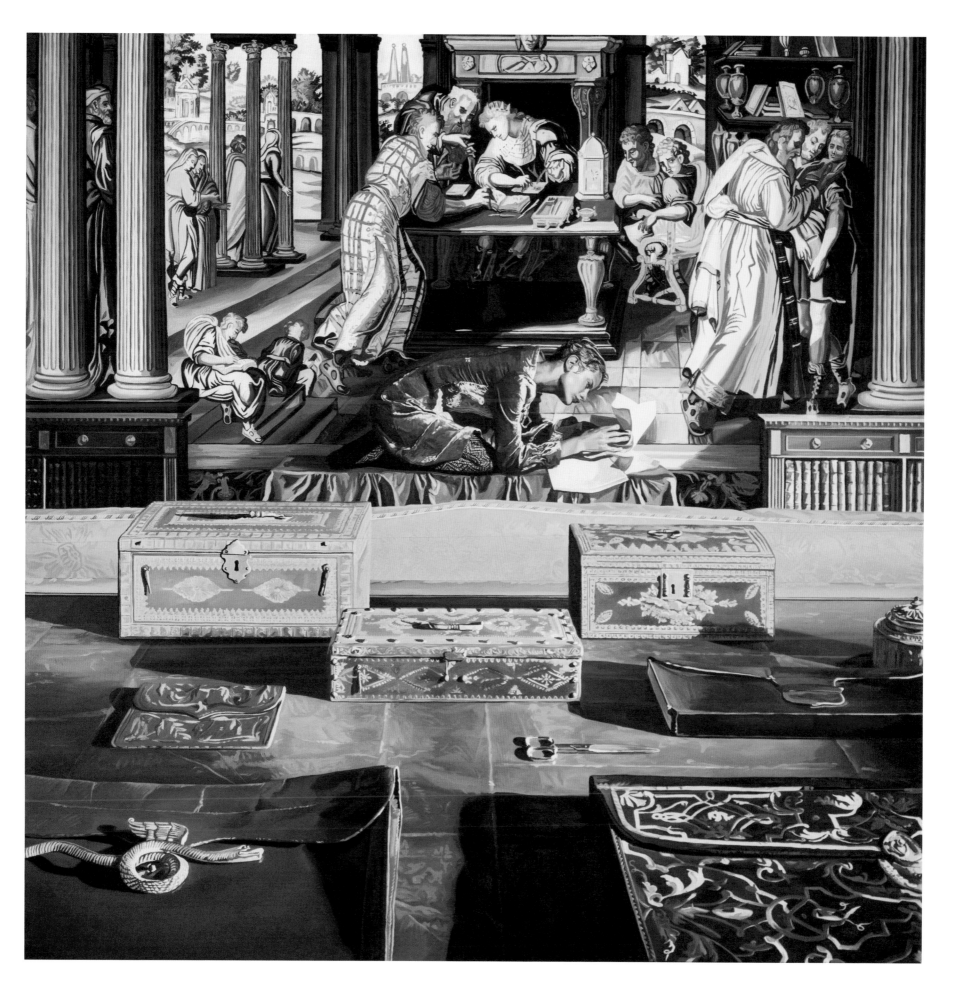

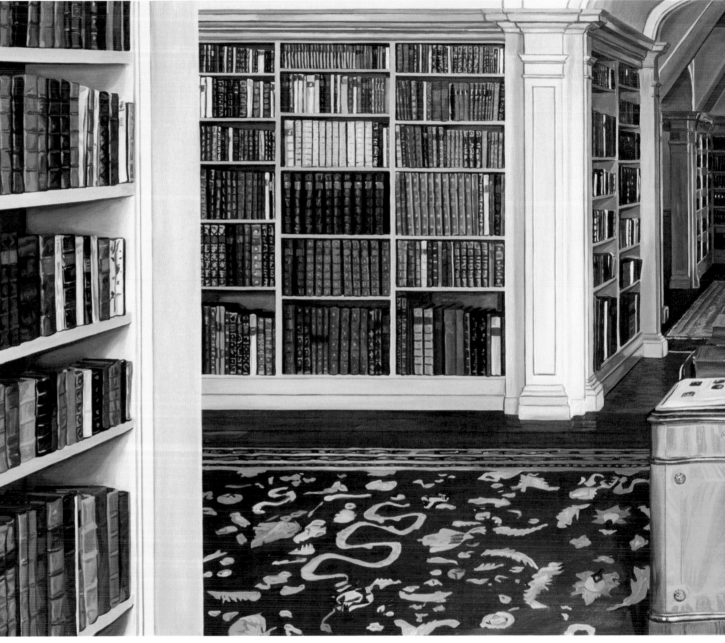

The Wait
2000

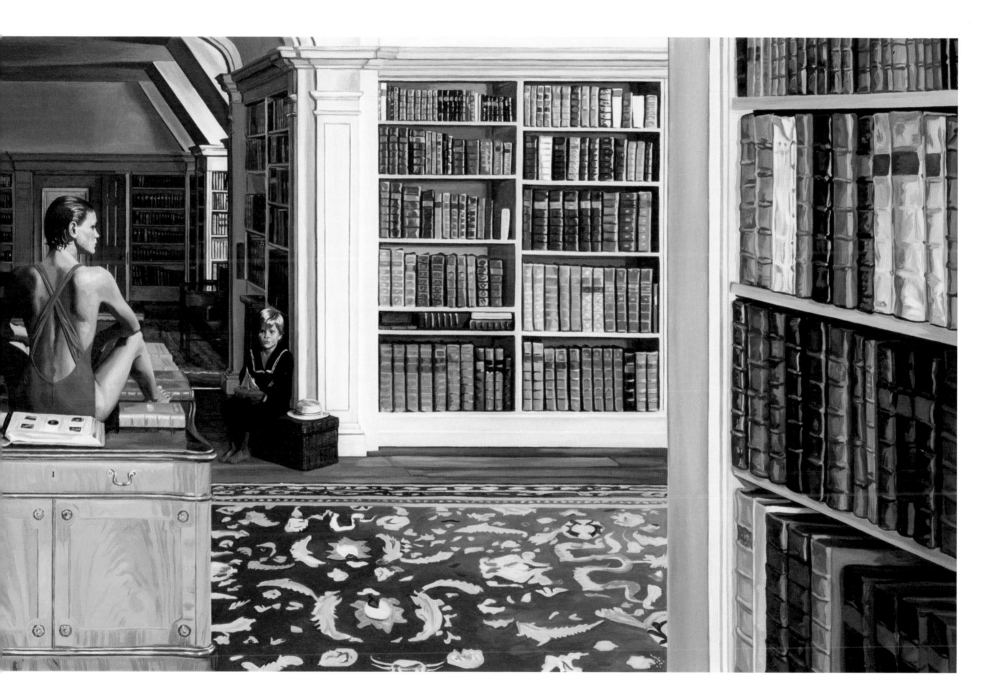

In Passing
2000

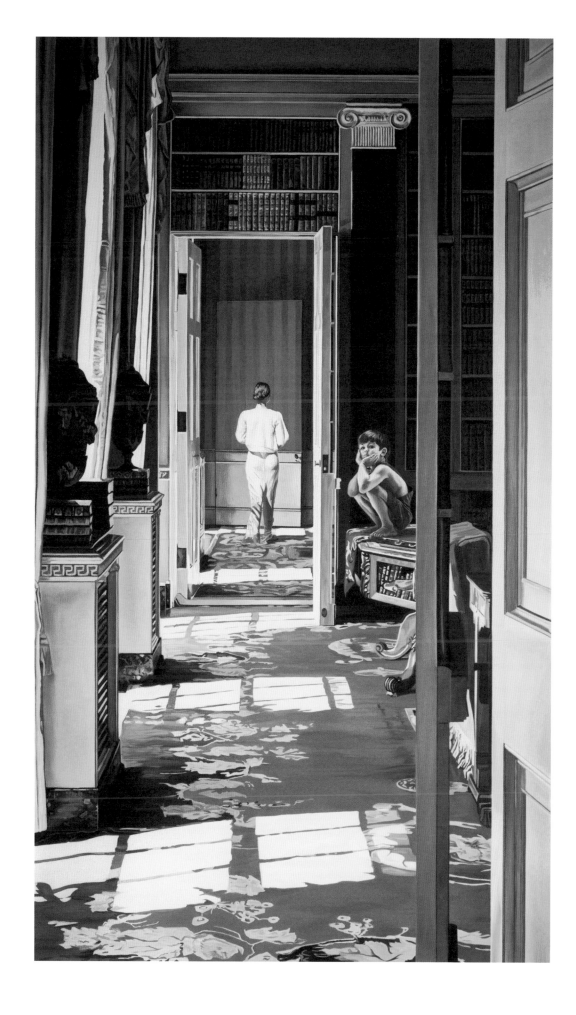

A Favourite Scene
2000

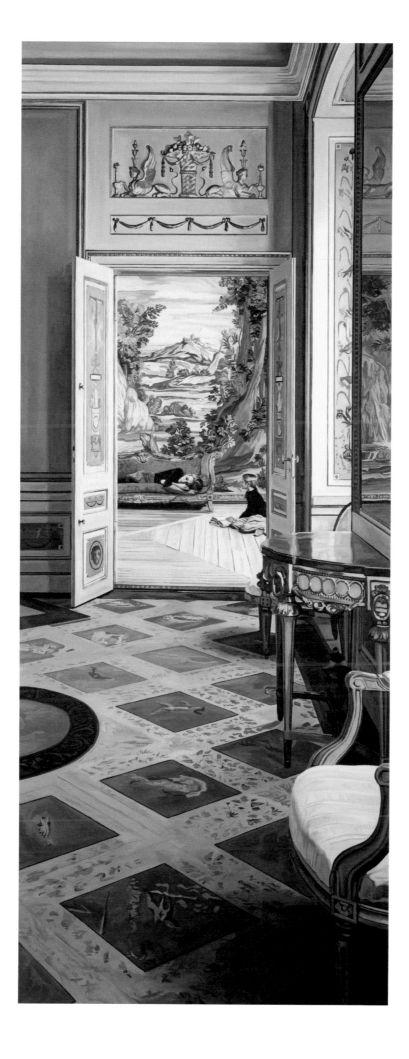

The Virtue of Unlikeness

2000

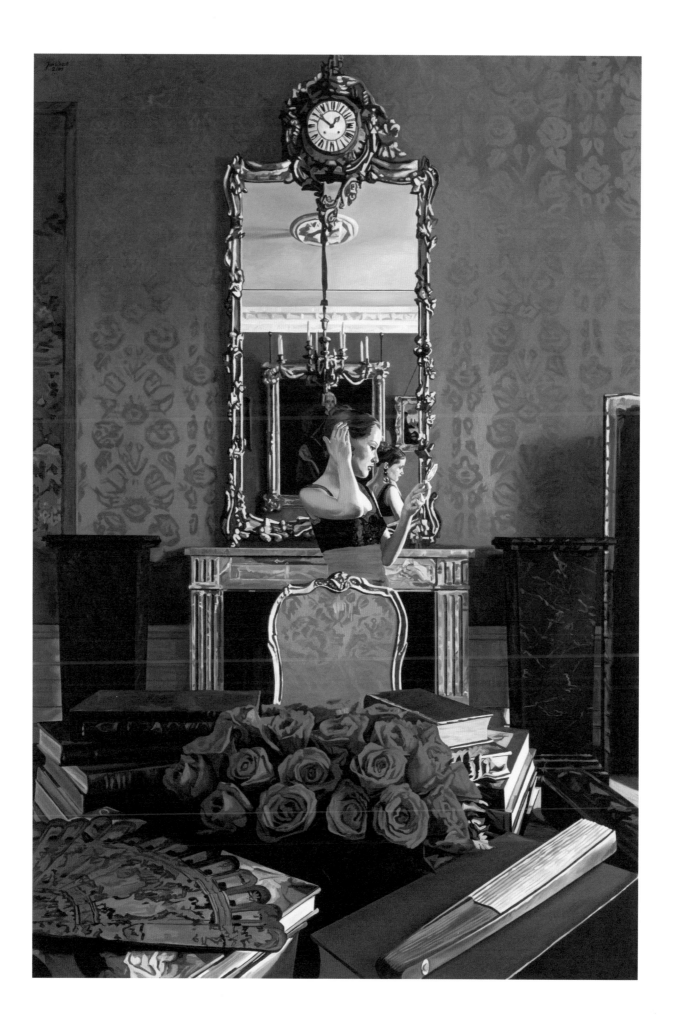

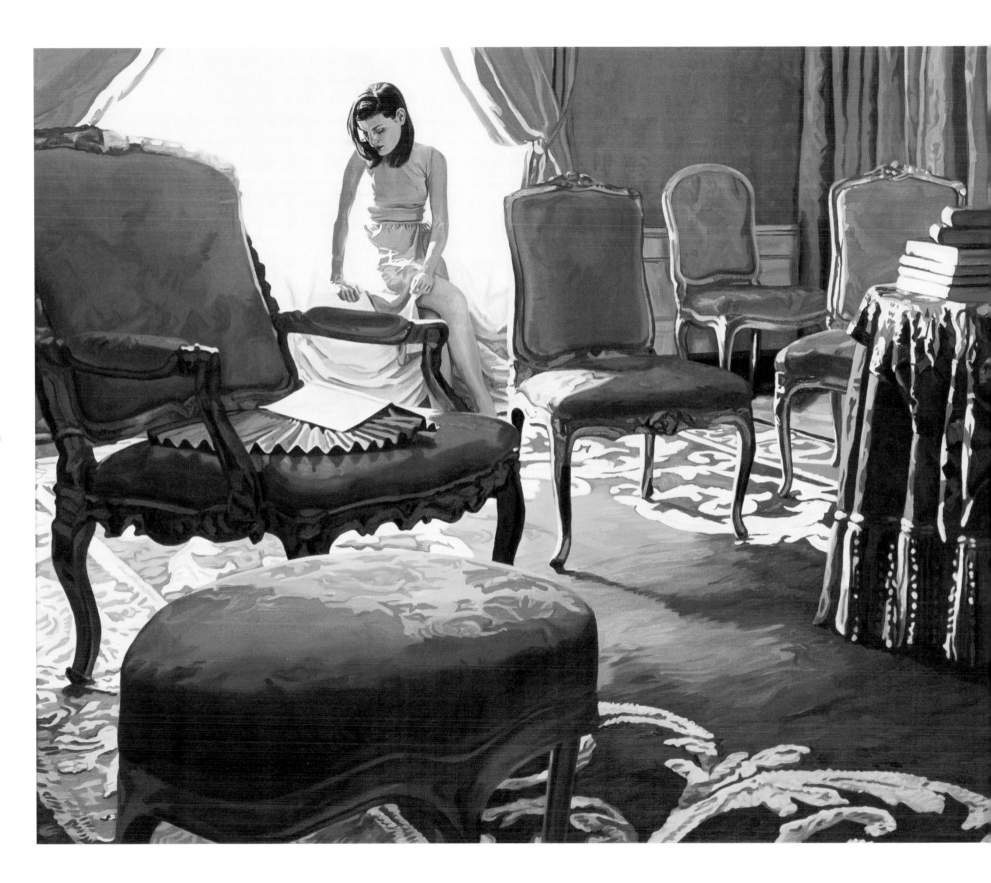

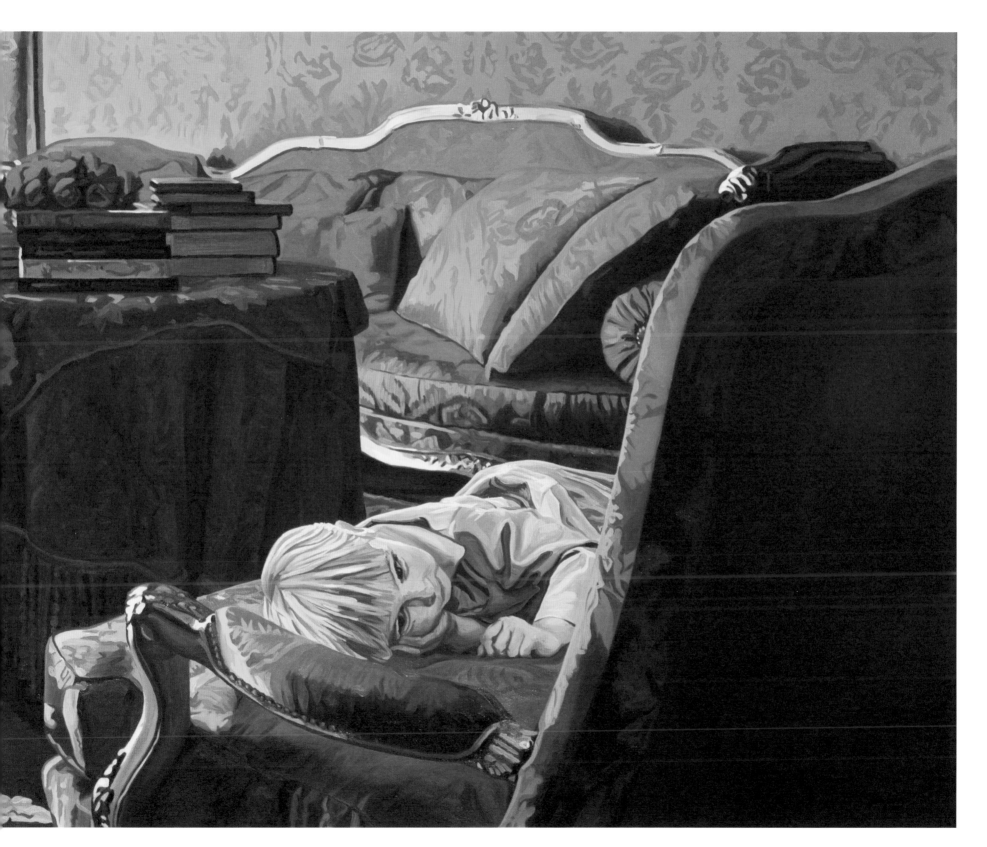

(page 168) *Red Interior*
 2000

His Curious Universe
2000

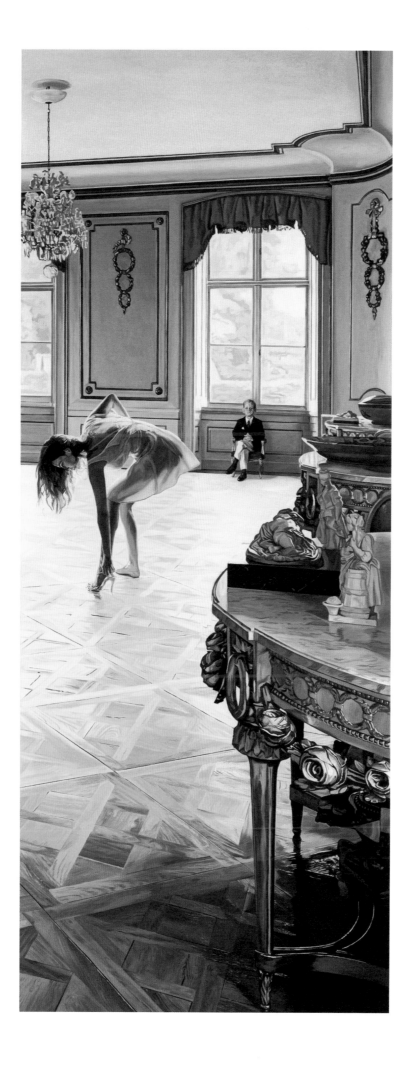

His Curious Universe II
2000

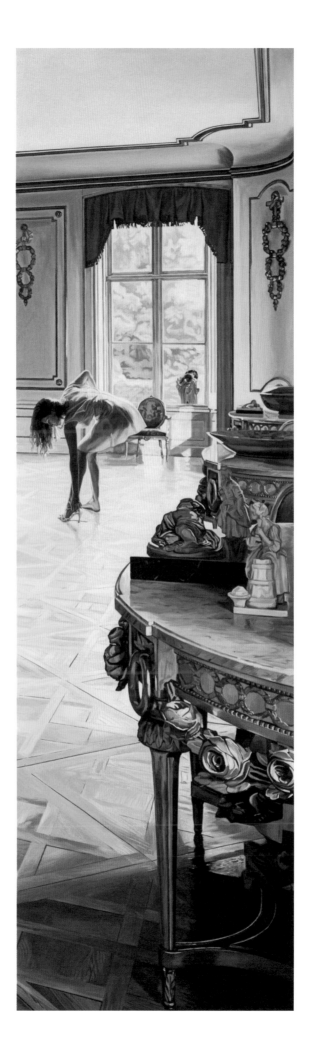

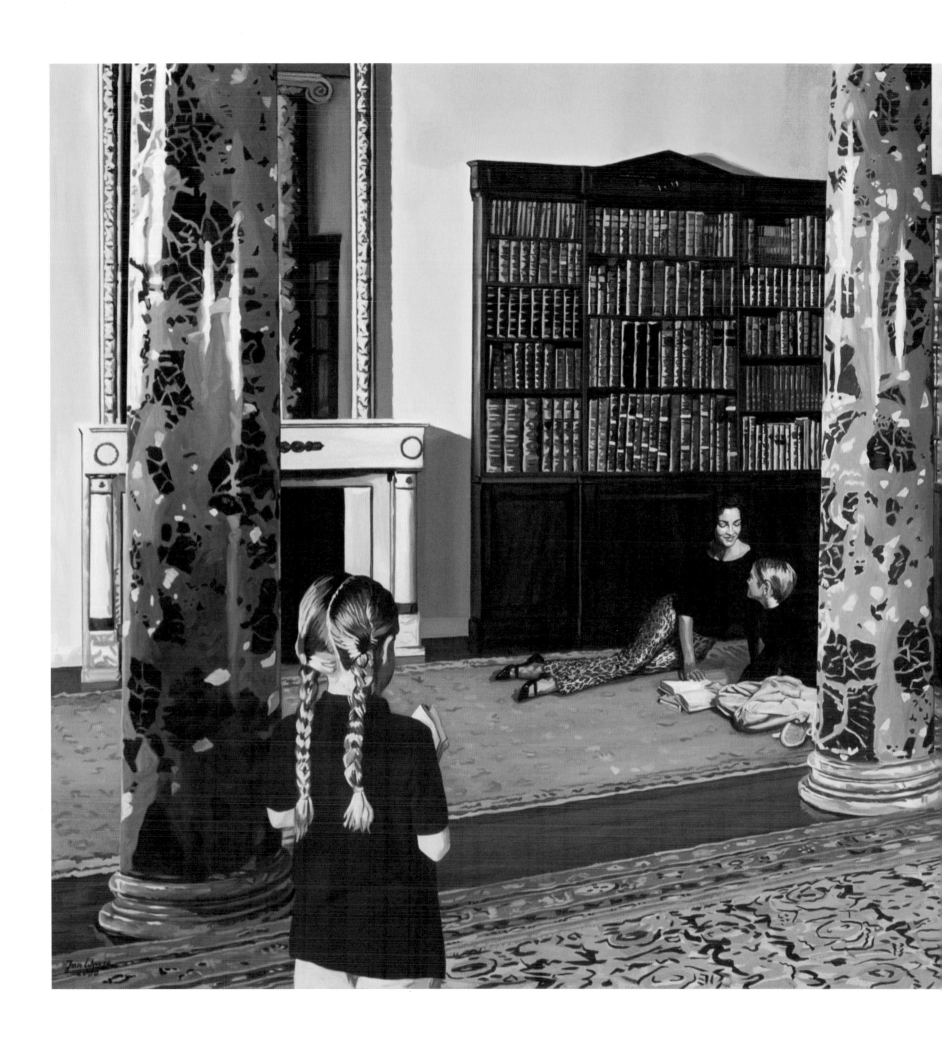

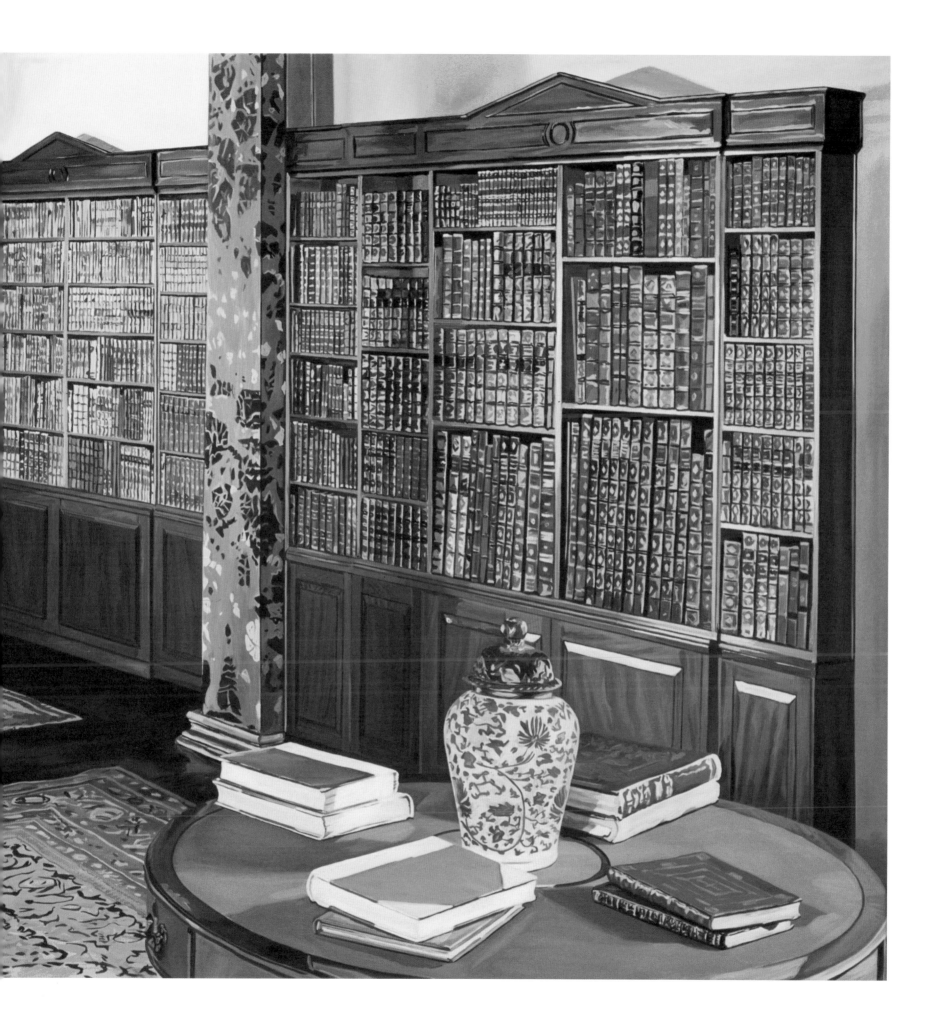

(page 174) *Bibliotheek* *The Children's Hour*
2000 2001

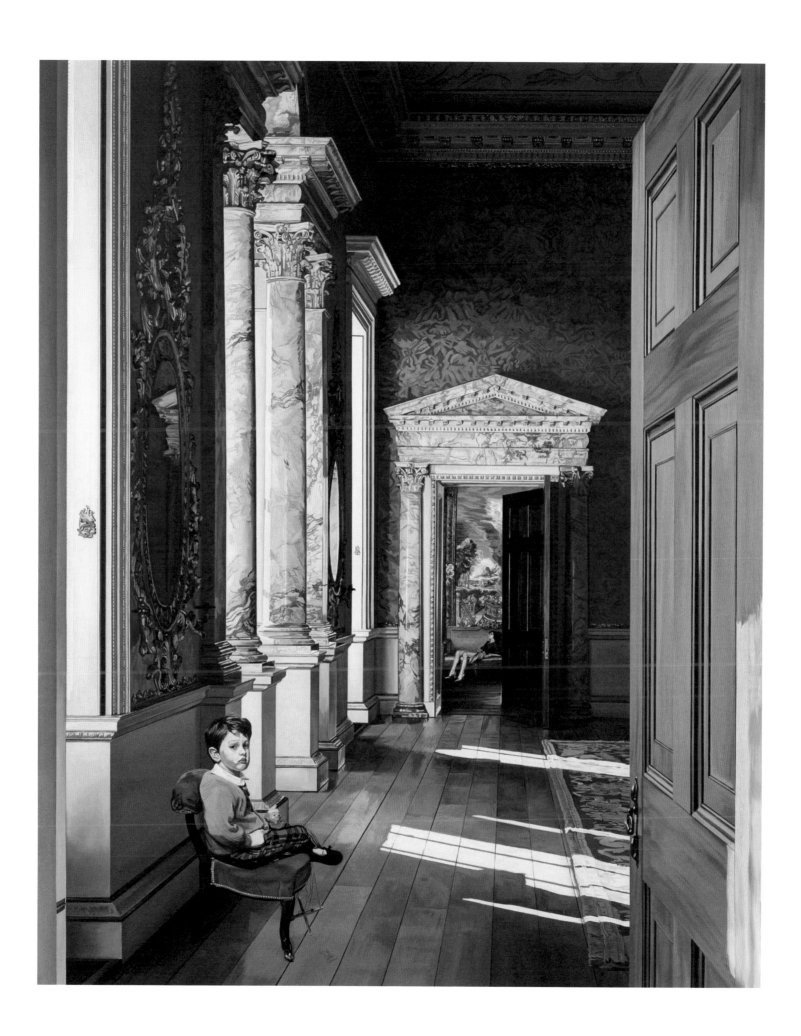

The Watcher
2001

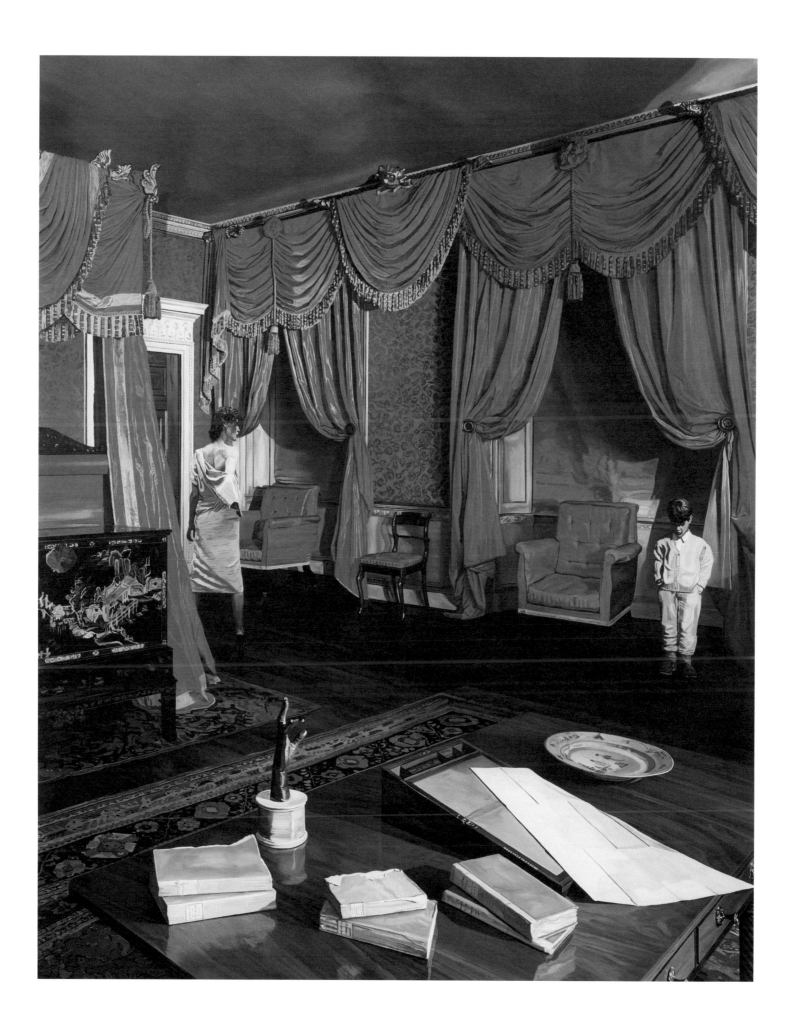

Dormeuse
2001

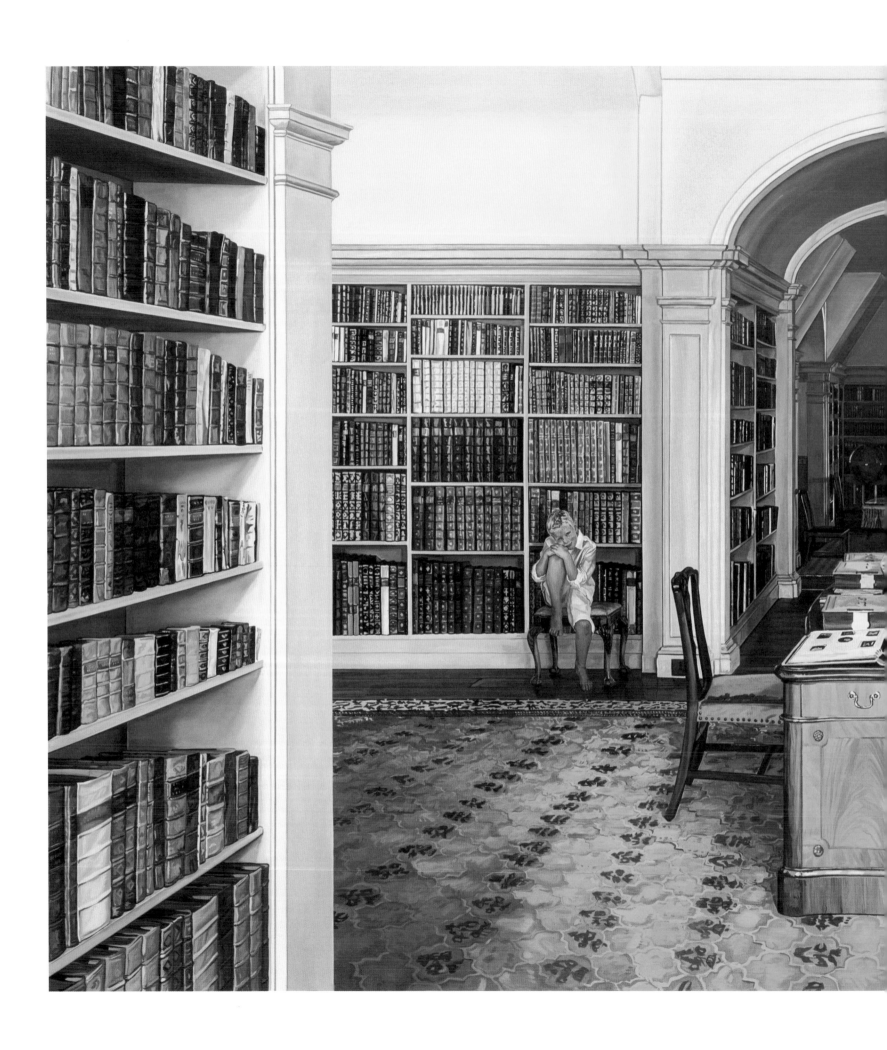

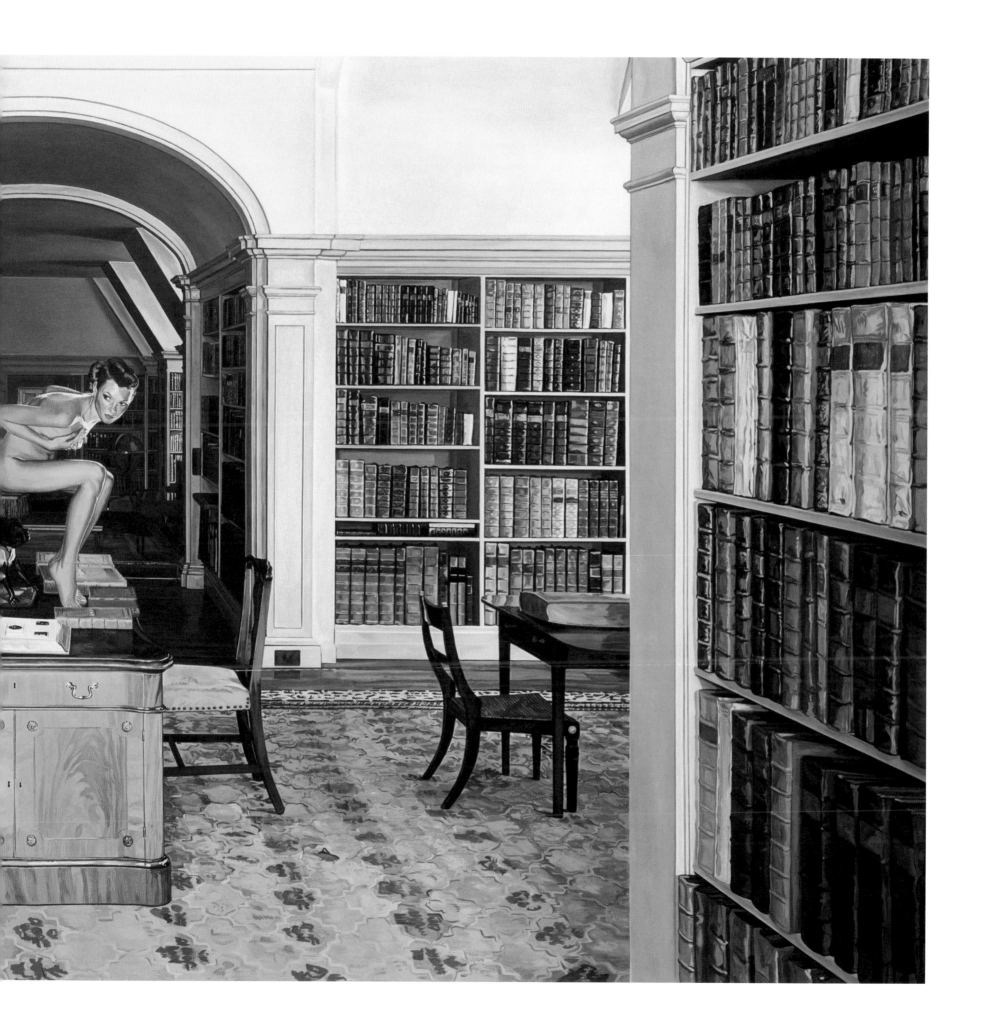

184

Rode slaapkamer
2002

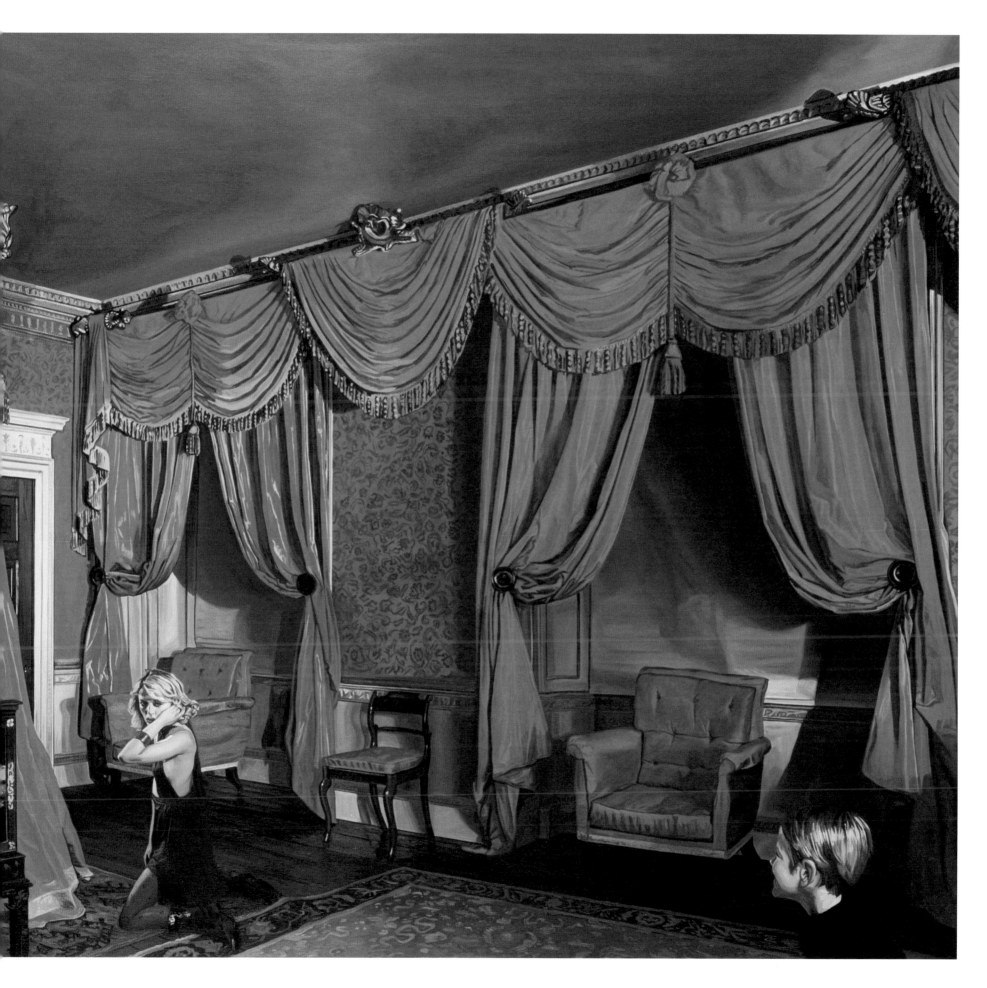

(page 182) *The Pitying Torturer* *The Final Gaze*
 2002 2002

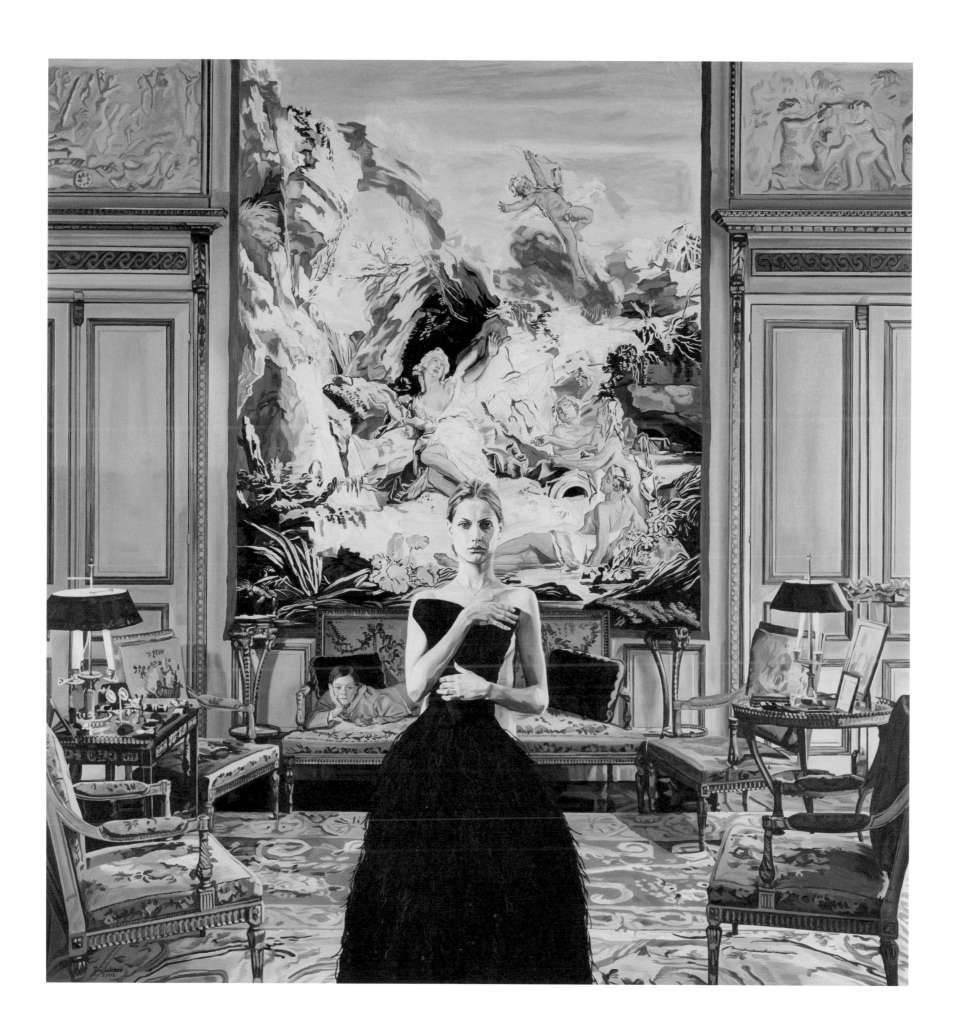

Twee jongens
2002

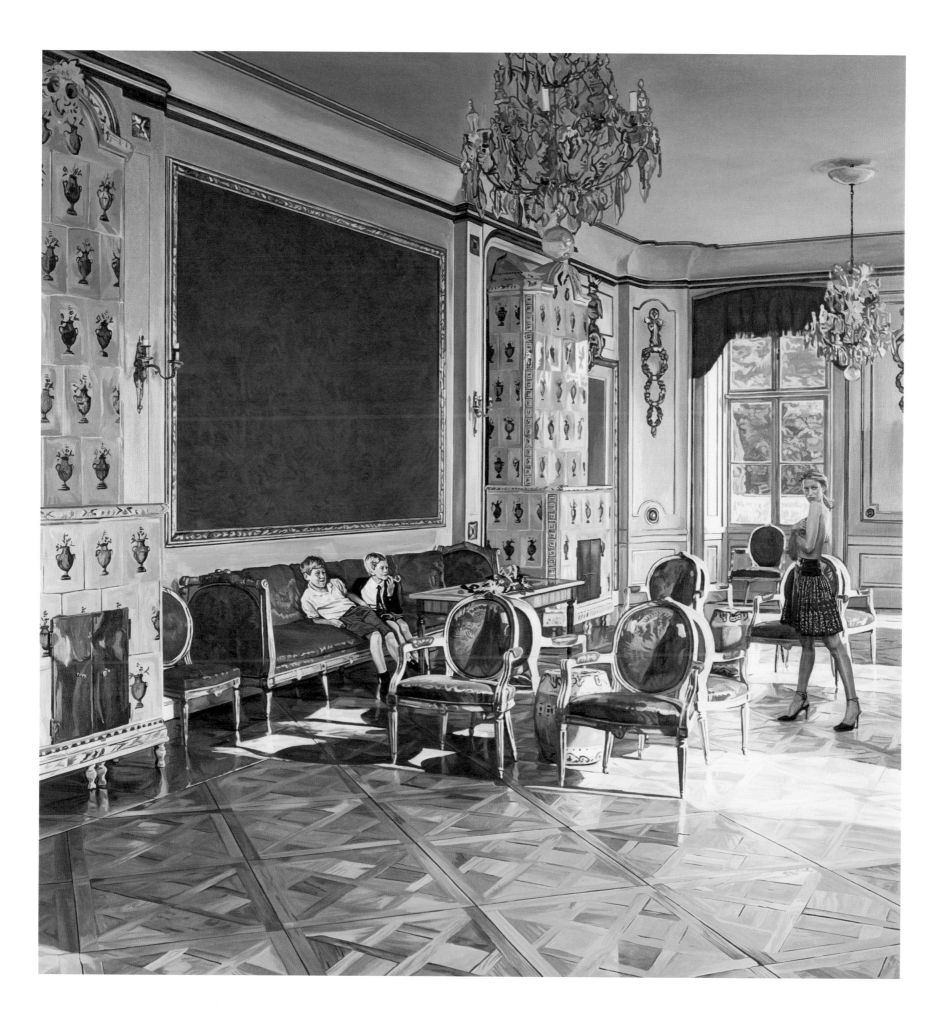

Biljartkamer
2002

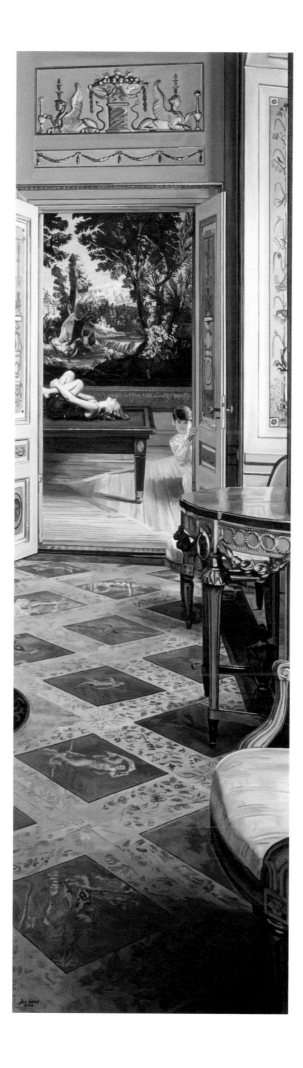

Lost Connections
2003

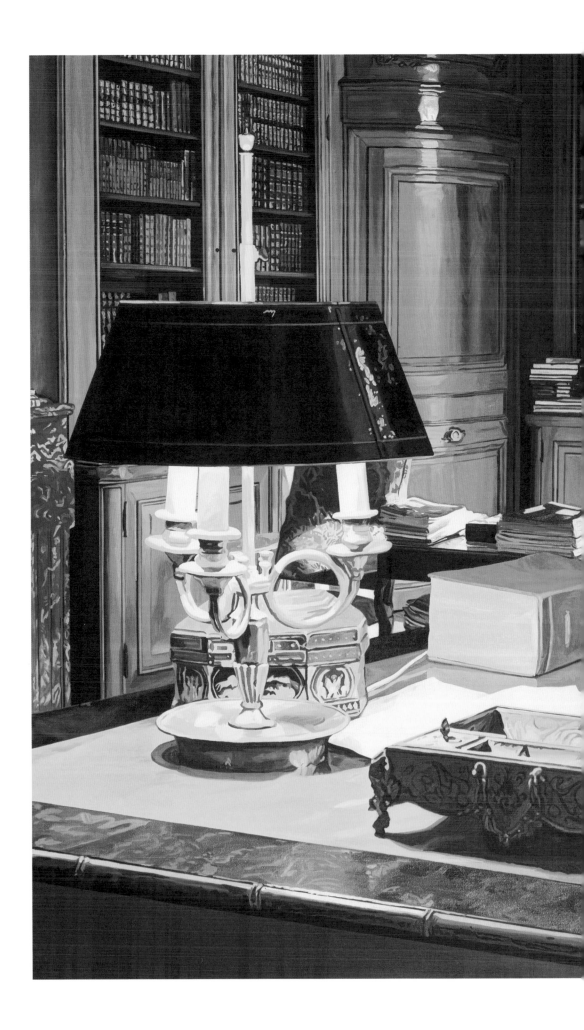

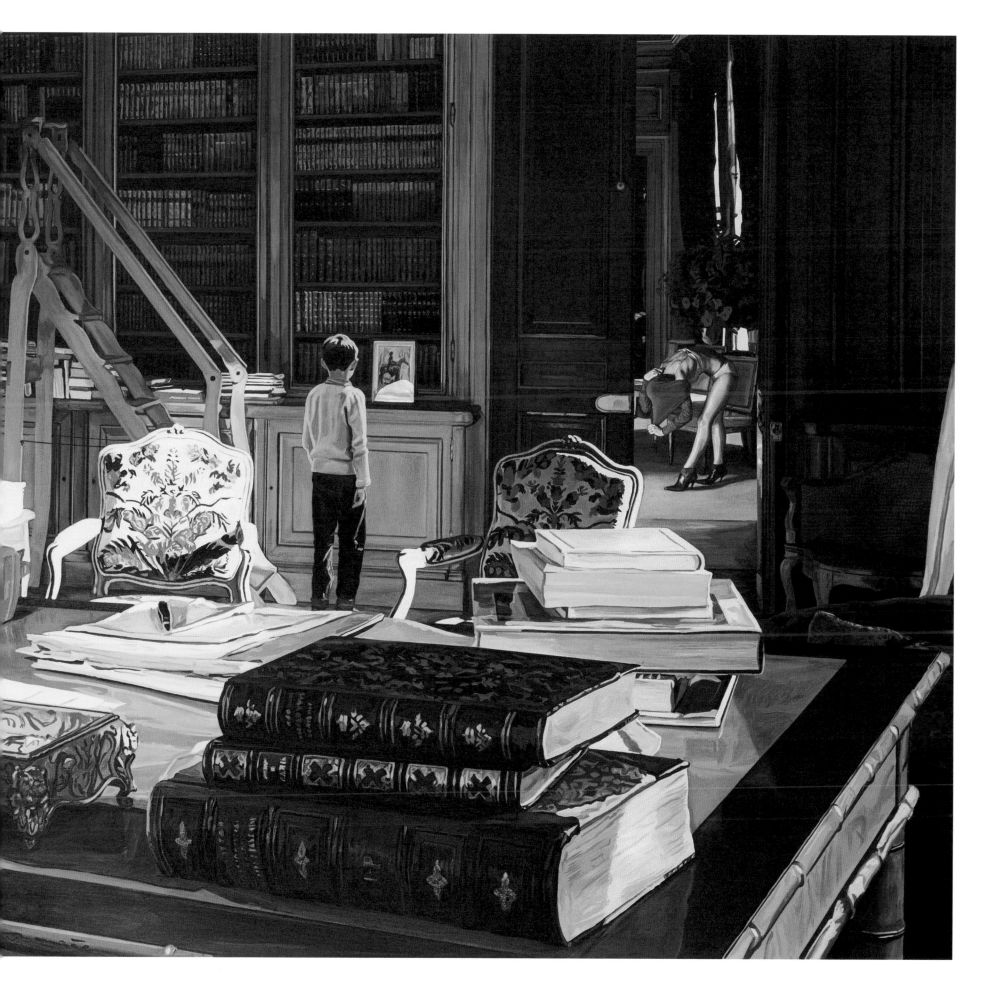

The Beautiful Fugitive
2003

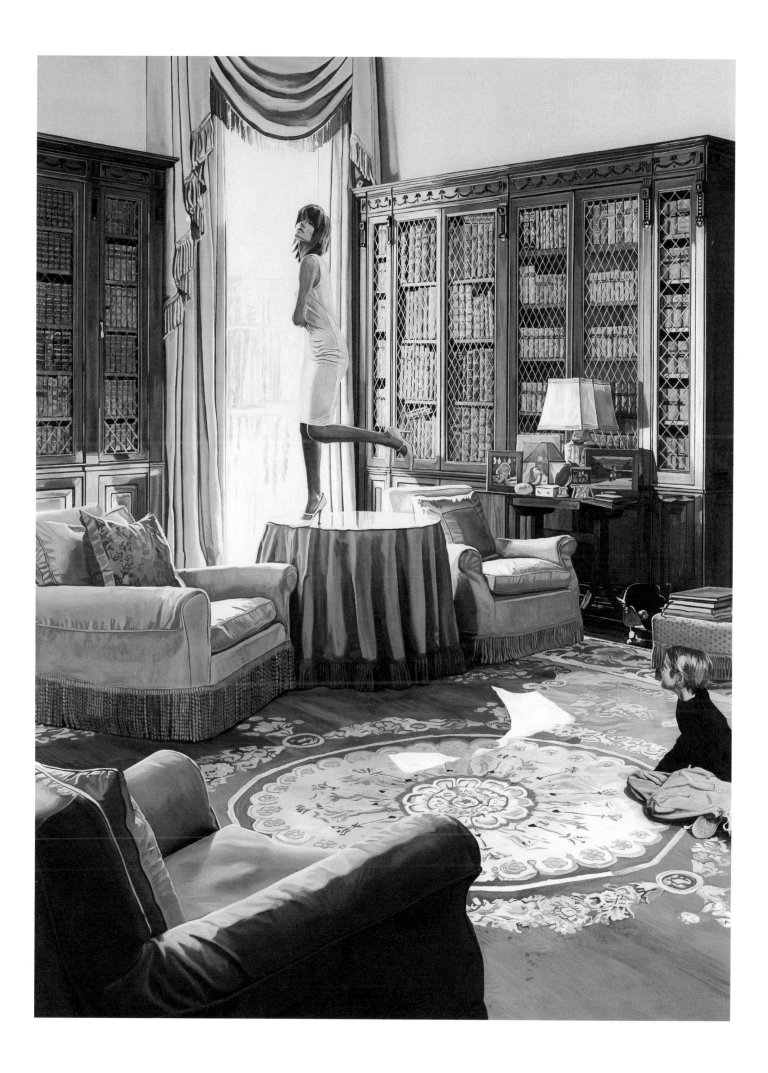

The Rich Hours
2003

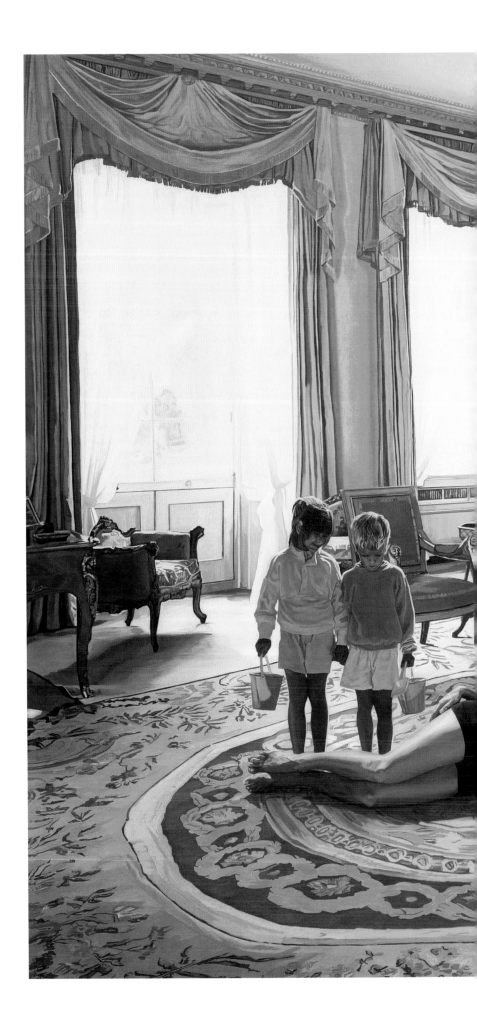

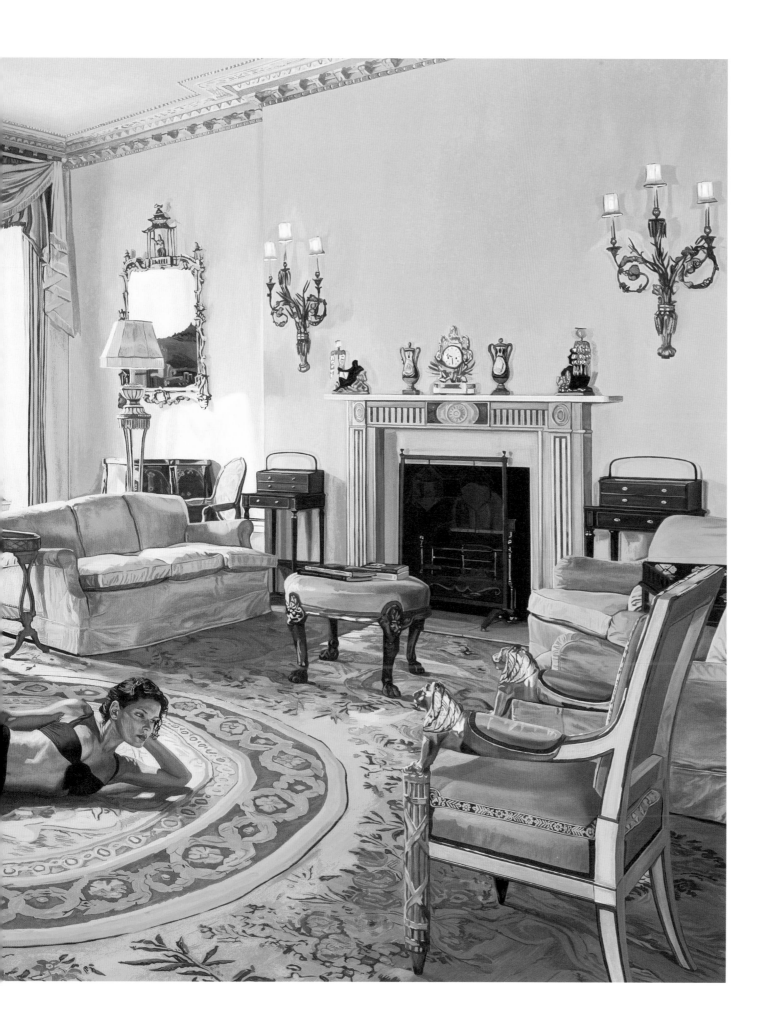

Tacit Understanding
2003

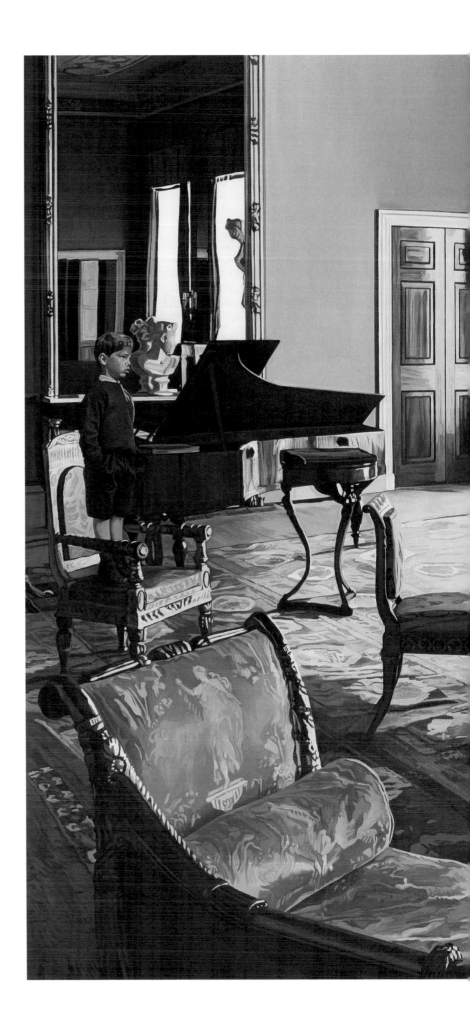

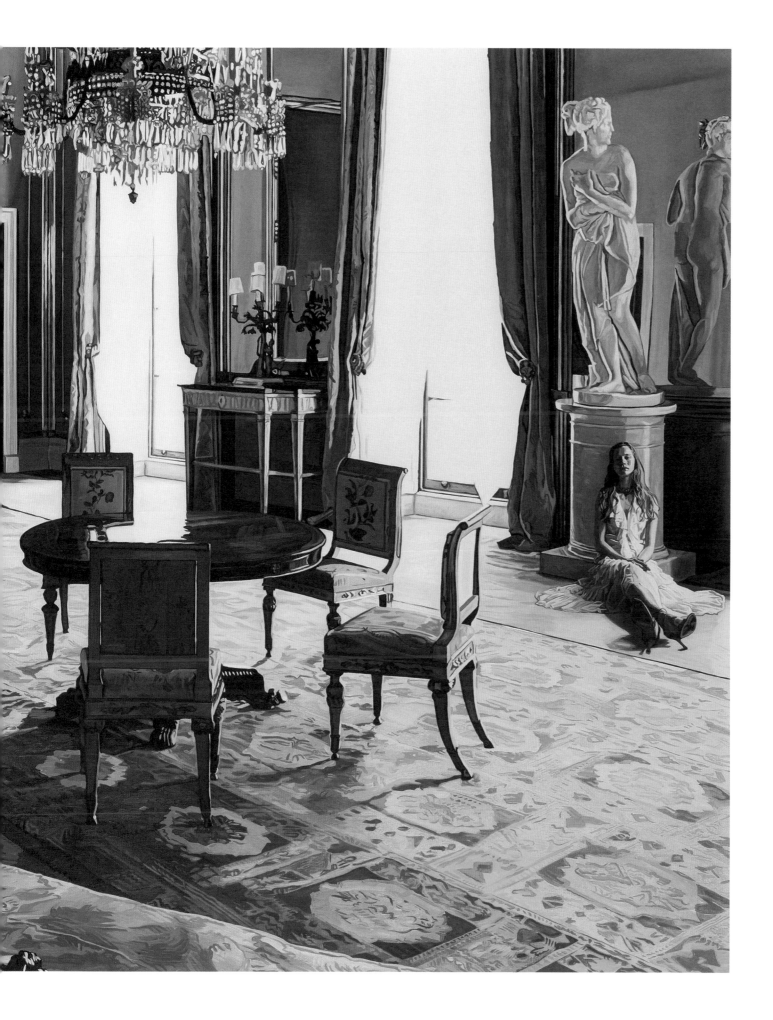

Two Boys Standing
2004

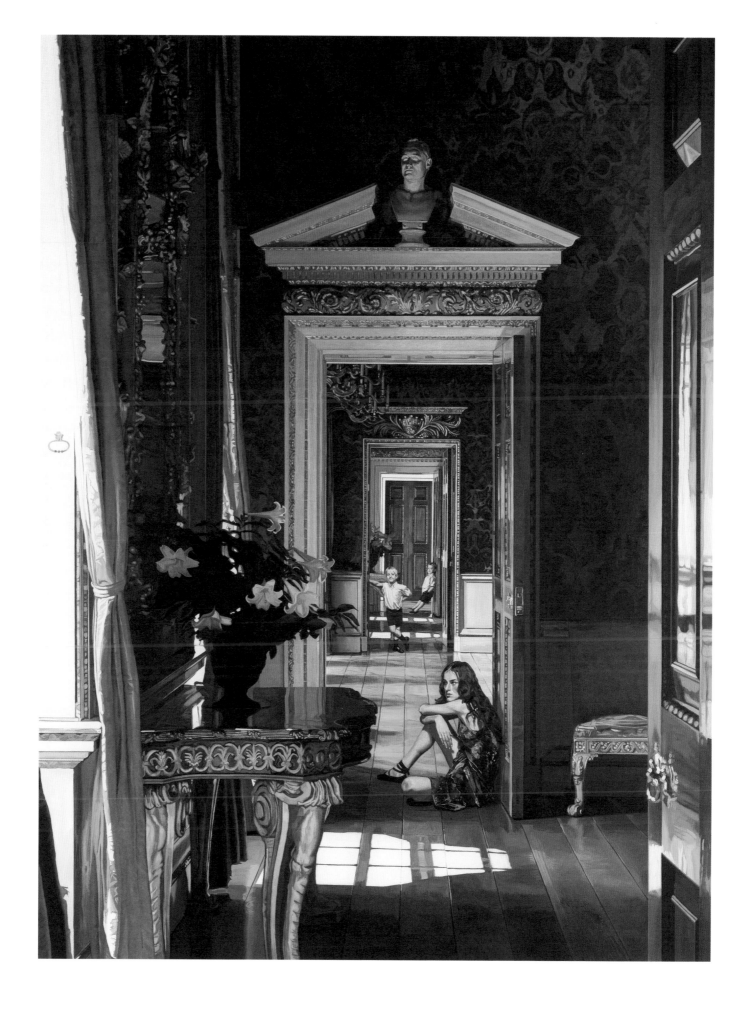

A Final Afternoon
2004

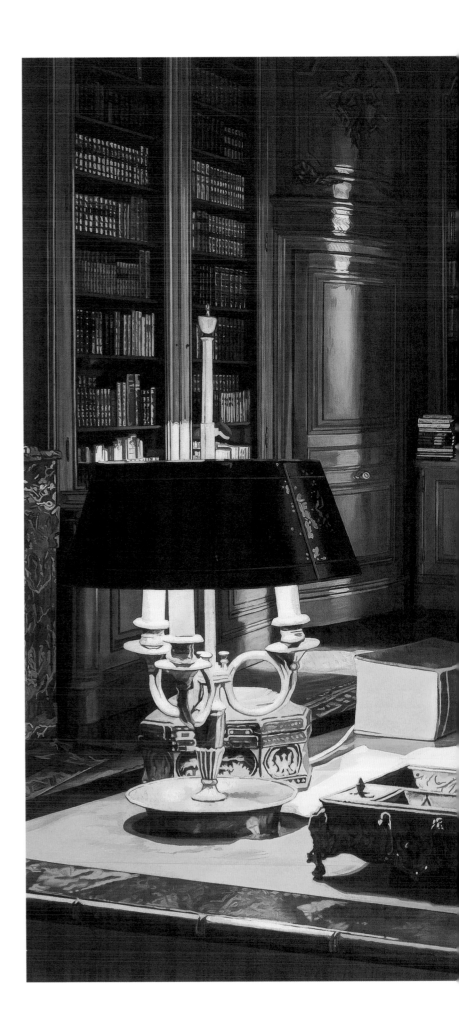

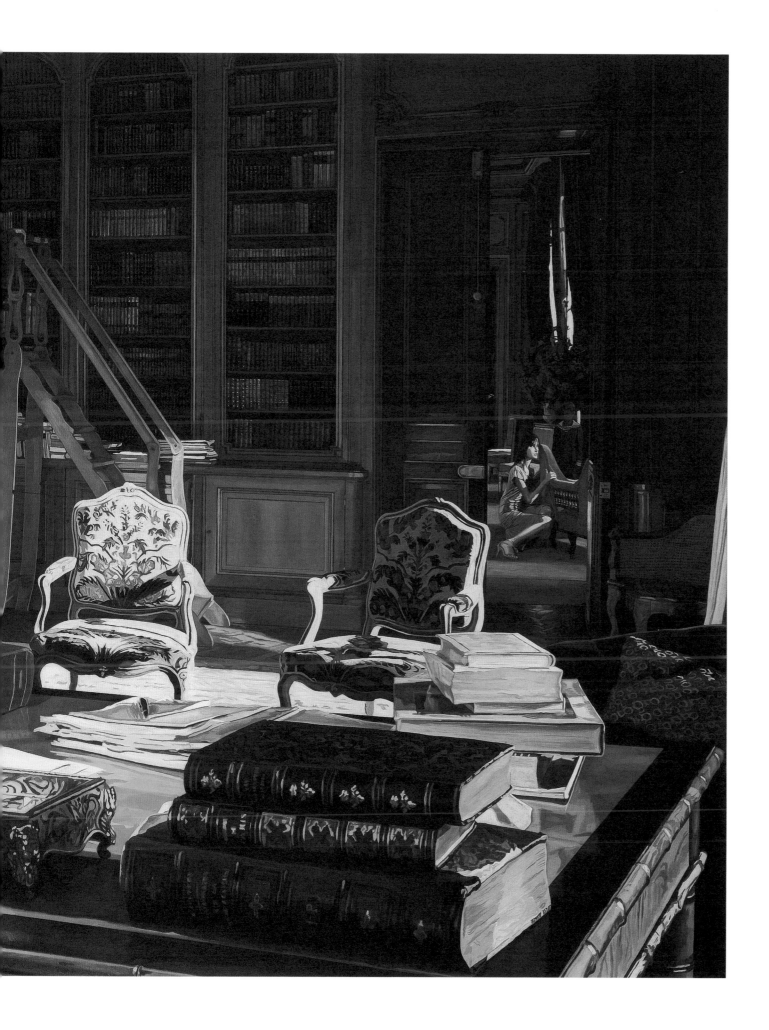

Almost Total Happiness
2004

The Mirror
2005

The Schoolboy

2005

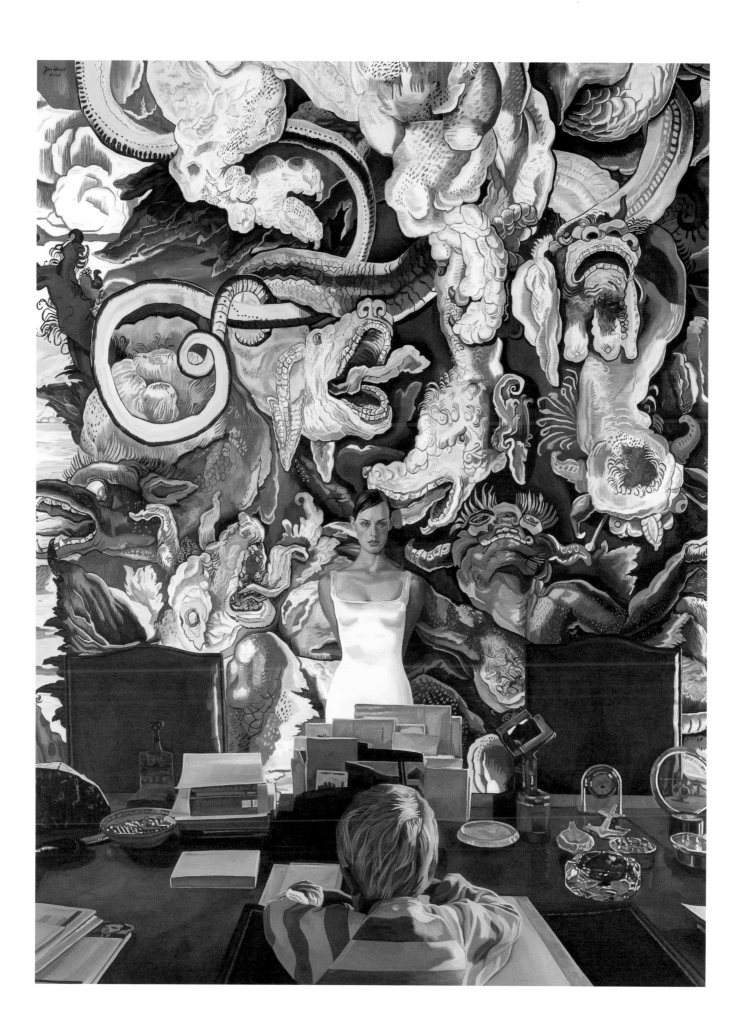

The Table
2005

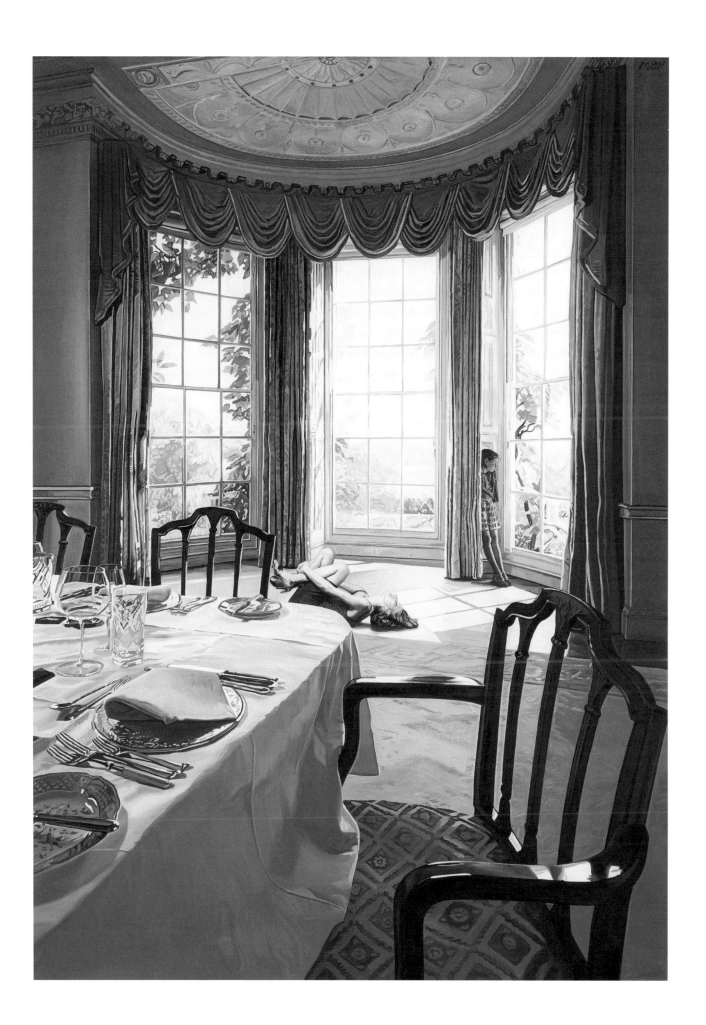

The Farewell

2005

The Generous Friend
2006

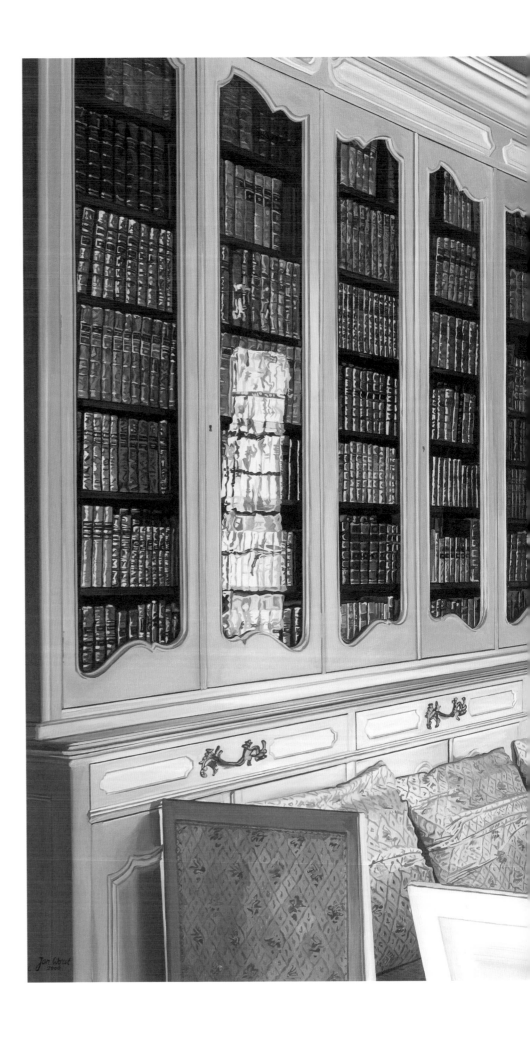

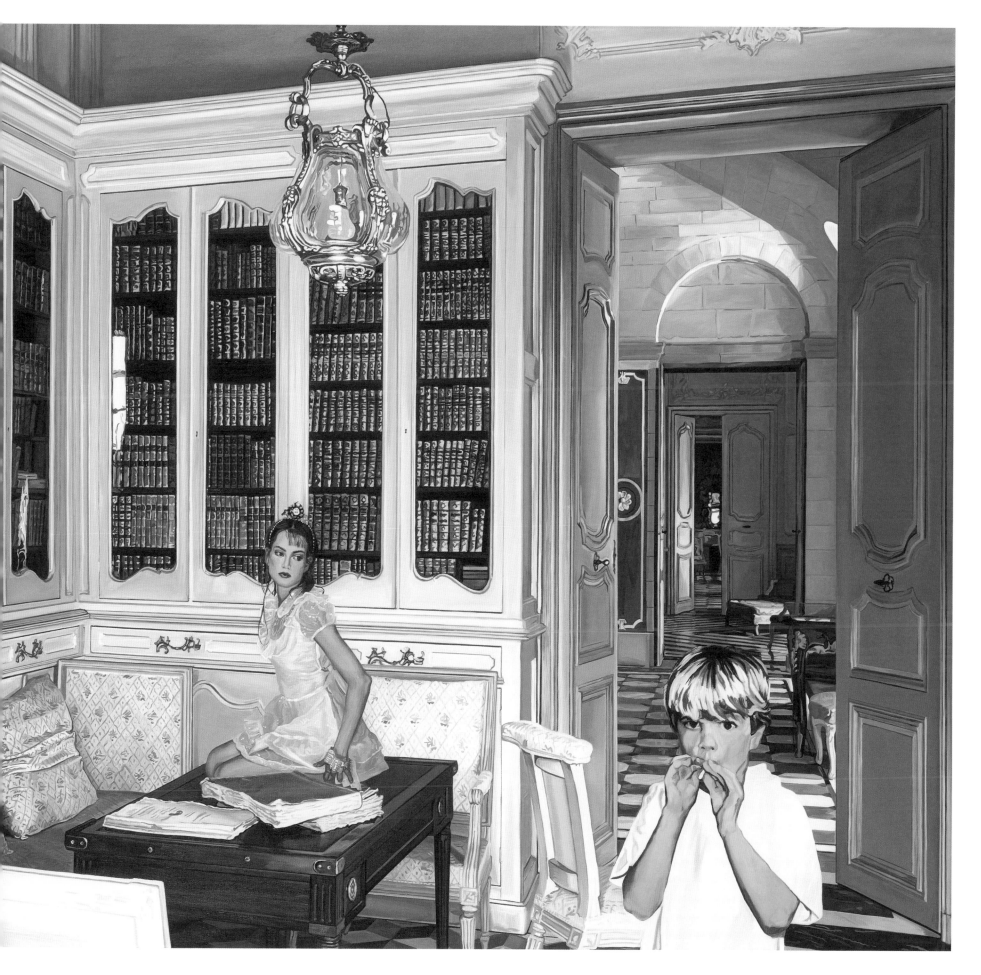

The Brothers
2006

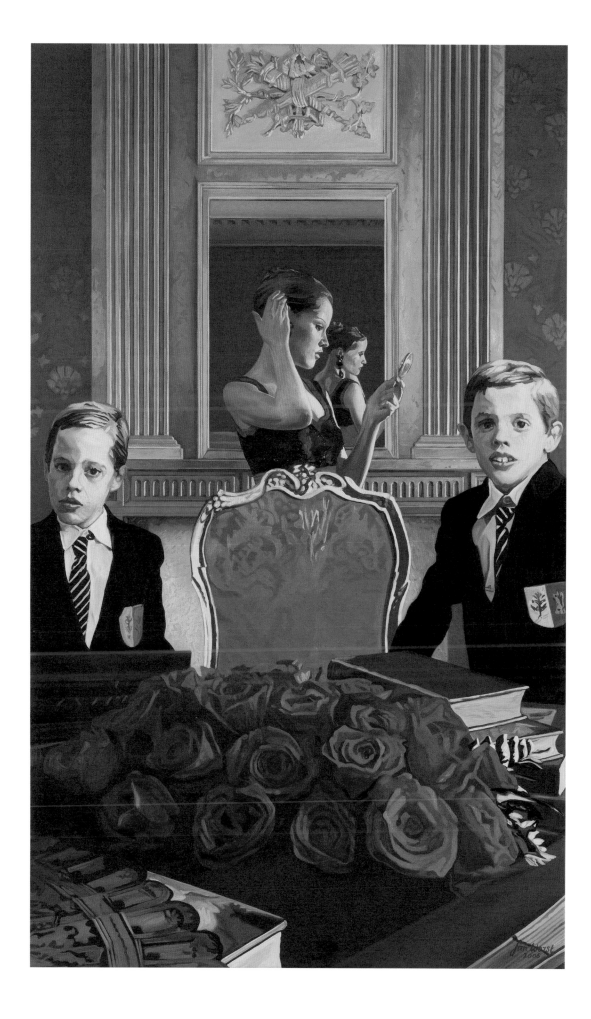

The Egoist
2006

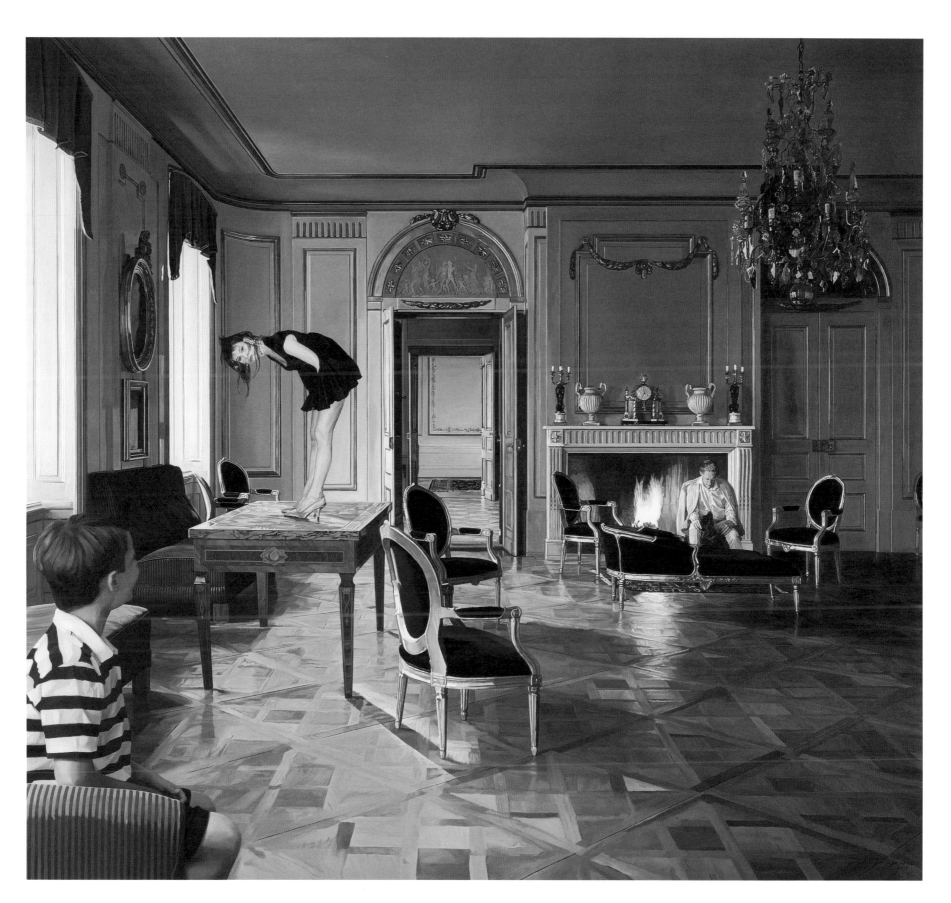

The Pocket
2007

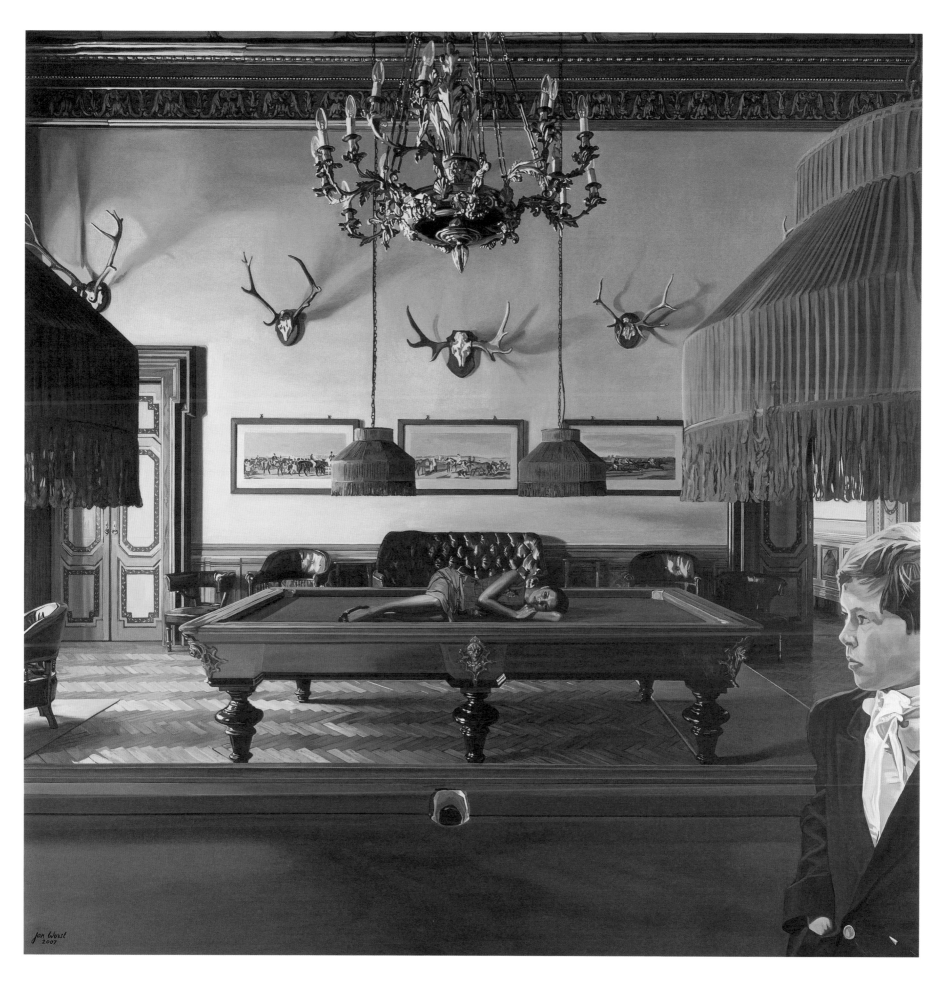

Flagrant Light
2008

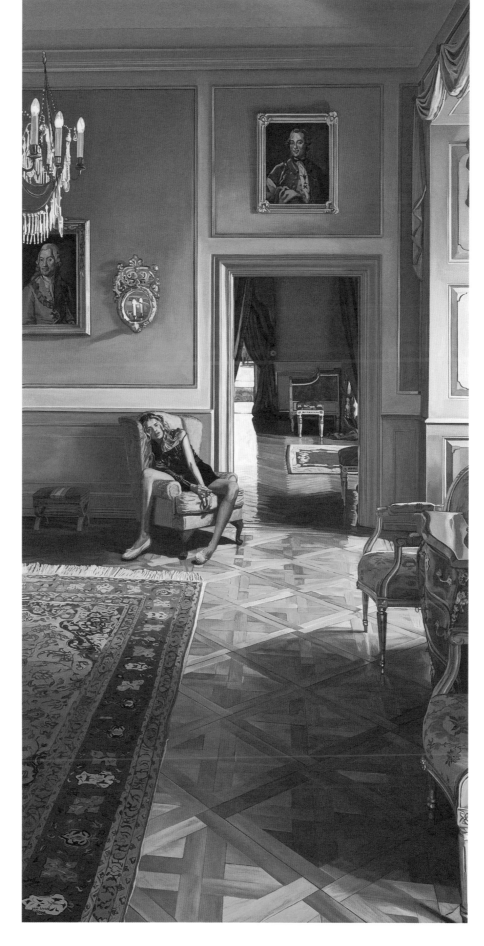

Paintings 1988 - 2008

all works are oil on canvas

Confidente, 50 x 200cm, 1988

De droom en de
verantwoordelijkheid,
100 x 75cm, 1988

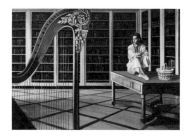

Elysium, 100 x 140cm, 1988

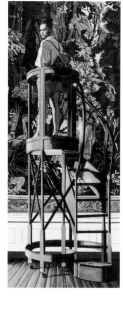

Belvédère, 200 x 80cm, 1989

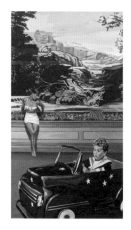

Zeus en Nemesis, 170 x 100cm, 1989

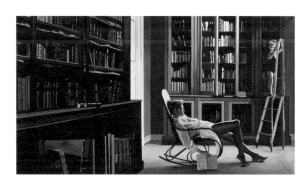

Deugd als slaapmiddel, 110 x 200cm, 1989

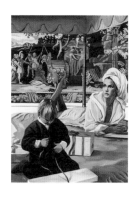

A propos Diogenes,
140 x 100cm, 1989

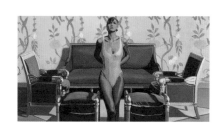

Ter geruststelling van de scepticus, 80 x 150cm, 1989

225

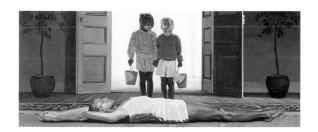

Presqu'ile, 80 x 200cm, 1990

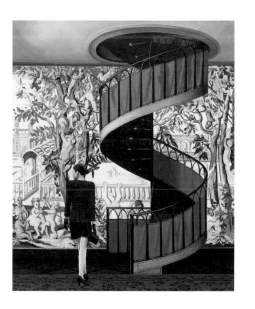

De eenzame wandelaarster, 200 x 170cm, 1990

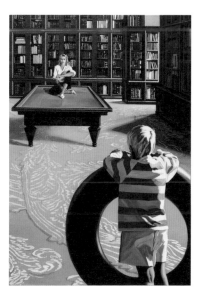

Kinderszene, 200 x 140cm, 1990

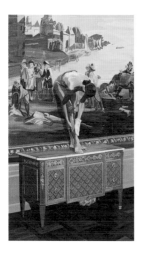

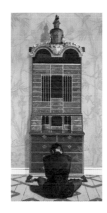

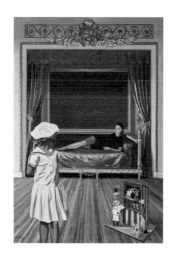

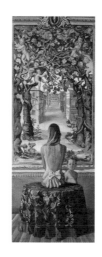

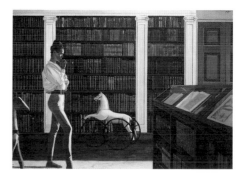

The Ecchoing Green, 140 x 200cm, 1991

Hoc erat in votis,
150 x 80cm, 1990

Et in Arcadia ego, 200 x 115cm, 1990

Dialogue interieur, 200 x 140cm, 1991

In Parenthesis,
200 x 80cm, 1991

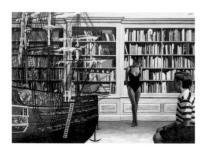

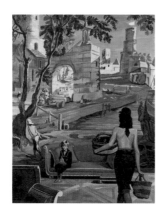

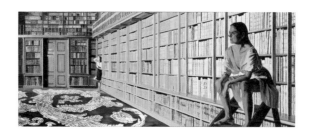

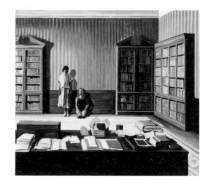

As idle as a painted ship upon a painted ocean,
125 x 180cm, 1991

Sirenenküste, 80 x 200cm, 1992

De groene bibliotheek, 140 x 160cm, 1992

Retour des Pêcheurs, 180 x 140cm, 1991

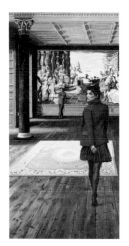

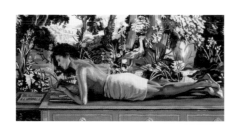

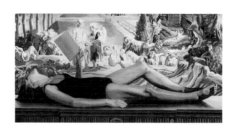

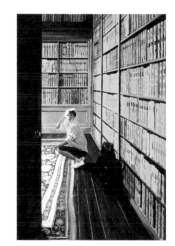

Sta Viator, 200 x 100cm, 1992

De lezeres, 75 x 150cm, 1992

De gevaarlijke roman, 75 x 150 cm, 1992

Reisebild, 170 x 115cm, 1992

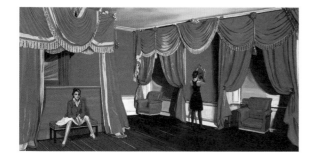

Die 2 Mädchen, 100 x 200cm, 1992

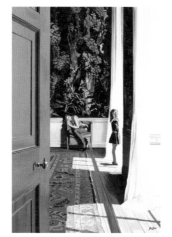

Allegorie, 170 x 115cm, 1992

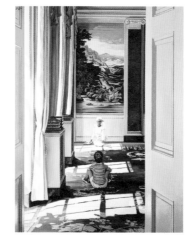

De ontmoeting, 170 x 130cm, 1993

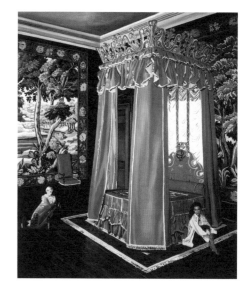

Senso, 200 x 170cm, 1993

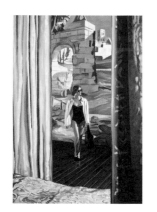

Seewind, 145 x 100cm, 1993

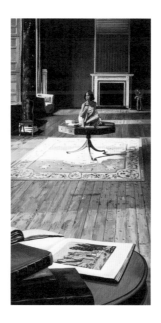

Lesebild, 200 x 100cm, 1993

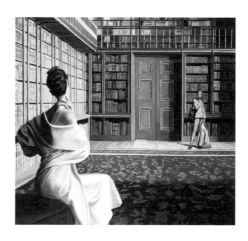

Bibliotheek met twee vrouwen, 145 x 160 cm, 1993

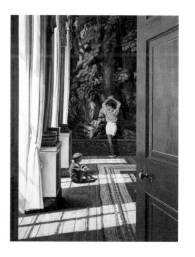

Spelenderwijs, 170 x 130cm, 1993

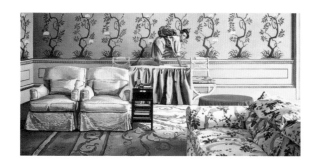

Die Abenteuerin, 100 x 200cm, 1993

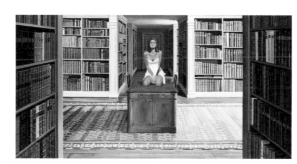

Labyrinth, 100 x 200cm, 1993

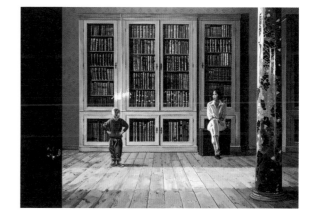

Vertrek, 140 x 200cm, 1994

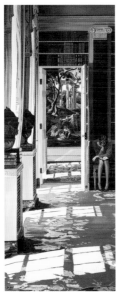

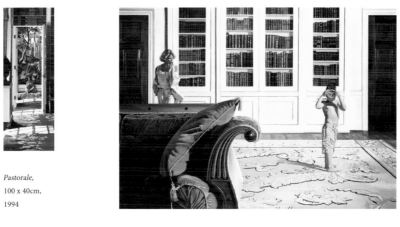

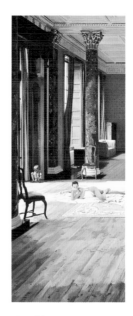

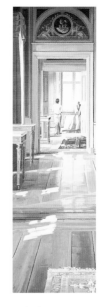

Aandachtig, 200 x 80cm, 1994

Pastorale,
100 x 40cm,
1994

Il Tuffatore, 140 x 200cm, 1994

Het vrolijke meisje,
200 x 80cm, 1994

Rückenfigur,
200 x 60cm, 1994

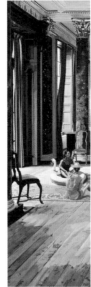

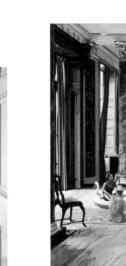

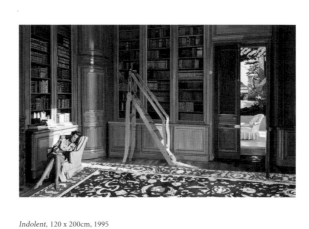

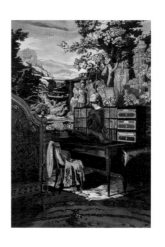

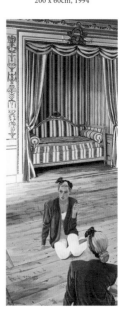

In 't voorbijgaan, 145 x 85cm, 1994

Het spel, 200 x 60cm, 1995

Indolent, 120 x 200cm, 1995

Antiek idool , 160 x 110cm, 1995

Verwant, 200 x 80cm, 1995

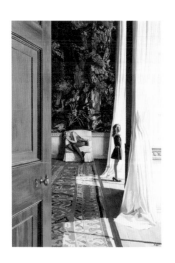

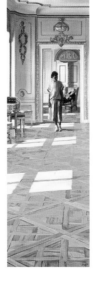

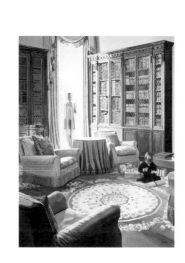

Allegorie II, 170 x 115cm, 1995

Herr und Hund, 100 x 100cm, 1995

Man en vrouw,
200 x 60cm, 1995

Het geschenk, 170 x 130cm, 1996

Lesefieber,
20 x 20cm, 1996

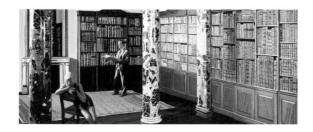

De voorlezing, 80 x 200cm, 1996

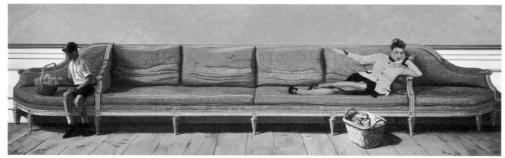

Confidente II, 120 x 400cm, 1996

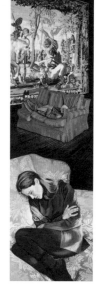

Dagdroom,
200 x 60cm, 1996

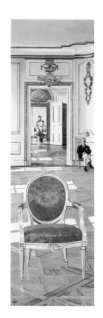

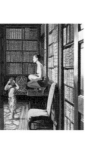

Urszene, 85 x 60cm, 1997

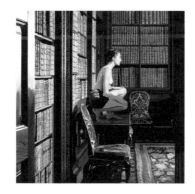

Primal Scene, 125 x 125cm, 1997

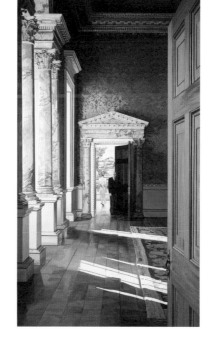

Cicerone, 250 x 140cm, 1997

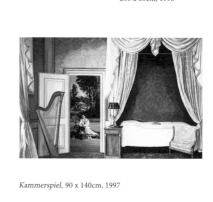

Kammerspiel, 90 x 140cm, 1997

De rode stoel,
200 x 60cm, 1996

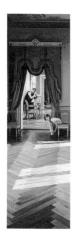

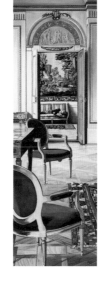

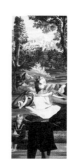

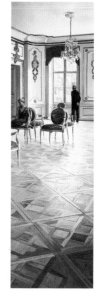

Die Fenster,
150 x 45cm, 1997

Camera Lucida,
200 x 60cm, 1997

Erscheinung,
100 x 40cm, 1997

Verschijning, 120 x 120cm, 1997

Good Looking,
100 x 40cm, 1997

De huisvriend,
200 x 60cm, 1998

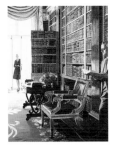

De moralist, 125 x 95cm, 1998

Herinnering, 140 x 100cm, 1998

Good Looking II, 200 x 80cm, 1998

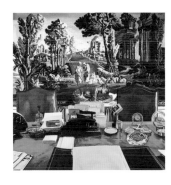

De briefschrijfster, 120 x 120cm, 1998

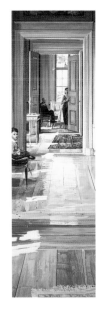

Disperaat ensemble,
200 x 60cm, 1998

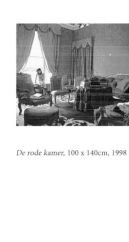

De rode kamer, 100 x 140cm, 1998

Sweet Neglect, 80 x 200cm, 1999

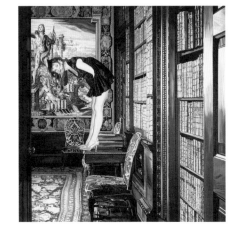

The Captive, 150 x 150cm, 1999

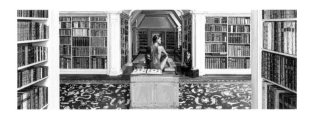

The Wait, 80 x 230cm, 2000

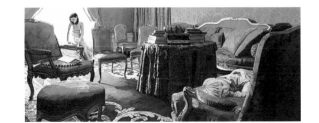

The Secret Miracle, 150 x 150cm, 1999

Red Interior, 80 x 200cm, 2000

In Passing, 200 x 110cm, 2000

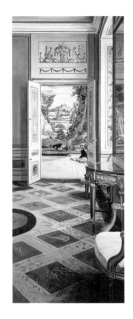

A Favourite Scene, 200 x 80cm, 2000

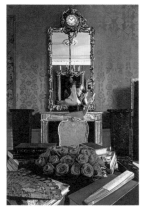

The Virtue of Unlikeness ,
185 x 125cm, 2000

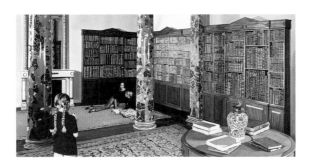

Bibliotheek, 100 x 200cm, 2000

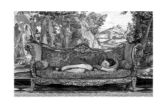

Dormeuse, 60 x 100cm, 2001

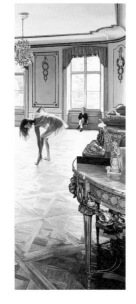

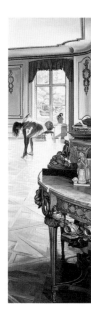

His Curious Universe,
200 x 80cm, 2000

His Curious Universe II,
200 x 60cm, 2000

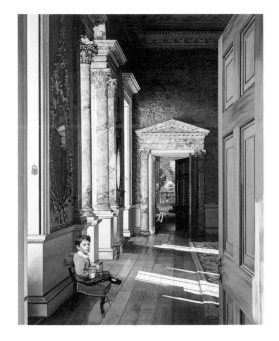

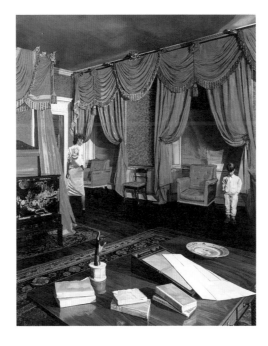

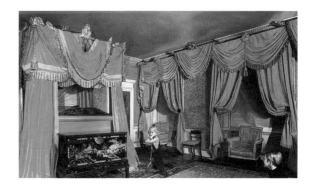

Rode slaapkamer, 120 x 205cm, 2002

The Children's Hour, 250 x 200cm, 2001

The Watcher, 250 x 200cm, 2001

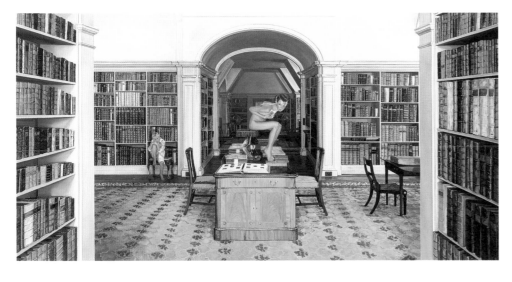

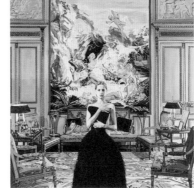

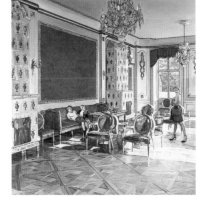

The Pitying Torturer, 200 x 400cm, 2002

The Final Gaze, 150 x 145cm, 2002

Twee jongens, 150 x 145cm, 2002

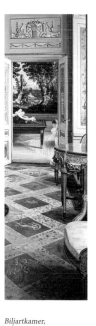

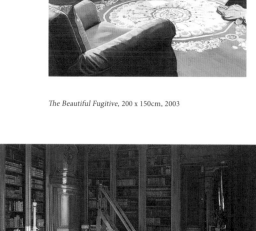

Lost Connections, 120 x 205cm, 2003

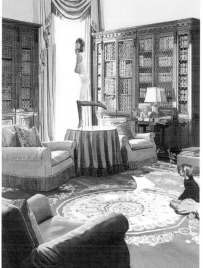

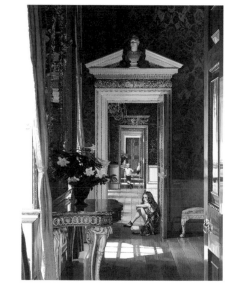

The Rich Hours, 150 x 200cm, 2003

Biljartkamer,
200 x 60cm, 2002

The Beautiful Fugitive, 200 x 150cm, 2003

232

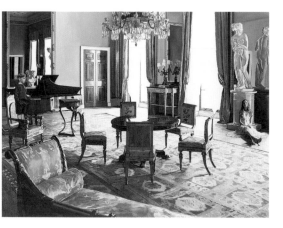

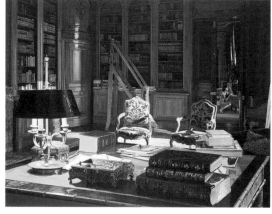

Tacit Understanding, 150 x 200cm, 2003

A Final Afternoon, 150 x 200cm, 2004

Two Boys Standing, 200 x 150cm, 2004

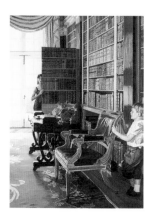

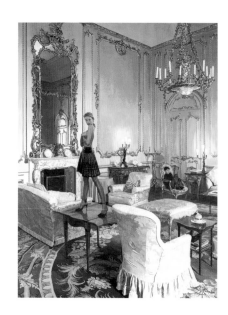

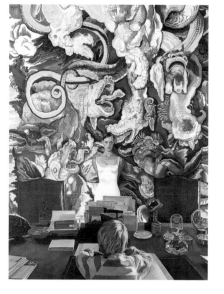

Almost Total Happiness, 140 x 100cm, 2004

The Mirror, 200 x 150cm, 2005

The Schoolboy, 200 x 150cm, 2005

The Table, 140 x 100cm, 2005

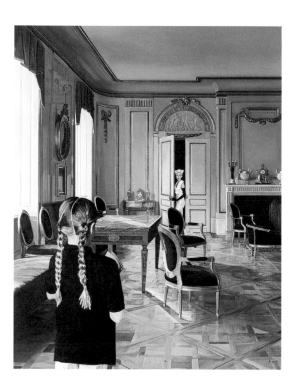

The Farewell, 250 x 200cm, 2005

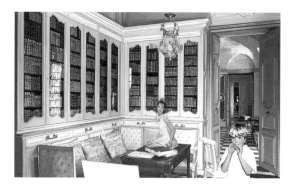

The Generous Friend, 120 x 200cm, 2006

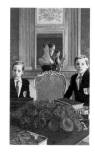

The Brothers,
100 x 60cm, 2006

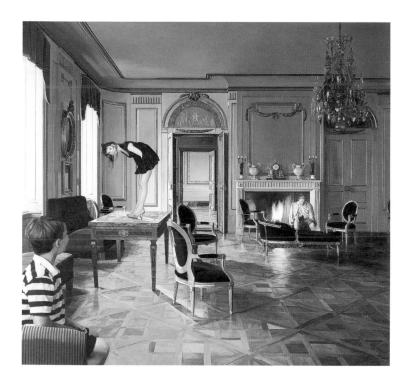

The Egoist, 250 x 275cm, 2006

The Pocket, 150 x 150cm, 2007

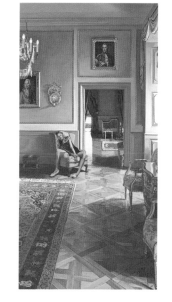

Flagrant Light, 200 x 100cm, 2008

234

Collections

Confidente, 1988: Private Collection, Groningen

De droom en de verantwoordelijkheid, 1988: Private Collection, Bloemendaal

Elysium, 1988: Private Collection, The Netherlands

Belvédère, 1989: Private Collection, Munich

Zeus en Nemesis, 1989: Private Collection, The Netherlands

Deugd als slaapmiddel, 1989: Private Collection, Schiedam

À propos Diogenes, 1989: Rijksdienst Beeldende Kunsten

Ter geruststelling van de scepticus, 1989: Private Collection, The Netherlands

Presqu'ile, 1990: Private Collection, The Netherlands

De eenzame wandelaarster, 1990: Private Collection, Belgium

Kinderszene, 1990: Private Collection, The Netherlands

Et in Arcadia ego, 1990: Private Collection, Cologne

Hoc erat in votis, 1990: Private Collection, Amsterdam

Dialogue intérieur, 1991: Caldic Collection, Rotterdam

In Parenthesis, 1991: Gemeentelijk Museum Jan Cunen, Oss

The Ecchoing Green, 1991: Private Collection, Amsterdam

As idle as a painted ship upon a painted ocean, 1991: Caldic Collection, Rotterdam

Retour des Pêcheurs, 1991: Private Collection, Italy

Sirenenküste, 1992: Private Collection, Cologne

De groene bibliotheek, 1992: Trip Advocaten & Notarissen, Groningen

Sta viator, 1992: KLM Airfreight Services, Schiphol

De lezeres, 1992: Private Collection, Belgium

De gevaarlijke roman, 1992: Private Collection, Belgium

Reisebild, 1992: Private Collection, Düsseldorf

Die 2 Mädchen, 1992: Private Collection, Germany

Allegorie, 1992: Private Collection, Italy

De ontmoeting, 1993: Private Collection, Groningen

Senso, 1993: Private Collection, Belgium

Seewind, 1993: Private Collection, The Netherlands

Lesebild, 1993: Trip Advocaten & Notarissen, Groningen

Bibliotheek met twee vrouwen, 1993: Private Collection, Belgium

Die Abenteuerin, 1993: ING Collection, Amsterdam

Spelenderwijs, 1993: Private Collection, The Netherlands

Labyrinth, 1993: Private Collection, The Netherlands

Vertrek, 1994: Private Collection, Belgium

Aandachtig, 1994: Private Collection, Belgium

Pastorale, 1994: Private Collection, The Netherlands

Il Tuffatore, 1994: Delta Lloyd, Amsterdam

Het vrolijke meisje, 1994: Private Collection, The Netherlands

Rückenfigur, 1994: Private Collection, The Netherlands

In 't voorbijgaan, 1994: Private Collection, Leiden

Het spel, 1995: Koninklijke Bijenkorf, Amsterdam

Indolent, 1995: Private Collection, The Netherlands

Antiek idool, 1995: Private Collection, Frankfurt/M

Verwant, 1995: Private Collection, Groningen

Allegorie II, 1995: Private Collection, Amsterdam

Herr und Hund, 1995: Private Collection, The Netherlands

Man en vrouw, 1995: Private Collection, Cologne

Het geschenk, 1996: Collection AXA Leven, Den Haag

De voorlezing, 1996: Private Collection, Germany

Dagdroom, 1996: Private Collection, The Netherlands

Lesefieber, 1996: Private Collection, The Netherlands

Confidente II, 1996: Private Collection, Switzerland

De rode stoel, 1996: Private Collection, Amsterdam

Urszene, 1997: Private Collection, Groningen

Primal Scene, 1997: Gasunie Collection, Groningen

Cicerone, 1997: Gasunie Collection, Groningen

Camera Lucida, 1997: Private Collection, Munich

Die Fenster, 1997: Private Collection, Munich

Kammerspiel, 1997: Private Collection, Germany

Erscheinung, 1997: Private Collection, Munich

Verschijning, 1997: Private Collection, Groningen

Good Looking, 1997: Private Collection, Vienna

De huisvriend, 1998: Private Collection, The Netherlands

De moralist, 1998: Private Collection, The Netherlands

Herinnering, 1998: Private Collection, The Netherlands

Good Looking II, 1998: Private Collection, Schiedam

De briefschrijfster, 1998: Private Collection, Arnhem

Disparaat ensemble, 1998: Private Collection, Utrecht

De rode kamer, 1998: Private Collection, Belgium

Sweet Neglect, 1999: Private Collection, The Netherlands

The Captive, 1999: Private Collection, Italy

The Secret Miracle, 1999: Private Collection, Italy

The Wait, 2000: Collection Gian Enzo Sperone, New York

In Passing, 2000: Private Collection, Augsburg

A Favourite Scene, 2000: Private Collection, Augsburg

The Virtue of Unlikeness, 2000: Private Collection, Switzerland

Red Interior, 2000: Private Collection, The Netherlands

His Curious Universe, 2000: Private Collection, Milan

His Curious Universe II, 2000: Private Collection, Utrecht

Bibliotheek, 2000: De Nieuwe Academie, Groningen

The Children's Hour, 2001: Private Collection, Germany

The Watcher, 2001: Private Collection, Turin

Dormeuse, 2001: Private Collection, Switzerland

The Pitying Torturer, 2002: Collection Gian Enzo Sperone, New York

Rode slaapkamer, 2002: Private Collection, Augsburg

The Final Gaze, 2002: Private Collection, The Netherlands

Twee jongens, 2002: Private Collection, Augsburg

Biljartkamer, 2002: Private Collection, Amsterdam

Lost Connections, 2003: Private Collection, The Netherlands

The Beautiful Fugitive, 2003: Private Collection, Texas

The Rich Hours, 2003: Brignone Collection, London

Tacit Understanding, 2003: Brignone Collection, Turin

Two Boys Standing, 2004: Private Collection, Italy

A Final Afternoon, 2004: Olbricht Collection, Essen

Almost Total Happiness, 2004: Brignone Collection, Turin

The Mirror, 2005: Olbricht Collection, Essen

The Schoolboy, 2005: Olbricht Collection, Essen

The Table, 2005: Private Collection, Germany

The Farewell, 2005: Private Collection, Germany

The Generous Friend, 2006: Scheringa Museum voor Realisme

The Brothers, 2006: Scheringa Museum voor Realisme

The Egoist, 2006: Private Collection, The Netherlands

The Pocket, 2007: Private Collection, Italy

Flagrant Light, 2008: Courtesy Sperone Westwater, New York

Jan Worst

1953 Born Heerenveen, The Netherlands

EDUCATION
1971-1976 Academie Minerva, Groningen, The Netherlands

ONE-PERSON EXHIBITIONS
1987 Pictura, Groningen
1988 Galerie Frontaal, Appingedam
1989 Galerie Apunto, Amsterdam
1991 Jan Worst, schilderijen 1988/1991, Instituut voor Kunst-,
 Architectuurgeschiedenis en Archeologie, Groningen
1992 Die Aktualität des Schönen, Galerie Christian Gögger, München
1993 Jan Worst, schilderijen, Museum Willem van Haren, Heerenveen
1994 Galerie Christian Gögger, München
1995 Interiors, Torch Gallery, Amsterdam
1996 Galerie Edition Voges + Deisen, Frankfurt am Main
1997 Galerie Christian Gögger, München
1998 Primal Scenes, Torch Gallery, Amsterdam
 Good Looking, Gasunie galerij, Groningen
 Good Looking, Kunstverein Ulm
1999 Torch Gallery, Amsterdam
2000 Galleria Cardi, Milano
2001 Kunstverein Hochrhein e.V., Bad Säckingen
2002 Torch Gallery, Amsterdam
 Gian Enzo Sperone, Roma
2004 Sperone Westwater, New York
2005 Art Basel 37, Sperone Westwater, Basel
2008 Ben Brown Fine Arts, London

GROUP EXHIBITIONS
1988 Met Verve, Centrum voor Beeldende Kunst, Groningen
 Triënnale Noord-Nederland, Groninger Museum, Groningen
1990 Beroep kunstenaar, Rijksmuseum Twente, Enschede
 Realisme!, Realisme?, Galerie Apunto, Amsterdam
 Realisme, Pictura, Groningen
1991 Elseviers keuzeprent, Art Index, Amsterdam
 Souvenirs, Frans Halsmuseum, Haarlem
 Op het eerste gezicht, Gemeentelijk Museum Jan Cunen, Oss
 Aanwinsten Nederlandse grafiek, Stedelijk Museum Amsterdam
 Een verzameling; realisme renaissance, Caldic Collectie, Rotterdam
 100 jonge schilders onder 1 dak, Voormalige Passagiersterminal Holland-
 Amerika Lijn, Rotterdam
1992 Realities, Circulo de Bellas Artes, Madrid
 In het licht van het lezen, Frans Halsmuseum, Haarlem
 100 jonge schilders onder 1 dak, Sonsbeek International Art Centre, Arnhem
 La Ragione Trasparente, Eos Arte Contemporaneo, Madonna di Campiglio
 Aanwinsten 1985-1993, Stedelijk Museum. Amsterdam
1993 Groningen International, Exposorium Vrije Universiteit, Amsterdam
 Realities, Arti et Amicitiae, Amsterdam
 Erotik, Galerie Edition Voges + Deisen, Frankfurt am Main
1994 Galerie Witzenhausen + Partner, Amsterdam
1995 Galerie Christian Gögger, München
1996 Vuur onder de wereld, 4e galeriemanifestatie Noord Nederland, Martinihal, Groningen

1997 Multiple Box, Frankfurt a.M
 Caleidoscoop, Centrum Beeldende Kunst, Groningen
 Gewoon weer schilderen, Keunstwurk, Leeuwarden
 Der menschliche Faktor, Hypo-Bank, Luxembourg
1998 Grafiek, Artkitchen, Amsterdam
 Der menschliche Faktor, Achenbach Kunsthandel, Düsseldorf
 The Waking Dream:Psychological Realism in Contemporary Art, Castle Gallery,
 New Rochelle, New York
1999 Der bevorzugte Ort, Kunstverein Ludwigsburg
 Der kleine Hans, Galerie Christine König, Vienna
 Contemporary Works of Art, Boymans van Beuningen Museum, Rotterdam
2000 Blondies and Brownies, Torch Gallery, Amsterdam
 Innocence, Images of Kids, Aeroplastics Contemporary. Brussels
2001 Between Earth and Heaven, Museum voor Moderne Kunst, Oostende
 Galleria Cardi & Co, Milano
2002 Torch Gallery, Amsterdam
2003 Galerie Voges + Partner, Frankfurt am Main
2004 Centrum Beeldende Kunst, Groningen
 Collectie van de Gasunie, Museum De Buitenplaats, Eelde
2005 Der Rote Teppich, Kunstverein KISS, Abtsgemünd-Untergröningen
2006 De Magie van het Realisme, Het Gorcums Museum, Gorinchem
 Freeze! A Selection of Works from a New York Collection, Robilant + Voena + Sperone, London
2007 Leve de Schilderkunst! Terug naar de figuur, Kunsthal, Rotterdam
 Rockers Island. Olbricht Collection, Museum Folkwang, Essen
 Vrouwen aan de wal, een selectie uit de ING collectie, Zeeuws maritiem muzeeum, Vlissingen

Acknowledgements

This publication contains all of my paintings from the last twenty years. I am grateful to Sperone Westwater, New York for publishing this book. I am indebted to Gian Enzo Sperone, Angela Westwater and David Leiber, especially for their patience with my tortuous efforts to finish my paintings. I also wish to thank Michael Short who took care of the continuity for this project. Special gratitude goes to Adrian Dannatt for his inventive commentary on my work. Thanks to Peter Tahl for the quality of his photographic record of my paintings. Finally I thank my brother Ids for his unfailing support and criticism through all these years.

Jan Worst, 2008

ISBN 978-0-9799458-2-3

Published by Sperone Westwater, 415 West 13 Street, New York , NY 10014
Publication co-ordination by Jenny Lui

Designed by He Hao
Printed and Bound by Artron Color Printing Co., Ltd